face to face

Rick Sammon's complete guide to photographing people

Rick Sammon

O'REILLY®

BEIJING · CAMBRIDGE · FARNHAM · KÖLN · PARIS · SEBASTOPOL · TAIPEI · TOKYO

facetoface

Rick Sammon's complete guide to photographing people

by Rick Sammon

Printed in Canada

Published by O'Reilly Media, Inc. 1005 Gravenstein Highway North, Sebastopol CA 95472

O'Reilly books may be purchased for educational, business, or sales promotional use. Online editions are also available for most titles (safari.oreilly.com). For more information, contact our corporate/institutional sales department: (800) 998-9938 or corporate@oreilly.com.

Editor: Audrey Doyle

Interior Designer: Ron Bilodeau

Technical Editor: James Duncan Davidson

Indexer: Ted Laux

Cover Designer: Monica Kamsvaag

Print History: May 2008. First Edition

This book uses RepKover™, a durable and flexible lay-flat binding.

ISBN-13: 9780596515744

[F]

For Dr. Richard Zakia

Thank you for your insight into perception and imaging.

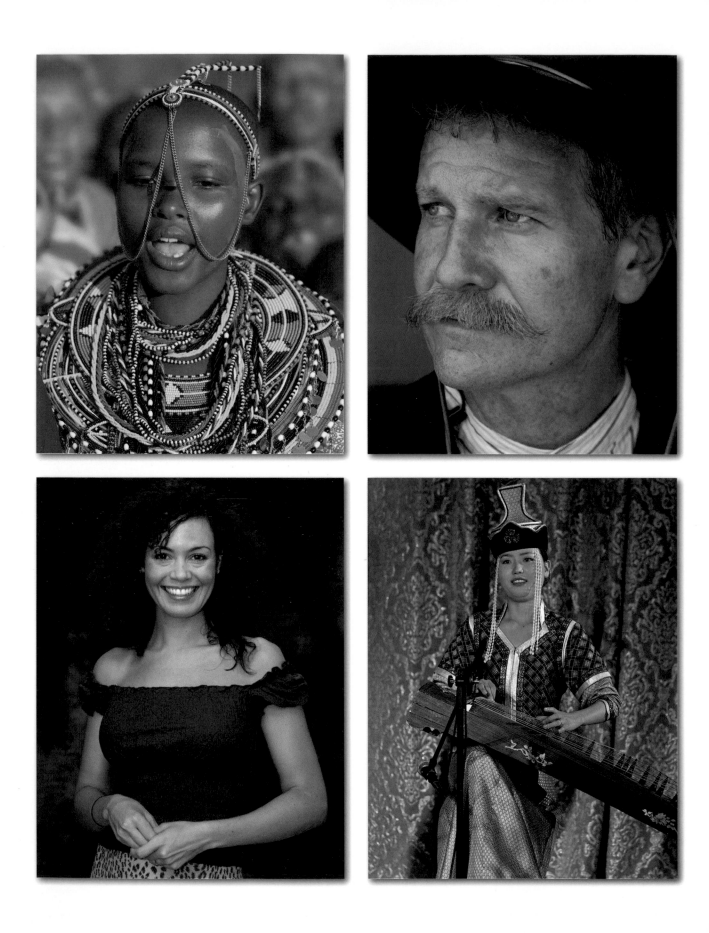

Contents

	Acknowledgments	vii
	Foreword	ix
Preface	Evolution of a Photo Shoot	xi
Introduction	The Camera Looks Both Ways	xv

Part I Cameras Don't Take Pictures, People Do

| | Jumpstart Your Photo Session | 3 |
| **Lesson 1** | A Quick Look at Gear | 21 |

Part II Photo Philosophies

Lesson 2	Making Pictures Versus Taking Pictures	33
Lesson 3	From Head to Toe	37
Lesson 4	Creating a Sense of Place	41
Lesson 5	Dead Center Is Deadly	45
Lesson 6	Horizontal and/or Vertical	49
Lesson 7	Silence Is Deadly	51
Lesson 8	Being There and Being Aware	53
Lesson 9	Portraits Versus Environmental Portraits	55
Lesson 10	The All-Important Background	59
Lesson 11	Paying People	63
Lesson 12	Dress for Success	67
Lesson 13	Body Language and Hands	71
Lesson 14	Seeing Eye to Eye	75
Lesson 15	Choose a Location	81
Lesson 16	Adding Props	85
Lesson 17	Seeing Pictures Within a Picture	91
Lesson 18	Adding a Person Adds Scale to a Picture	95
Lesson 19	Thinking Creatively	99
Lesson 20	Taking Fun Shots	101

Part III Outdoor Photography

Lesson 21	Capturing Action	109
Lesson 22	Using Reflectors	113
Lesson 23	The Beauty of Using Diffusers	117
Lesson 24	Garage Glamour	121
Lesson 25	Daylight Fill-in Flash	125
Lesson 26	The Disequilibrium Technique	129
Lesson 27	The Key to a Good Profile	133
Lesson 28	Photographing People in Low Light and at Night	135
Lesson 29	Group Photography	141
Lesson 30	Take Advantage of Backlight	145
Lesson 31	Photographing Festivals	151
Lesson 32	Creating a Sense of Depth	161

Part IV Indoor Photography

Lesson 33	Rembrandt Lighting	169
Lesson 34	Shooting Silhouettes	173
Lesson 35	Basic Flash Techniques	177
Lesson 36	Using Lighting Kits	187
Lesson 37	Working with Mirrors	195
Lesson 38	Photographing a Stage Show	199

Part V Enhancing Your Pictures in Photoshop

Lesson 39	Create a Beautiful Black-and-White Image	209
Lesson 40	The Renaissance Painter Effect	215
Lesson 41	Color and Black-and-White in the Same Image	219
Lesson 42	From Snapshot to Artistic Image	223
Lesson 43	Create the Disequilibrium Effect	229
Lesson 44	Change the Shutter Speed and F-Stop	233
Lesson 45	Remove Distracting Elements in a Scene	239
Lesson 46	Brighten a Subject's Eyes and Smile	243
Lesson 47	Basic Skin Softening	247
Lesson 48	Hand-Color a Picture	251
Lesson 49	Playin' with Plug-ins	257
Epilog	Your Assignment: On-Location Portraiture	265
Index	Index	278

Acknowledgments

If you are reading these acknowledgments, you are probably looking for your name and for some nice things that I might have said about you. Or, you may be interested in seeing who is on my "thank you" list for helping me with this book. Well, many people have helped me with this work, as well as with my photography career. If you are one of them, I hope I remembered to properly thank you in this section. If you don't see your name here, please drop me an email and remind me of my temporary memory loss. I'll be sure to remember to get you into my next book!

The guy who made this book happen was Steve Weiss, executive editor at O'Reilly. Working on any creative endeavor is never easy, but Steve manned the helm for smooth sailing over the course of producing this book.

My editor at O'Reilly, Audrey Doyle, not only caught all my typos, but also kept track of all the words and pictures and molded them into what you see here as easy-to-follow lessons. Not an easy task, to be sure.

James Duncan Davidson was the tech editor on this book. Hey, I never met the guy, but he caught some technical stuff that I missed, which saved me from writing the reader a "sorry for the mistake" note on my blog.

Other folks at O'Reilly played an important role in producing this book: Dennis Fitzgerald, managing editor; Ron Bilodeau, interior design; and Steve Fehler, cover designer, all get a big "thank you" for helping me present my work in a most attractive manner. I'd also like to thank Derrick Story, who did not work on this book directly, but who offered moral support and advice on the project.

I am not the only Sammon who worked on this book. My dad, Robert M. Sammon, Sr., who, among other things, taught me how to take pictures with a Linhof 4x5-inch view camera, read all my lessons and offered advice before I sent them off to Audrey. My son, Marco, helped me with some of the photographs. And my wife, Susan, never complained when I announced that I was taking off for places like Mongolia, Africa, Antarctica, or Namibia to take pictures for this book.

Julieanne Kost, Adobe Evangelist, gets a big thank you for inspiriting me to get into Photoshop in 1999. Addy Roff at Adobe also gets my thanks. Addy has given me the opportunity to share my Photoshop techniques at trade shows around the country.

Some friends at Apple also helped me during the production of this book by getting me up to speed with Aperture 2, which speeds up my digital imaging workflow. So, more "thank you" notes go to Don Henderson, Fritz Ogden, Kirk Paulsen, and Ann Townsager.

Other friends in the digital imaging industry who have helped in one way or another include David Leveen of MacSimply and Rickspixelmagic. com, Mike Wong and Craig Keudell of onOne Software, Rob Sheppard and Wes Pitts of *Outdoor Photographer* and *PCPhoto* magazines, Ed

Sanchez and Mike Slater of Nik Software, George Schaub, editorial director of *Shutterbug* magazine, Kelly Mondora of F.J. Westcott, Kriss Brunngraber of Bogen Imaging, Scott Kelby of *Photoshop User* magazine, and Chris Main of *Layers* magazine.

At Mpix.com, my online digital imaging lab, I'd like to thank Joe Dellasega, John Rank, Dick Coleman, and Richard Miller for their ongoing support of my work.

Rick Booth, Steve Inglima, Peter Tvarkunas, Chuck Westfall, and Rudy Winston of Canon USA have been ardent supporters of my work, as well as my photography seminars. So have my friends at Canon Professional Service (CPS). My hat is off to these folks, big time! The Canon digital SLRs, lenses, and accessories that I use have helped me to capture the finest possible pictures for this book.

Jeff Cable of Lexar hooked me up with memory cards (4 GB and 8 GB because I shoot RAW files) and card readers, helping me to bring back great images from my trips.

My photo workshop students were, and always are, a tremendous inspiration for me. Many showed me new digital darkroom techniques, some of which I used in this book. During my workshops, I found an old Zen saying to be true: "The teacher learns from the student."

So, thank you one and all. I could not have done it without you!

Foreword

Rick Sammon has authored 27 books on photography and conservation, but this one, he tells me, is his favorite. His photographs reveal, with clarity, the reason why. He is truly a photographer who loves to engage people with his camera, people in different cultures, young and old. He photographs them with great sensitivity, dignity, and love.

I think Rick picked up his charm with people from his dad, who was director of the early notable television program, "Person to Person," with Edward R. Morrow. He is very close to his dad, who has a creative mind, a strong work ethic, and a gentle and respectful way with people that Rick emulates. His dad is still a great influence on Rick, and even with a vision problem (macular degeneration), he continues to assist Rick with his books, articles, and television programs. Like father, like son; Rick has passed on these qualities to his 15-year-old son, Marco, named after the famous Italian explorer, Marco Polo.

Photographing people in your own culture is much easier than doing so in other cultures. You must have some understanding of other cultures and sensitivity to differences. Body language can play an important role, but you must be cautious. For example, thumbs up, which is a signal of acceptance or approval in some cultures, can have quite a different meaning in other cultures. Body language can become bawdy language. Personal space is another factor to consider. Some cultures require a greater distance between the photographer and the person being photographed to feel at ease. It is a common practice for Rick to first spend some time with the person or persons to be photographed so as to establish a rapport and trust. Sometimes he will entertain them with mag-

ic tricks, as he did with a group of monks when he was photographing in Bhutan.

As you spend time with his photographs, you will notice that in most of them there is direct eye contact between the subject and Rick, and subsequently, between the subject and you, the viewer. People in his photographs have a real presence, and you can experience a feeling of openness and trust on the part of the person being photographed. Minor White underscored the importance of rapport and trust when he wrote, "Creativity with portraits involves the invocation of the state of rapport when only a camera stands between two people ... mutual vulnerability and mutual trust."

The eyes are the "windows of the soul," as the saying goes. But the eyes are seen in the context of the face. The many possible expressions of the face, with its 50 or so muscles, make you realize how important the instant of clicking the shutter is. Being able to read those subtle and rapidly changing expressions and quickly respond to them is essential. For me, Rick's photographs are more than "Face to Face." They are also "Eye to Eye."

An interesting aspect of looking at his photographs is that, as a viewer, you can spend as much time as you want, eye to eye, with a photograph and not break eye contact. In a person-to-person situation, such staring would be uncomfortable.

As you look at Rick's photographs, you will notice that he has been careful to position his subjects against a background that provides a context for the person being photographed. Take, for example, the photo that appears in this book's introduction that shows a beautiful young Cuban girl in a blue outfit (blue blouse and blue jeans),

sitting on the hood of an old blue car (common in Cuba), crossed legs, natural smile, and relaxed expression. The old blue car and the old stone wall behind the car provide context.

If I had to choose my favorite photograph in this book, I would have great difficulty doing so. However, one photograph has completely captivated me. The photo also in the Introduction and on the cover, is a close-up of the three beautiful young girls in which their smiling faces fill the frame. Eye contact is direct, open, and trusting and you sense an intense feeling of presence. For me, the three girls are symbolic of the "Three Graces." I have returned to this photograph many times and continue to do so. It is charming. I know it is one of Rick's very favorite people photographs, which is why he chose it for the cover of this book.

Many of Rick's portraits, which he took on location and not in a studio, fall under the genre of "environmental portraiture." One of the great portrait photographers of our time, Arnold Newman, was an early advocate. Some photographs by Annie Liebowitz carry on this tradition. Newman's portraits are of celebrities, as are those of Liebowitz; great photographs of great people. Rick has taken a different road and it is well traveled— great photographs of common, ordinary people in all walks of life.

When you look back into the history of portrait painting, you'll find that at one time only royalty and important people had their portraits painted. Van Gogh and earlier Dutch painters broke with this tradition and painted portraits of commoners and friends. One of Van Gogh's well-known paintings is of his mailman.

Portrait photographs that reveal the inner spirit of a person are truly an art form. Not every great photographer is a great portrait photographer. A case in point is Ansel Adams, whose art form was landscape photography. According to John Szarkowski, at one time Adams wanted to photograph the head of a person as though it was a piece of sculpture, and regrettably, says Szarkowski, he often succeeded. Personality plays an important role here. Some photographers are more people-oriented than others. Fortunately, photography embraces many different forms.

Rick is a people person; outgoing, energetic, and charmingly extroversive. You only have to meet and spend time with him to realize that he loves to engage people with his camera. Even without having the opportunity to meet him in person, you can vicariously meet him by studying his photographs. Like other serious photographers he readily admits that his photographs are echoes of himself.

An old German metaphor, "The apple never falls far from the tree," rings true here. Rick's photographs and love of people, as well as his work ethic, mimic those of his father.

—Richard D. Zakia
Professor Emeritus
Rochester Institute of Technology

Evolution of a Photo Shoot

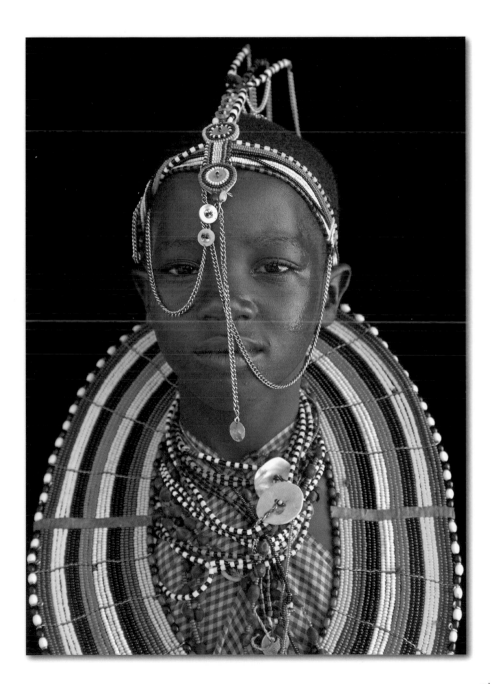

Many of the pictures in this book are the result of a photo shoot, or photo session, which lasted at least several minutes. Only in a few, rare cases did I have a one-shot photo session that happened in the blink of an eye.

Understanding the importance of the photo shoot process and the need to work toward the exact shot you want helps you get that perfect photograph.

Here, I'll discuss two examples from my countless photo sessions: one from a photo workshop I led in Kenya, and one from an adventure to Mongolia.

The opening picture for this Preface is the shot I envisioned when I saw this young girl in a Massai village in Kenya. When I see a subject I want to photograph, that envisioning process helps me get the shot. I ask myself, "If I had room on my memory card for only one shot, what would it be?" In this situation, I wanted to picture the girl against a black background, which I easily created by posing her in front of the doorway to her hut.

But she and I were strangers and spoke different languages. I could not simply walk up to her and ask her whether I could take her picture. That would have been very awkward, especially because I wanted to work within a distance of a few feet and get a head-and-shoulder shot. So, working with my guide, through whom I asked the girl about her daily life, I started taking pictures from a distance—pictures that I knew would be outtakes. I showed the girl her pictures, thereby developing a relationship with her.

As I gained her confidence, and as she became more comfortable and relaxed, I moved in closer. I kept shooting and kept showing her the pictures on my camera's LCD monitor. She was thrilled to see the pictures just seconds after I had taken them.

Here are two of the dozens of outtakes from that photo session. One is a full-length shot with bad lighting and a bad pose, and the other shows the girl's eyes are closed, indicating that I missed the shot.

Let's move on to Mongolia.

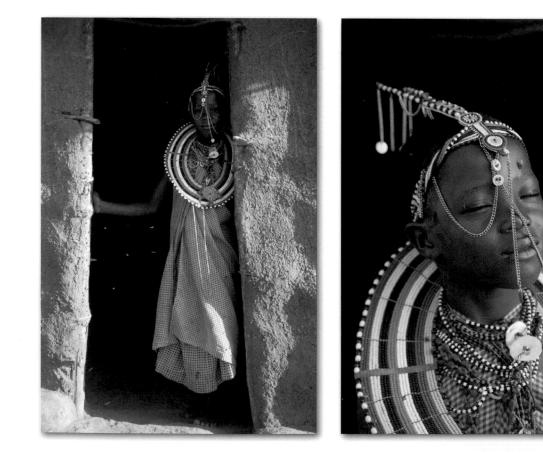

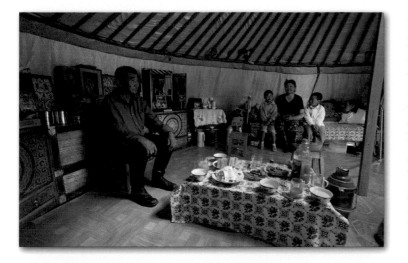

I photographed this nomad in his ger (a tent-like hut) on my first day in Mongolia. It's one of my favorite nomad pictures from the adventure. Like my Kenya portrait, it was the last shot in the evolution of a photo shoot. Unlike the pictures that follow this one, it's a flash picture (I bounced the light off the ceiling of the ger for soft and even lighting)—because I did not like the high-contrast range created by light coming through an opening in the ger's ceiling and through the open door.

Read on to see how the session began.

Here's the first shot I took. My friend, Jack, and I were welcomed into the ger by the man's family and we were invited to drink fermented camel's milk (a local custom to which you can't say "no"). I saw a potential picture, but the light coming through the opening in the ger's ceiling caused the table to be way over-exposed. I took my test shot anyway.

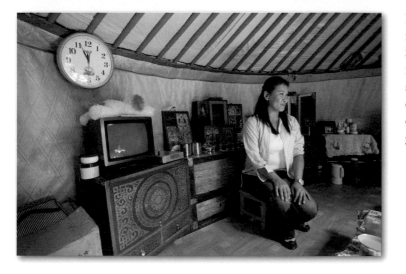

I never like to overstay my welcome, because it can make the subject feel uncomfortable. So, rather than start to photograph the man right away, I asked our guide to move into position for a test shot. I liked the composition, especially with the clock in the picture, but I could see that the contrast range was still too great.

Almost happy with my picture, I asked our host to move into position, and he gladly accommodated my request. I played around with my exposures, but I could not get the man and the table evenly exposed. So, I knew I needed to use a flash for even illumination. The result of this photo session, which, as you can see from the clock on the wall lasted about 15 minutes, is the "keeper" I showed you at the beginning of this montage. As you may have noticed, the man in my "keeper" is wearing traditional nomad clothes and boots. Changing his clothes was his idea. He thoroughly enjoyed the photo session, according to our guide, who also acted our as translator.

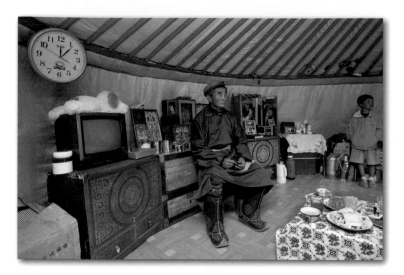

In case you were wondering what a ger looks like from the outside, here you go. And in case you were wondering what fermented camel's milk tastes and smells like, try this: leave a cup of milk in the hot sun for two days, and then force yourself to drink it with a smile.

I share these images with you not only to illustrate the evolution of one of my photo sessions, but also to encourage you to keep shooting, even if you think you have already taken a good photograph.

If you keep in mind that a photo session is an evolving process, you will have a better chance of getting the shot you want, and you will not be frustrated if you don't get your "keeper" with your first shot.

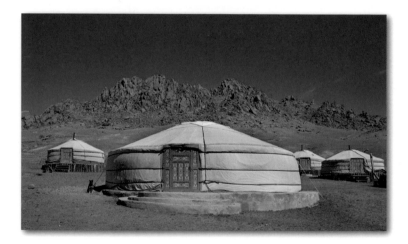

The Camera Looks Both Ways

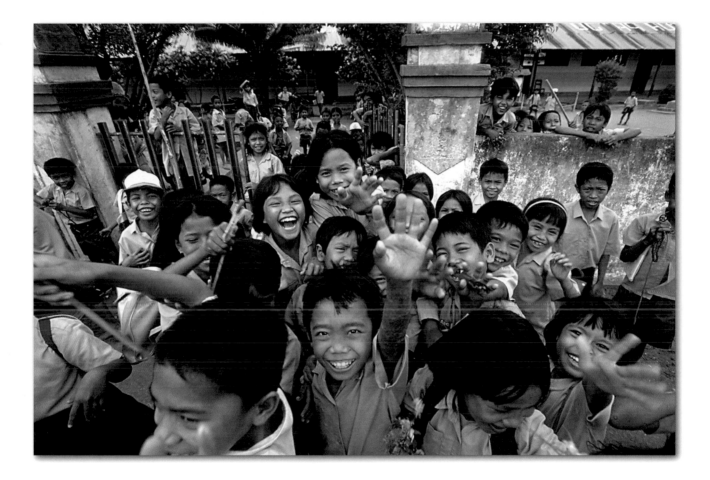

"In picturing the subject, we are also picturing a part of ourselves."

When it comes to photographing people, that is, no doubt, the most important photo tip I can share with you. "Every picture is a self-portrait" is another way to convey that point. Let me explain.

When you are looking through your camera's viewfinder, viewing and framing a subject, if you realize that the feeling, the emotion, the attitude, and the energy that you project will be reflected in your subject's face —and eyes—you'll get a higher percentage of pictures that you like. That's because by your actions, you are subconsciously "directing" the subject to mirror the way you feel.

So, in looking at the photo on the previous page, I am sure that you know exactly how I was feeling when I took the picture outside a school in Lombok, Indonesia. That's right! I was having a blast.

For all the photographs in this book, I will provide location information so that you'll know where I took them. Some of you may find that photographing strangers in strange lands is the ultimate photography experience. For me, getting people to like, or at least accept, me in a matter of seconds in faraway places is my prime goal as a travel photographer. After achieving that goal, taking the pictures is relatively easy—if you follow the tips in this book.

Even if you are not a world traveler, however, you'll find that my tips and techniques for photographing people are, for the most part, the same no matter where you go.

In this book, the book I've dreamed about writing for years, I'll also share some behind-the-scenes stories. For my Lombok picture, for example, I had just finished doing magic tricks for about an hour in one of the school's classrooms. I love doing magic tricks when I travel because it's a great technique for breaking the ice and getting people to let me into their lives for a few moments. Magic is a universal language. That effort resulted in one of my favorite group shots—a shot that captures the enthusiasm of the school kids.

On the pages that follow, I'll also get into the technical aspects of photographing people. You'll learn how to photograph people in low light and in bright light, with a flash and without a flash. You'll see how reflectors and diffusers can turn a snapshot into a great shot. You'll understand the difference between an environmental portrait (a picture of the person in his or her environment) and a portrait—and the difference between taking and making a picture. Camera settings and lenses will also be covered.

You'll find sections on outdoor photography and indoor photography. In some cases, you'll be able to use the techniques interchangeably, such as when it comes to posing a group or creating a sense of depth in a photograph.

In fact, I will share with you everything I know about photographing people—all while trying to make the learning process fun and enjoyable.

Before moving on, I'd like to share three more pictures with you that illustrate my "camera looks both ways" philosophy. Check out the picture of a young woman whom I photographed in Cuba (below), and on the next page check out the pictures of a Buddhist monk whom I photographed in Cambodia, and a man with face piercing whom I photographed in Cuba.

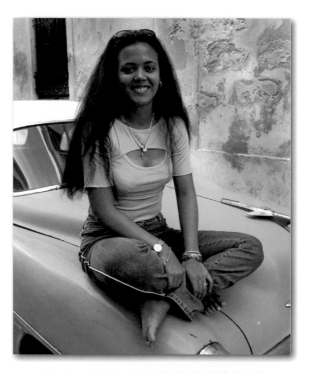

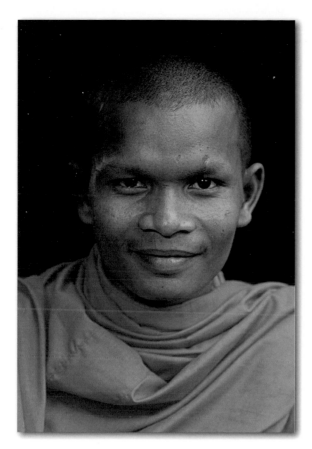

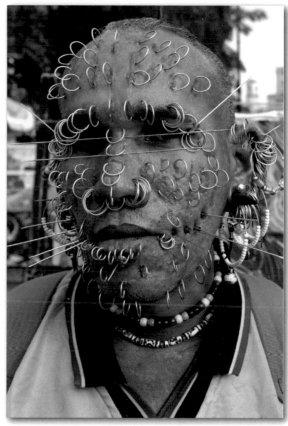

While photographing one subject, I was beaming with joy. For another, I was trying to show an honest feeling of respect. And for the third, I was expressing the feeling of "Man, you look totally awesome." I don't have to match the photos with the feelings for you. See? The camera does, indeed, look both ways.

Speaking of photo philosophies, if you check out the table of contents, you'll see that "Part II: Photo Philosophies" is the longest section in this book. That's because getting a good picture of a person goes way beyond technique. When it comes to photographing a person, you really need to think before you shoot, and that section offers a lot of food for thought.

So, what about Photoshop and Aperture? Well, all of the pictures in this book have been enhanced to some degree—even if it was only in sharpening, cropping, and/or adjusting their brightness, contrast, and color.

With that said, this is not a Photoshop and Aperture book. But because Photoshop can help you achieve more dramatic, dynamic, and artistic images, I've included a section at the end of this book that features my favorite Photoshop enhancements when it comes to people pictures.

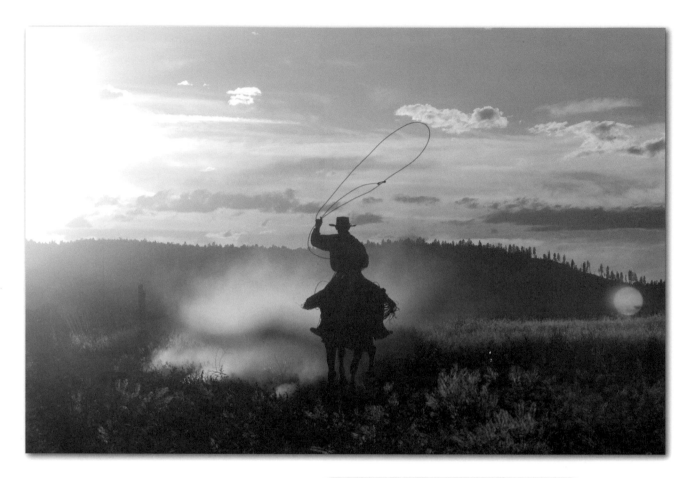

For now, this before-and-after pair of images of a horse and rider at sunset, photographed at the Ponderosa Ranch in Oregon, shows how simple cropping and a bit of color, contrast, and brightness enhancement can turn a snapshot into a great shot.

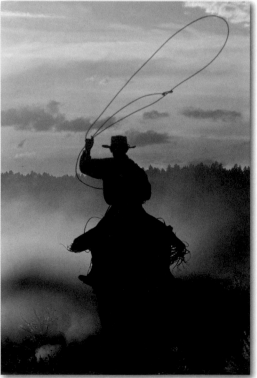

And check this out. I photographed this woman during one of my workshops in Miami's South Beach. By simply cropping the image, reducing its saturation, and adding a digital frame, I created a more artistic image.

Are you ready to get going with some solid tips and techniques? I am. In fact, I can't wait for you to read the rest of this book—because I truly enjoy teaching and sharing my photographic experiences. Naturally, I also like "revisiting," so to speak, some of my favorite subjects.

Those of you who have attended my workshops and seminars, or have seen my xTrain.com web TV shows, also know that I enjoy meeting people. For those of you who are joining me for the first time, I hope you enjoy "meeting" me here. If you have a question or would like to share a low-resolution JPEG file with me, you can reach me through my web site, *http://www.ricksammon.com*. Hope to see you there!

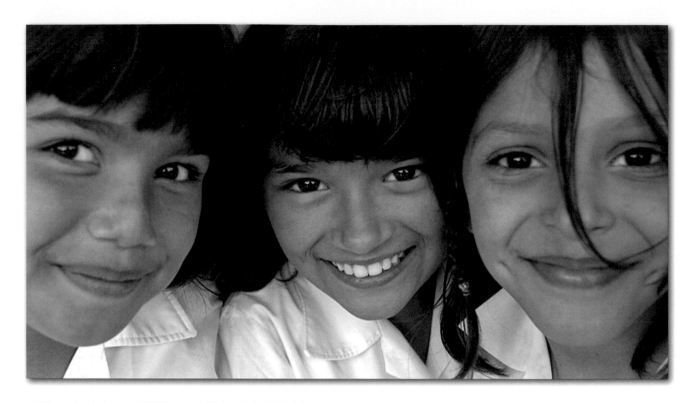

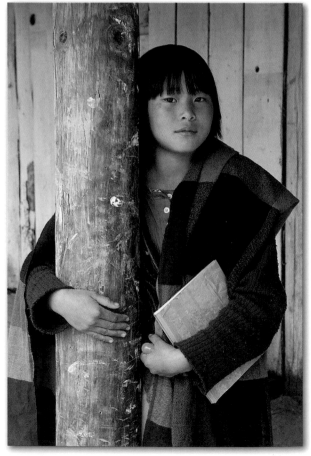

I'd like to share with you two of my all-time-favorite people pictures: a picture of three girls whom I photographed in Costa Rica and a portrait of a young girl whom I photographed in Bhutan. What I like about these pictures is the direct eye contact the subjects are making with my camera—and with me. Connect with your subjects, and your pictures will connect with those who view them.

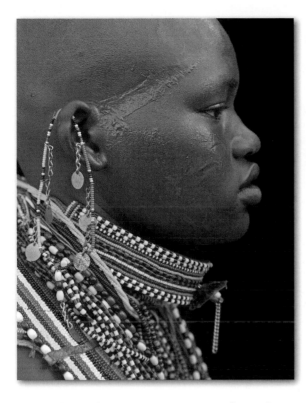
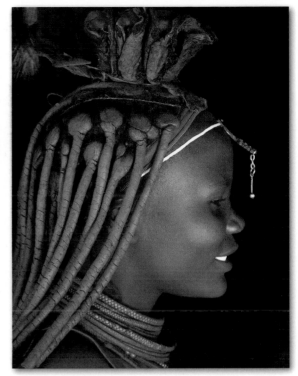

Next let's check out two portraits I took in Africa. Both women were photographed in the doorway of their huts, which created the nice black background.

The woman on the left is a Massai, whom I photographed in Kenya on Africa's East Coast. The other woman is a Himba, who lives on the West Coast of Africa. I photographed her in a remote area of Namibia. You'll "meet" both of these women later in this book.

I include their pictures in this introduction because I know you can see the subjects' similarities—in the way they dress daily, the way they use jewelry, and the way they exude dignity and confidence.

I also include these pictures to illustrate the point that people of different cultures have similar lifestyles, beliefs, and customs—all over the planet.

Some even share the same sense of humor. Understand our global culture, and you'll know, somewhat, what to expect when you go on location in a foreign land.

Understand your subject, and you'll gain some insight into the soul of your subject, and the soul of the photographer—your soul.

And speaking of understanding, to gain a better understanding of how your lens choice and exposure settings affect a picture, check out the Technical Table pdf located on this book's catalog page on the website *www.oreilly.com*. It includes tech data for the images on the following pages, along with information on where they were taken.

Catch you later!

—Rick Sammon
Croton-on-Hudson, New York
March 2008

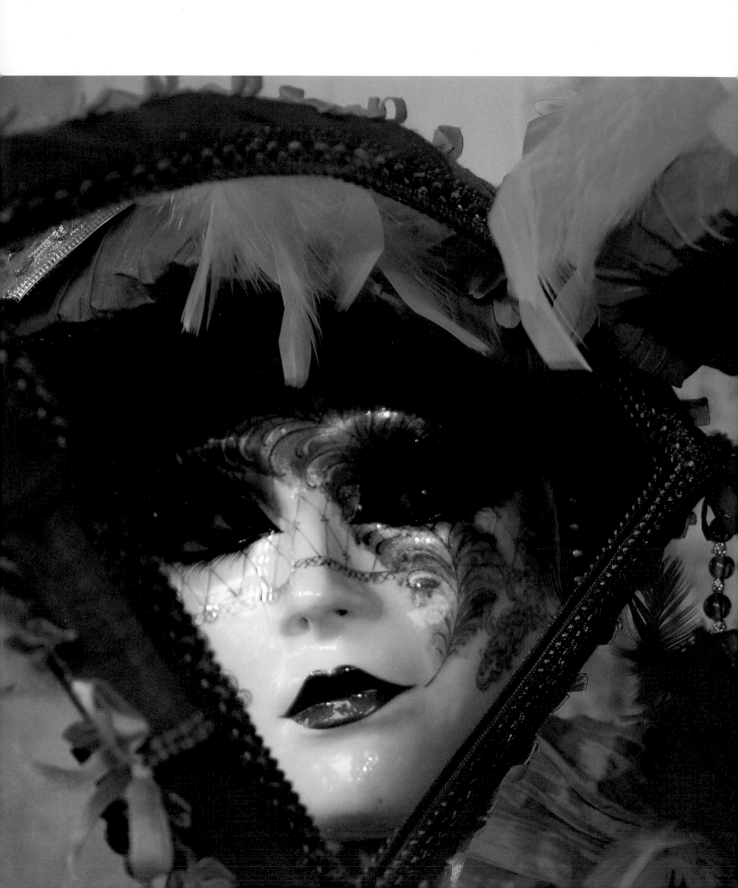

Cameras Don't Take Pictures, People Do

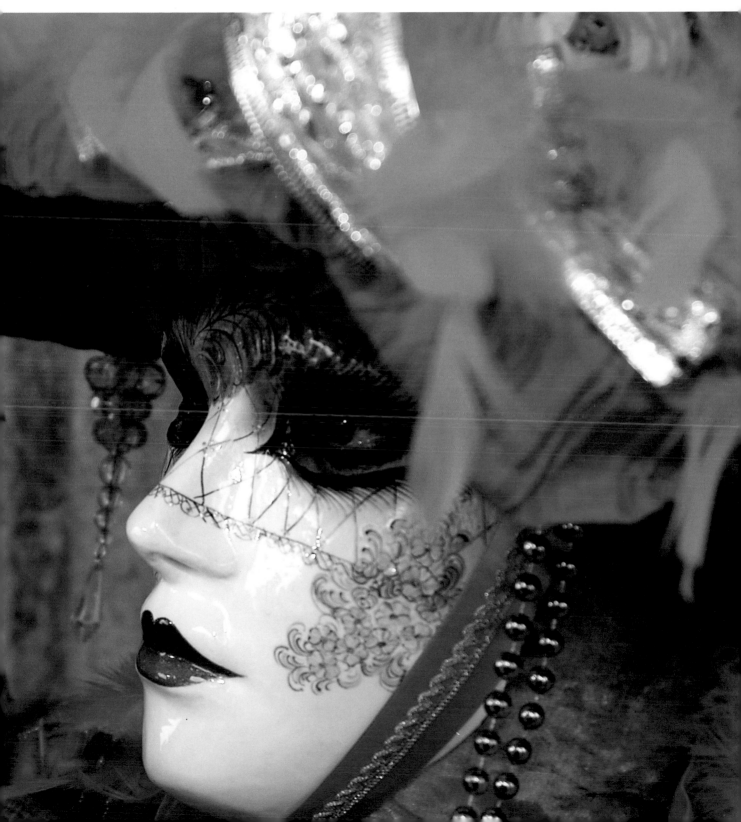

Jumpstart Your Photo Session

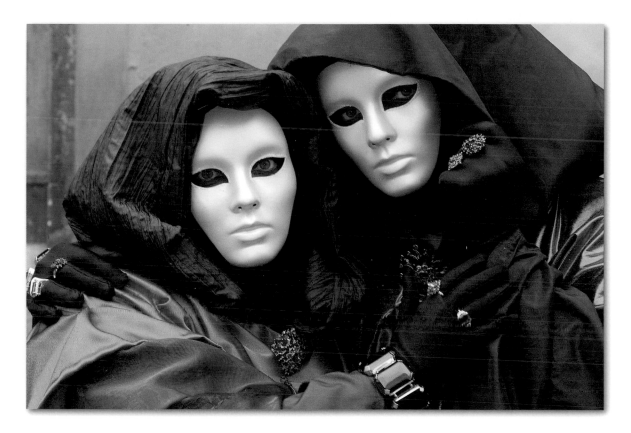

While paging through this book, you'll see that I've included hundreds of photographs supported by thousands of words—illustrating everything I know about photographing people. There is much to learn and digest on the following pages, which, indeed, will take some time.

For those of you who don't immediately plan to sit down for several hours and read the book cover to cover (hey, I understand, I'm a bit antsy when it comes to learning something new too), here I have compiled my top tips—in abbreviated form—for photographing people. I'll go into more detail on these ideas on the following pages.

I took these photographs over a five-day period during a VSP Workshop (www.vspworkshop.com) in Carnevale in Venice—one week before the deadline for this book. So, the images you see here (and the other Venice images you'll see later) are the freshest pictures in this book.

If you have the opportunity to go to Carnevale I know you'll enjoy the experience—and you'll come home with some memorable photographs.

OK. It's time to move into jumpstart mode.

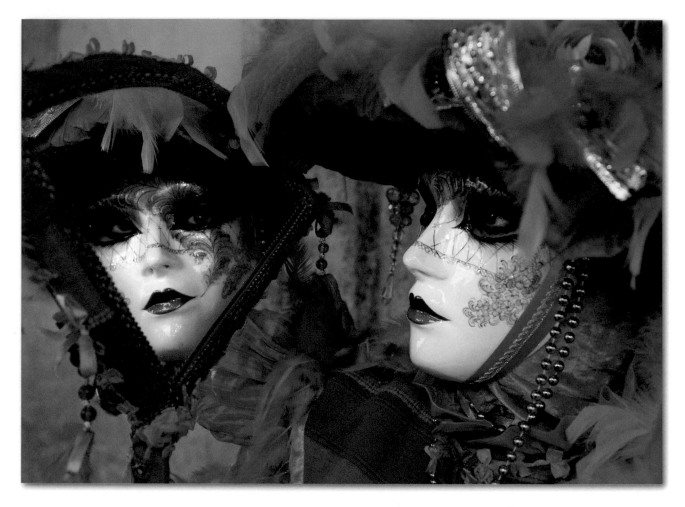

Make the picture, don't just take the picture. Take the time to expertly position a subject or subjects in a scene. Remember, when you are behind the camera, you are the director of the shoot.

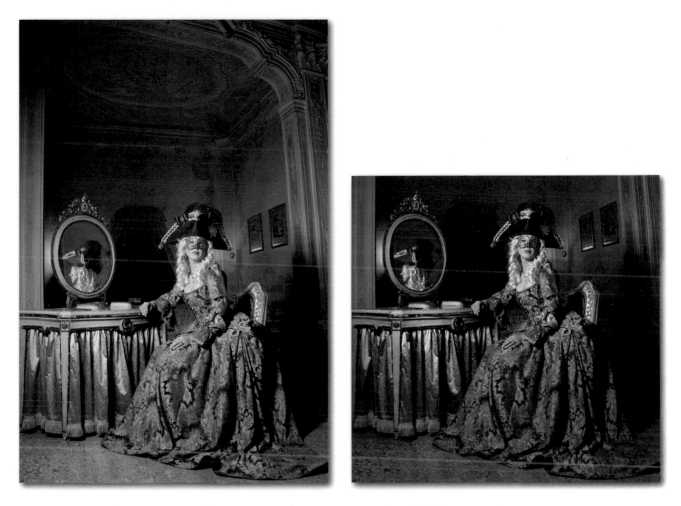

Envision the end result. Always keep in mind the power of the digital darkroom and try to envision creative options and enhancements that are only a few mouse clicks away. Here you can see how a few simple adjustments in Apple's Aperture created a much more dramatic image (above right) from a RAW file.

See the light. Keep in mind this photo adage: highlights illuminate, shadows define. Work with highlights and shadows to create a dramatic image.

Expose for the highlights. When you overexpose the highlights by more than one stop when shooting a RAW file, they are gone forever. Check your histogram to preserve highlights.

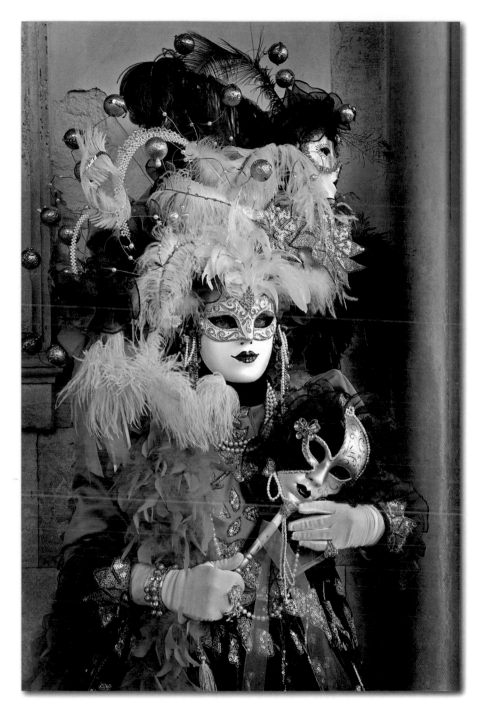

Communicate with your subject. Talk to your subject so that you get the desired reaction and expression.

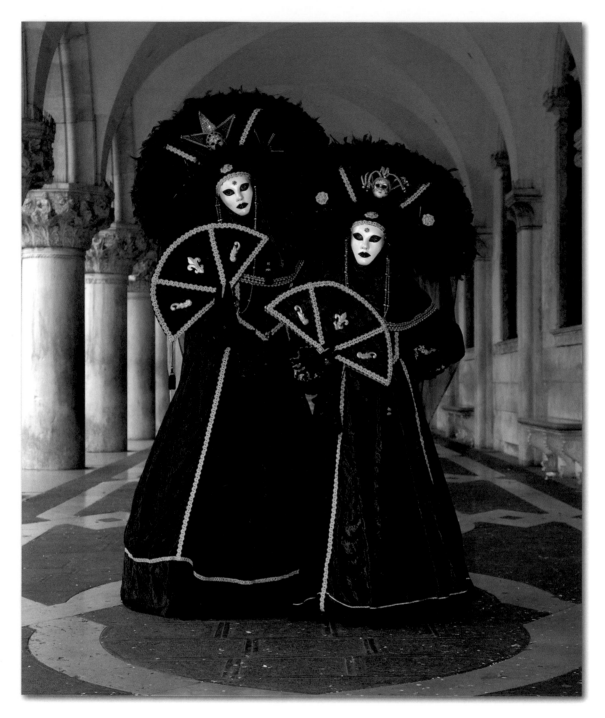

Compose carefully. Consider all the elements around a subject before you take the shot.

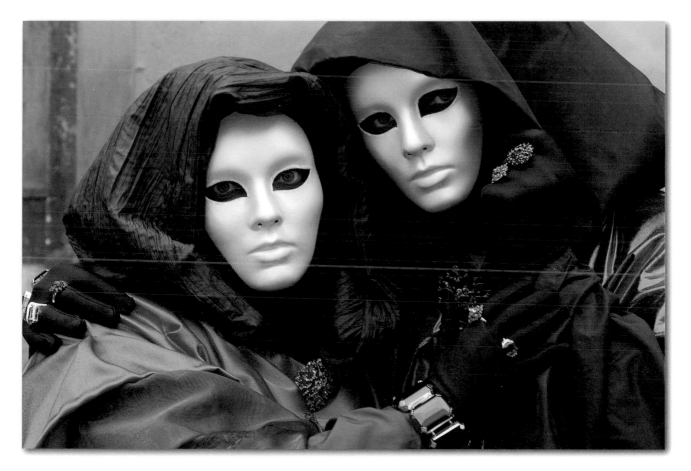

Look for body language. Body language greatly affects how the subject comes across in a photograph. Pay extra attention to the subject's hands.

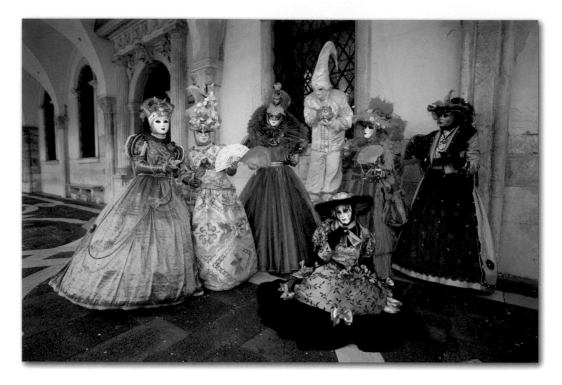

Think about depth of field. Carefully choose the aperture that will limit or extend depth of field.

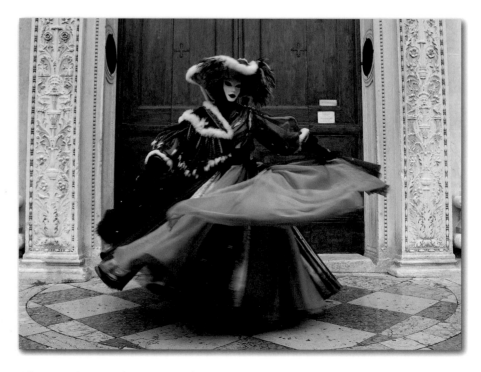

Shoot with your shutter speed in mind. Blur or freeze the subject with the correct shutter speed. The choice is yours.

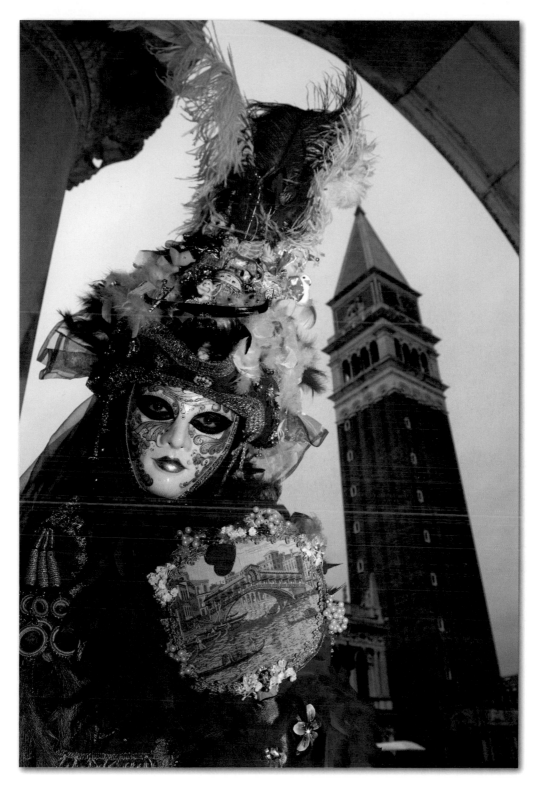

Choose a creative angle. Break the traditional rules of composition and look for unique angles.

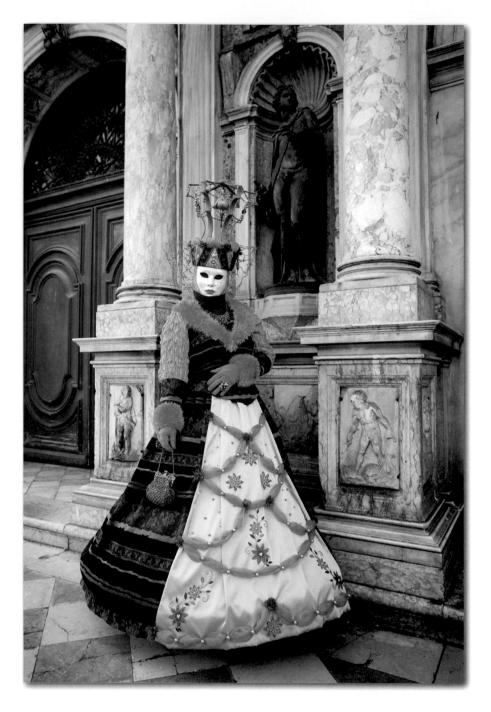

Be aware of the background. Know that the background can make or break the photograph.

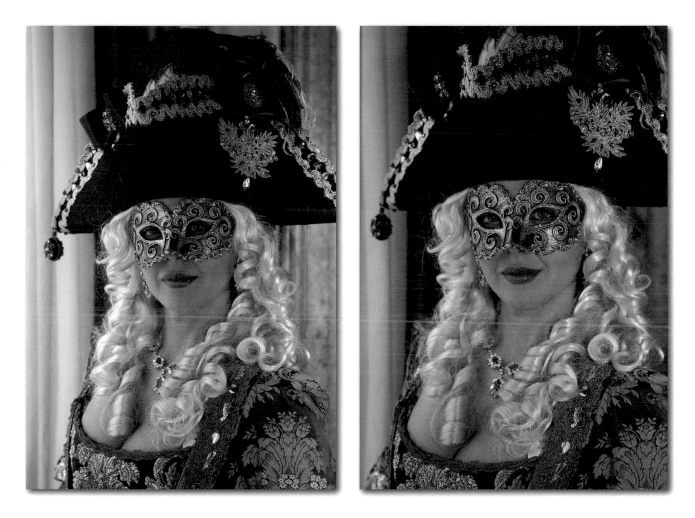

Think carefully about which is better: a natural light shot (left) or flash (right).

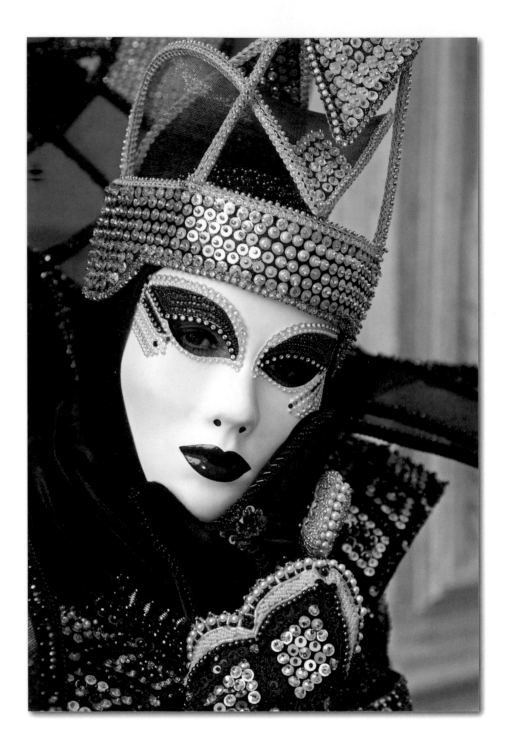

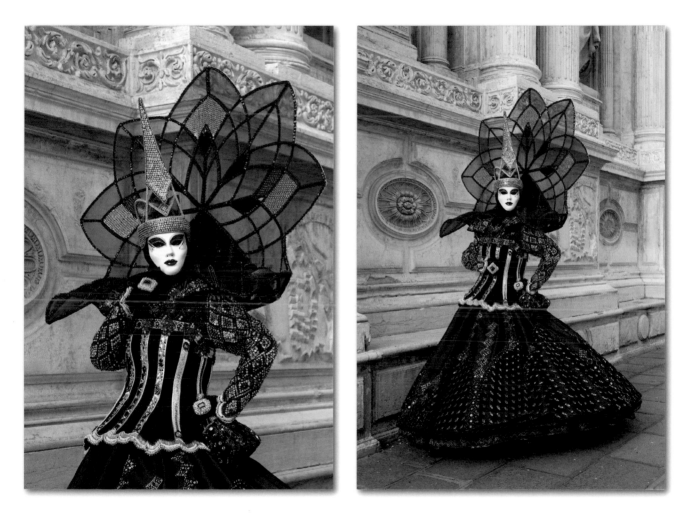

Take three. Take a headshot, a head and shoulders shot, and a full-length shot. Decide later which you prefer.

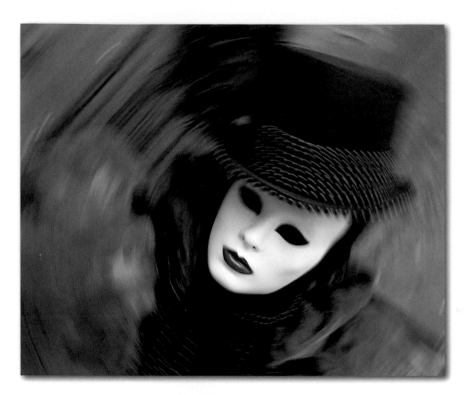

Choose your camera settings carefully. Check your ISO, white balance, aperture, shutter speed, and focus to ensure the result you envision in your mind's eye.

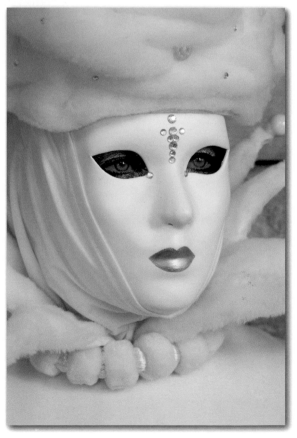

Fine-tune your flash pictures. Use exposure compensation to reduce the light from the flash to the point where your picture looks like a natural light shot.

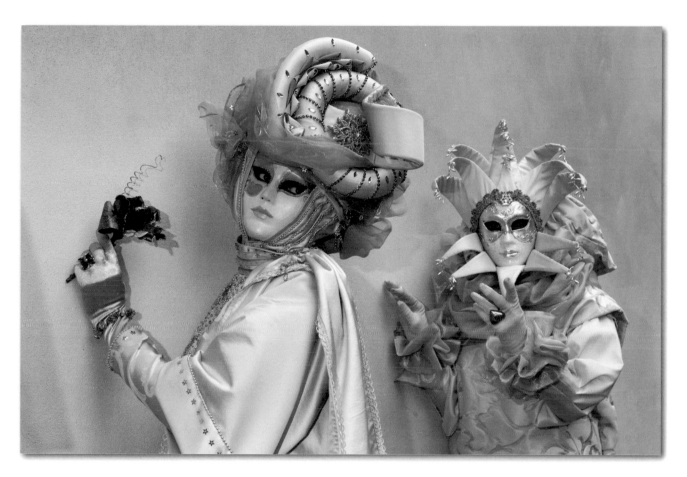

Think color. Look to see how colors can complement each other in a scene.

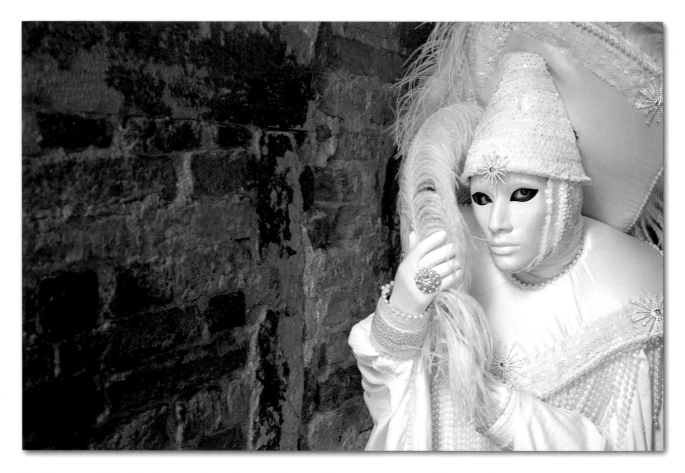

Dead center is deadly. Position the subject off-center for a more creative photograph.

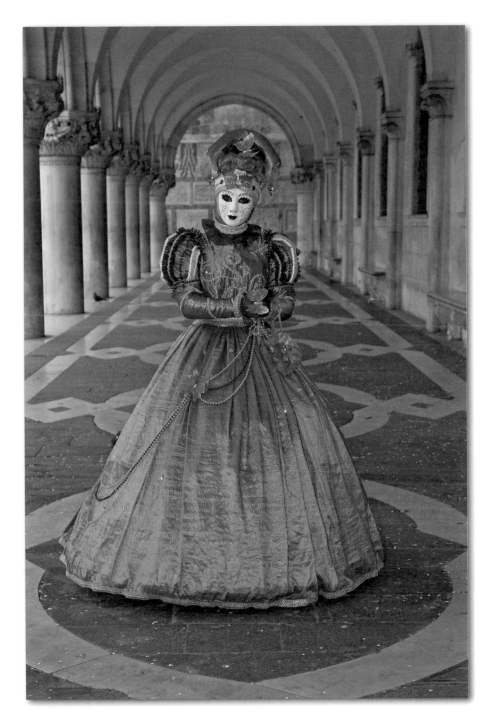

Create a sense of depth. Use the different elements in a scene to add a sense of depth and dimension to your photographs.

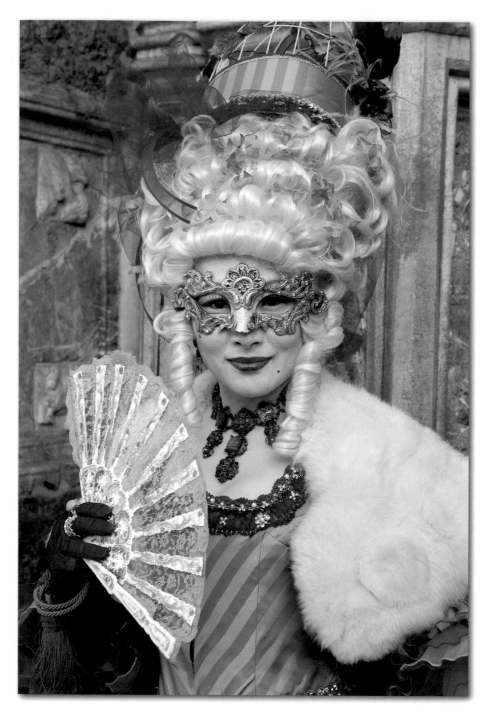

Have fun! What more can I say!

Lesson 1

A Quick Look at Gear

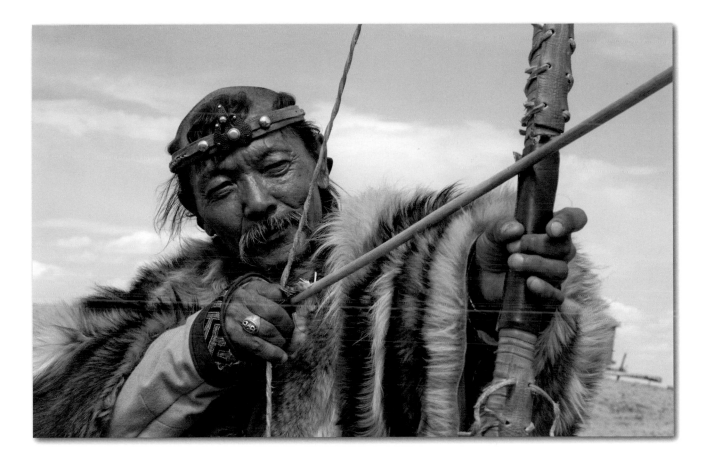

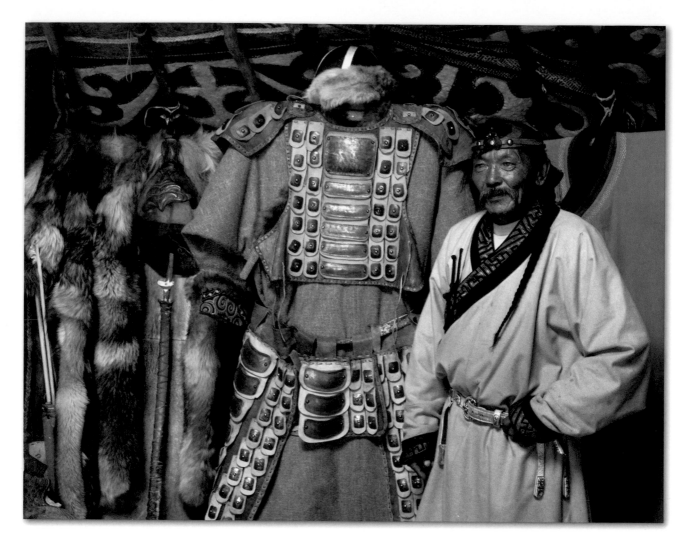

Cameras and Lenses

There is an old expression: "Cameras don't take pictures; people do." Well, that's true, but you still need a camera and the right lenses and accessories to capture your vision of a subject.

When it comes to my camera gear, I try to travel as light as possible. Traveling light offers two advantages. One, I can move from place to place and from position to position relatively easily. And two, the less gear I have, the less intimidating I am to a subject.

When taking people pictures I usually shoot with two Canon EOS digital SLR cameras (Canon EOD 5D or Canon EOS 1Ds MArk III), which are full-frame image sensor cameras. My Canon 24-105mm IS zoom lens is mounted on one camera body, and my Canon 70-200mm IS lens is mounted on the other camera body. With that setup, I take 95% of my people pictures. I used that setup for all the pictures in this lesson, which I took in Mongolia.

For shooting subjects in the distance, such as wildlife, I may use a 1.4x teleconverter (which extends the zoom range 1.4 times) on my Canon 100-400mm IS zoom lens. When shooting in very close quarters, when I want more depth of field, or when I want to get closer to a subject, I'll use my Canon 17-40mm lens.

I took these two portraits as well as the photograph on the preceding page with my 24-105mm IS lens. If I could recommend one lens for people photography, this would be it. It offers a nice focal length range, letting you zoom in and zoom out for different compositions, and it offers image stabilization, which helps to reduce the effect of camera shake at slow shutter speeds.

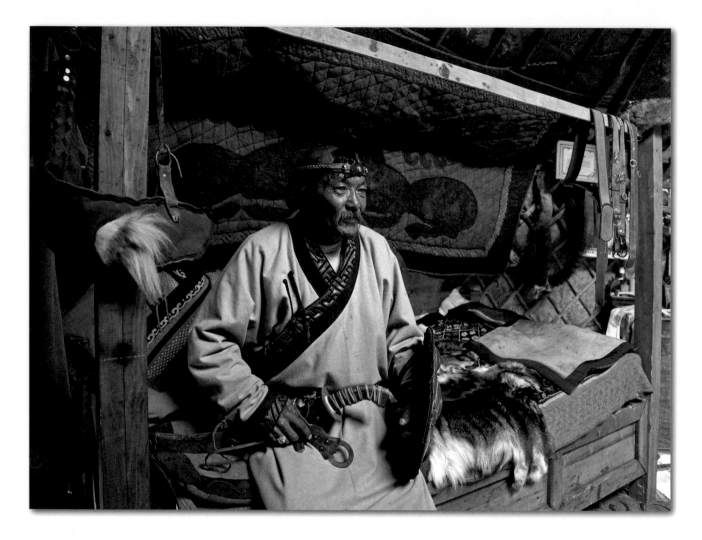

For this portrait, I used my 24-105mm lens set at f/8 I because I wanted everything in the scene to be in focus. The wider the lens and the smaller the aperture, the more you'll get in focus. For newcomers to photography, the aperture is the opening in the lens through which the light passes. Also called the f-stop, the aperture is the feature on your camera that controls how much of the scene in front of and behind a subject is in focus.

Accessories

From a technical standpoint, when you take a picture, all you are doing is recording light. Accessories let you add and control light. For now, let's take a quick look at the accessories I use. You'll find more examples of how I use accessories later in this book.

Reflectors and Diffusers

Compare these two pictures. In one, you notice harsh and unflattering shadows on the woman's face. In the other, you see that the diffuser produced soft and more flattering lighting, the kind of lighting you get when you shoot on an overcast day.

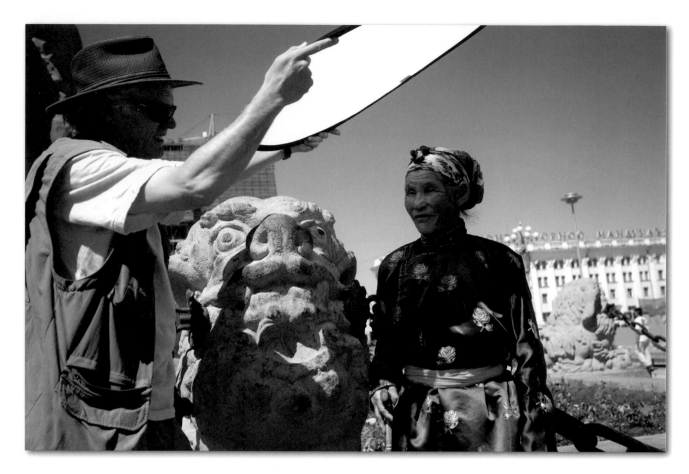

To eliminate the unflattering shadows, I had my friend, Jack, hold a diffuser between the sun and the subject. Here you see I am doing the same for Jack, who took this behind-the-scenes photograph for me.

A diffuser is one of my most important accessories. Another is a reflector, which looks like a diffuser, but rather than diffusing light passing through it, it bounces light from its reflective surface and onto the subject. Reflectors come in different versions. Some have a gold side (which reflects a warm quality of light) and a silver side (which reflects a cool light), like the one I used here. Others have a white and a silver side. And kits are sold that offer a white side, a gold side, a silver side, and a black side (to reduce light from reaching a subject).

Compare the earlier pictures in this lesson—of the man standing with his armor, and of him sitting on his bed. The standing shot is a natural-light photograph. The lighting is soft and even. For the sitting shot, I had my guide hold a reflector that bounced the light from the opening in the roof of the ger (hut) onto the subject. As you can see, the lighting is stronger and warmer in the sitting shot than it is in the standing shot.

I use a 36-inch reflector/diffuser kit that collapses to 12 inches and fits neatly into my camera bag.

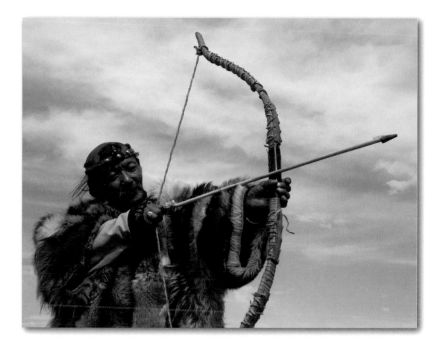

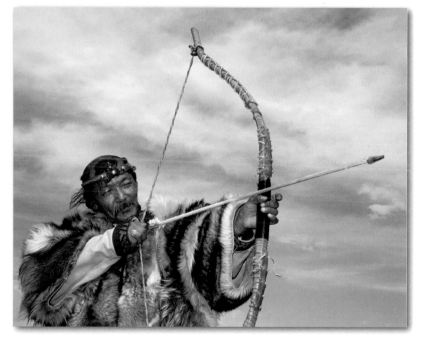

Accessory Flash

I never leave home without my Canon 580EX flash. I use it indoors and outdoors. To understand just one benefit of using a flash, compare these two pictures. The top image is a natural-light shot, and the other—the bottom image is one in which the man's face is easier to see—is the flash photograph.

In most situations, when the background is brighter than the subject, I use a flash to lighten the subject. I'll explain how I use the Canon 580EX flash in more detail later in the book, in "Part III: Outdoor Photography" and "Part IV: Indoor Photography."

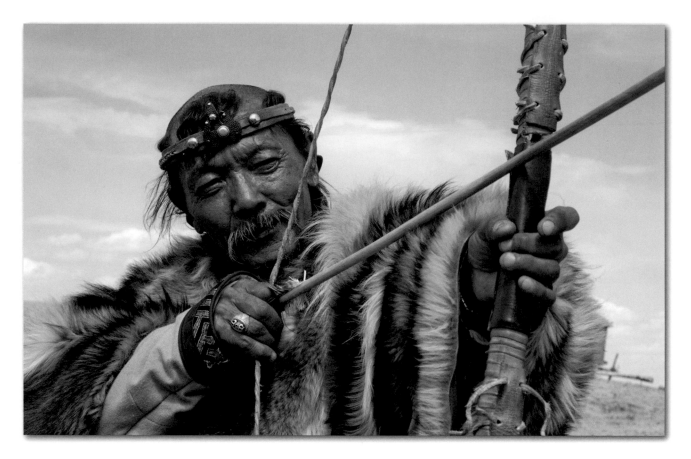

Photoshop

One of my most important accessories is something I use after I take a photograph. That accessory is Adobe Photoshop software. I use Photoshop to enhance virtually all of my pictures. In fact, when I see a subject that I want to photograph, I think about how I can enhance the picture in Photoshop, because for me, digital photography is part image capture and part image enhancement in the digital darkroom. Sure, digital darkroom enhancements can save the day—to an extent. But the key to a good photograph is to start out with the best quality image in a camera.

Here you see the original image before I adjusted the picture's color, brightness, and contrast. The photo on the opposite page shows the result of those adjustments. For more Photoshop enhancements, see "Part V: Enhancing Your Pictures in Photoshop."

Summing up, when you are composing a picture, think about how you can use an accessory for a more creative picture, or for turning a snapshot into a great shot.

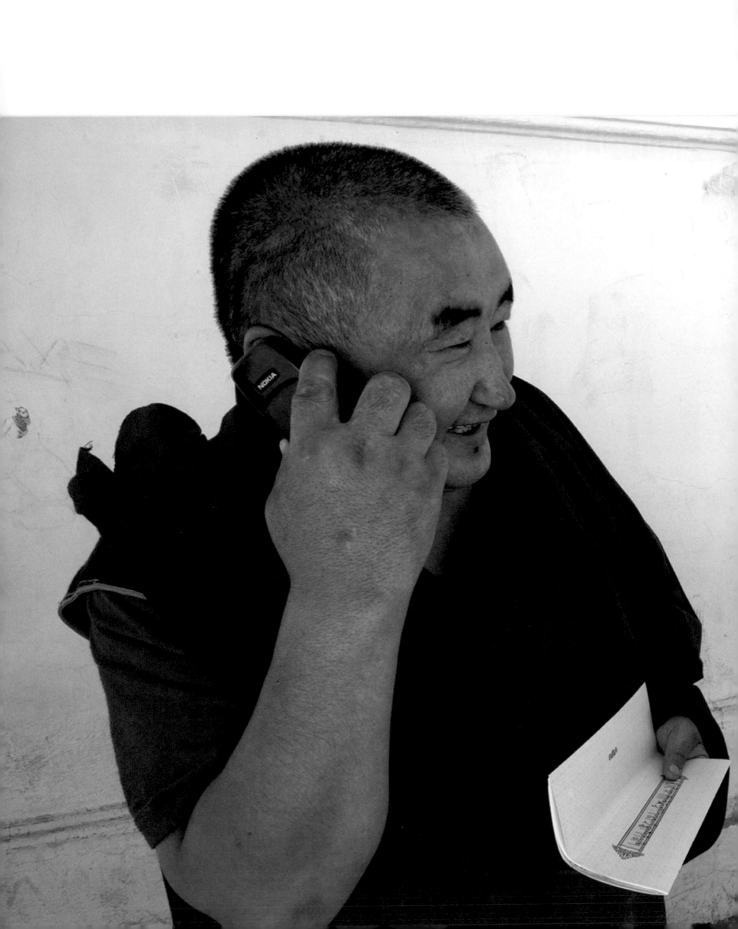

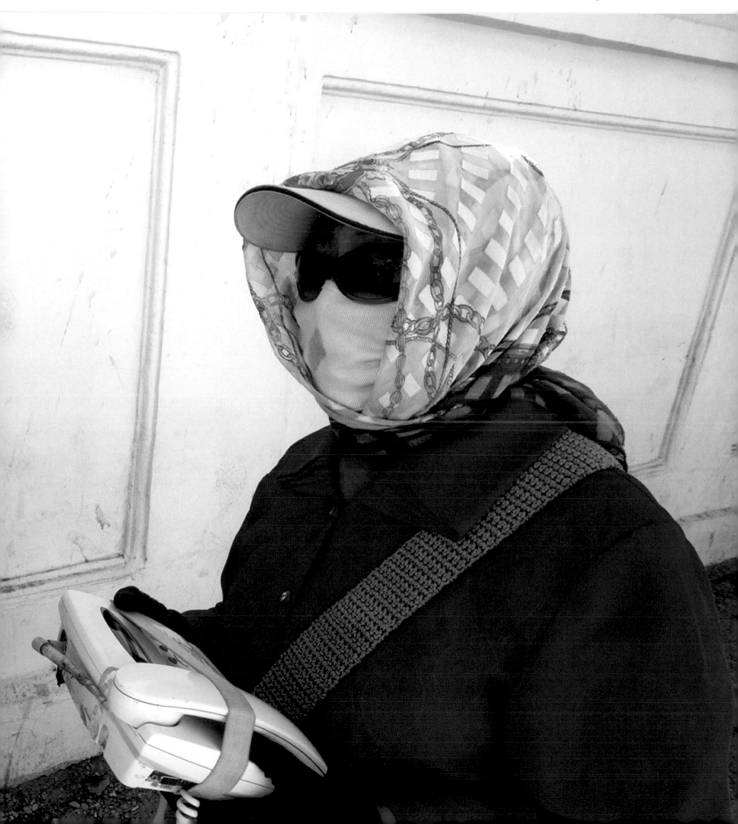

Making Pictures Versus Taking Pictures

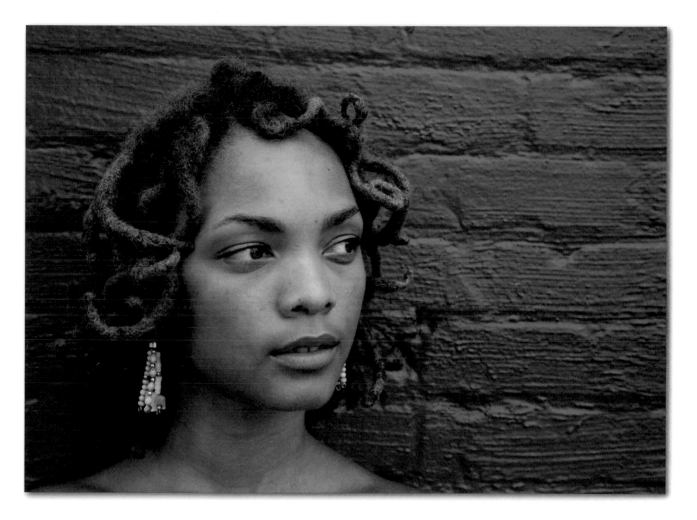

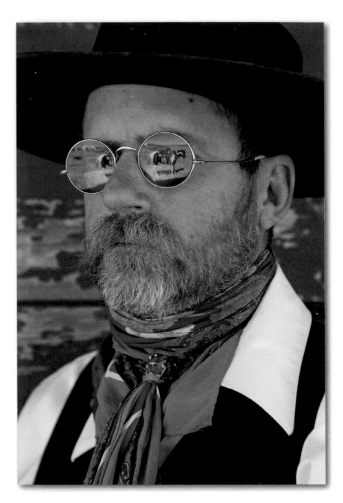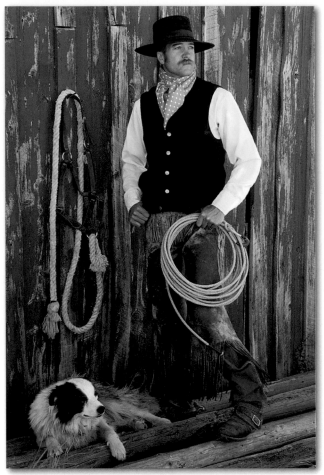

All the photographs in this lesson have something in common: I made them; I did not simply take them.

You see, rather than just pointing my camera, composing the scene, and setting the exposure and focus, I took my time and actually set up most of my shots.

Making pictures not only is fun, but also is part of the creative photography process. When you take control, you become the director of the shoot, just as a movie director takes control of the scenes he or she shoots.

In the cowboy picture on the left, look closely and you'll notice the reflection of a horse in his sun-

glasses. That, of course, was no accident. I carefully placed the horse and the cowboy in such a way as to capture the horse's reflection. The relatively plain background was also no accident. I selected the side of the red barn so that the subject stood out prominently in the scene.

The cowboy above right is another example of making a picture. I took this picture in the same location, but with a different cowboy and with a different composition technique in mind: a full-length shot this time.

I made this picture by asking the cowpoke to stand close to the rope on the side of the barn, to hold his lasso, and to pose with his dog at his feet. Finally, I directed him to look off-camera.

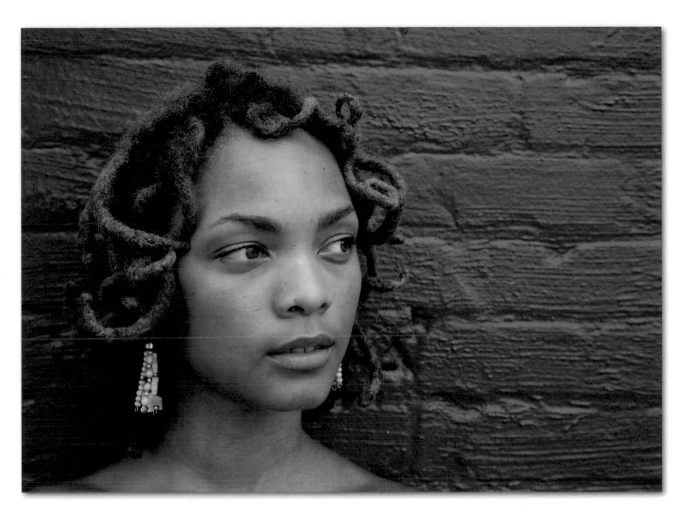

The photo on this page and the opposite page represent two more examples of making a picture. While in Atlanta's Little Five Points, I noticed this beautiful young woman walking down the street in the late afternoon. Harsh sunlight illuminated her, casting shadows on her face. Traffic, busy storefronts, and pedestrians created a distracting background.

I seriously wanted to capture her beauty and her "look" with my camera. So, I introduced myself as a professional photographer and asked her if I could take her picture. She said sure. Then, I asked her if she'd mind walking a block or two so that we could find a nice background with soft and flattering lighting. Again, she said OK.

I had noticed a bright-red brick wall a few minutes earlier and knew it would make a pleasing background for my impromptu photo session. I asked the young woman to lean against the wall and I starting shooting. In less than five minutes, I made a nice head shot and a nice, full-length portrait.

You'll "meet" this young woman later on in this book. I made all of those pictures, as well as these two, in Little Five Points in less than 15 minutes. I mention that because when you make pictures of strangers, you often have to work fast to keep the subject's interest. Working fast requires you to know how to operate all your camera's functions (ISO, aperture, and shutter speed control, focus mode, etc.) automatically, and so well, that making pictures becomes like point-and-shoot photography. When that happens, you can concentrate on what's happening in your camera's viewfinder, releasing the shutter at exactly the right moment to capture the expression and mood you are looking for—rather than fumbling around with camera controls and missing the shot.

The next time you think about taking a picture, think about how you can get a more creative image by making a picture, rather than just taking a snapshot.

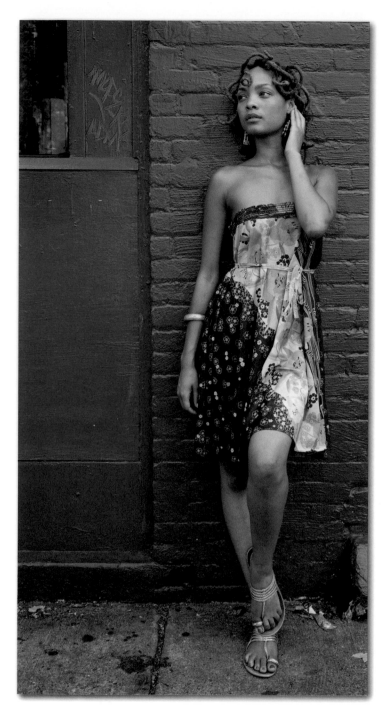

From Head to Toe

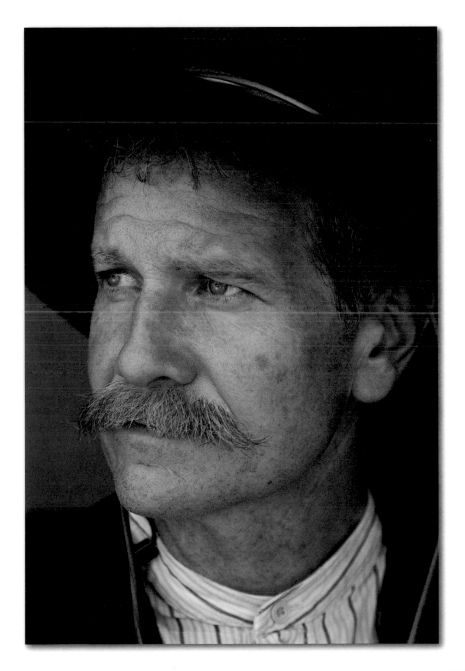

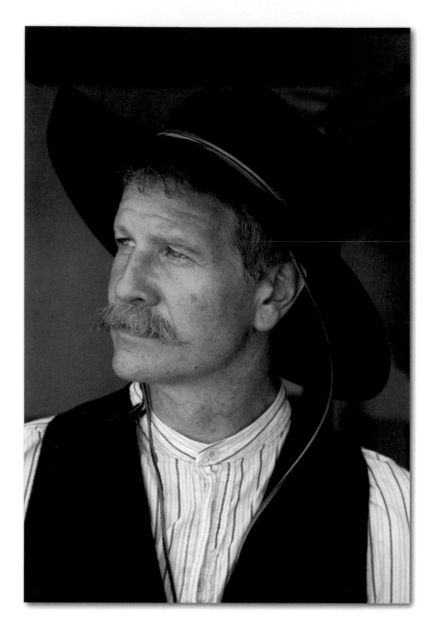

In most cases, when I photograph a subject, I try different framing possibilities: full length, three-quarter length, head and shoulders, and a head shot. By using different framing techniques, I give the subject a choice of which picture he or she likes best, and I give my magazine and book editors a choice of pictures from which to choose. Each picture tells a slightly different story, and each can be used to illustrate a different framing or composition technique. After taking all of those different views, I move in to capture the details.

I used different framing techniques when taking this lesson's pictures of my cowboy friend, whom I photographed in Marrow Bone Springs, Texas.

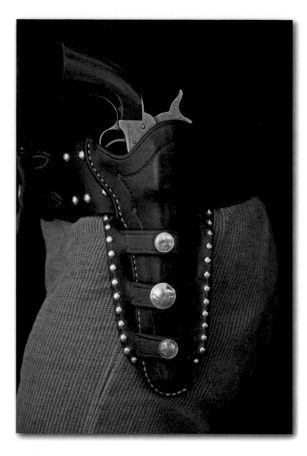

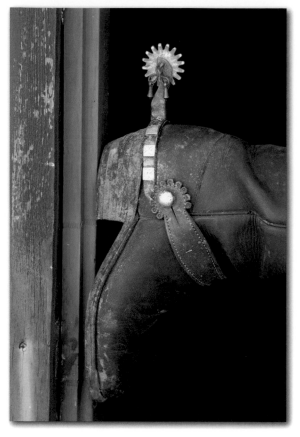

Then I took full-frame shots of his gun and spur.

You can apply the idea of using different framing techniques to any subject. For example, if you are photographing a bride, in addition to picturing the bride, you could move in and photograph her wedding ring or flower bouquet.

The idea is to try to tell the whole story of the subject. If you keep in mind that you are a story-teller, you'll be able to tell more complete stories of your subjects when you use different framing techniques.

Creating a Sense of Place

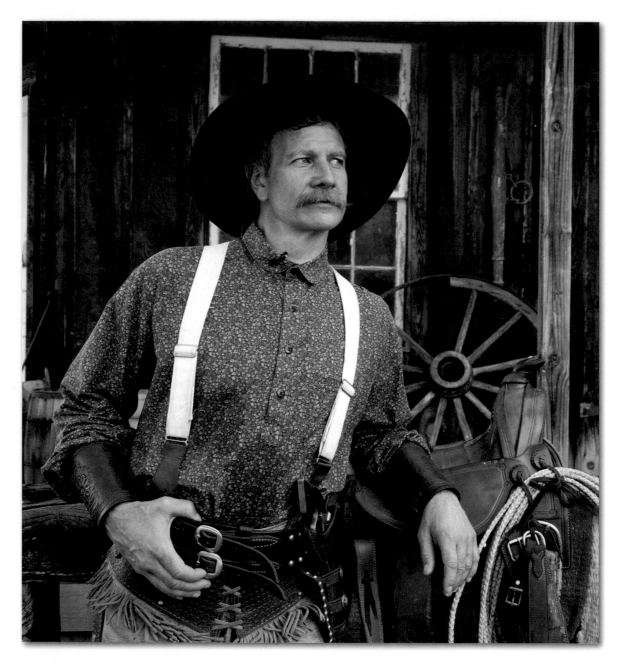

Compare this shot with the cowboy picture on the opposite page. I took these pictures only a few feet apart in Marrow Bone Springs, Texas. The main difference is the background. In this shot, the background—the building, the wagon wheel, and the saddle—add to the picture what we in professional photography call a "sense of place."

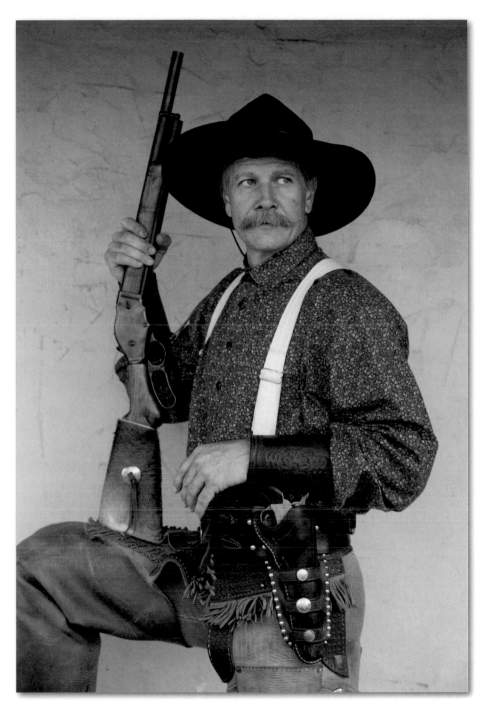

For all you know, I could have taken this picture against a stucco wall in Hoboken, New Jersey. How boring! No, not Hoboken, the background!

Seriously, it's that sense of place that adds to a picture's impact. Don't overlook that importance.

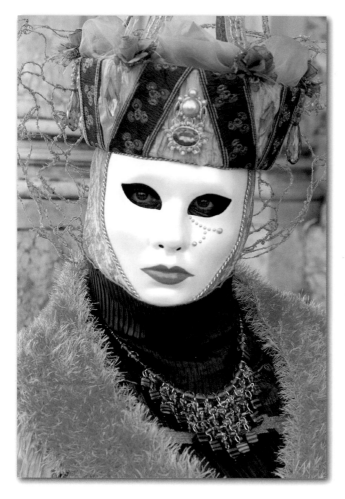

Here is another example of how a sense-of-place photograph differs from a portrait. I took both pictures in St. Mark's Square in Venice. The head shot could have been taken almost anywhere. But by moving back and zooming out to include part of the background, I gave the picture—and the subject—a sense of place.

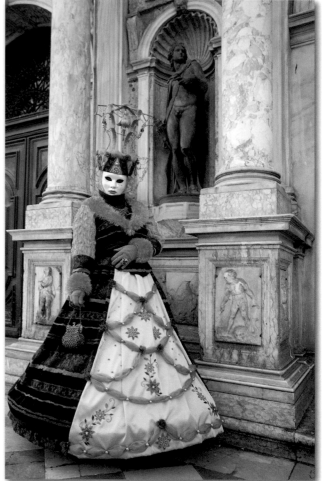

Dead Center Is Deadly

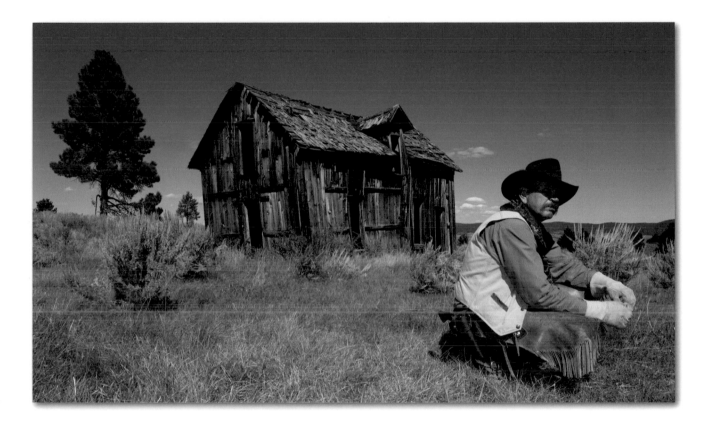

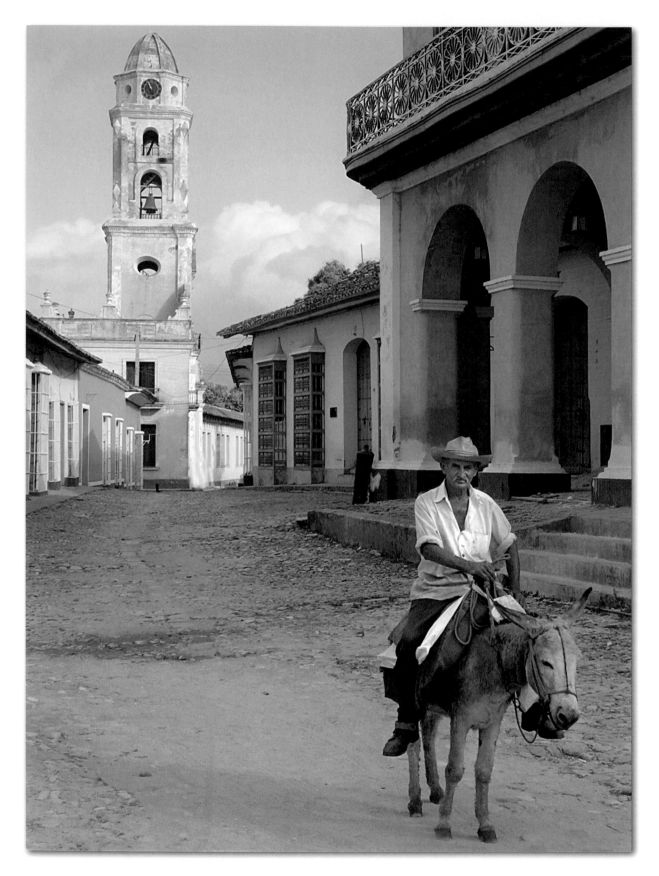

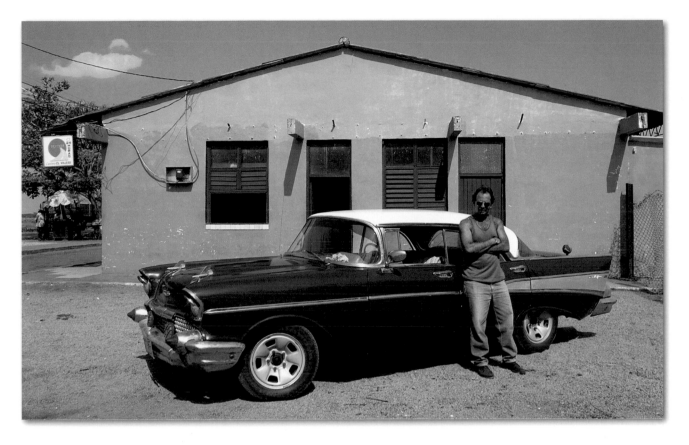

Generally speaking, placing a person in the dead center of a frame is deadly in terms of composition technique. For one reason, it's not a very creative composition technique. For another, when looking at the picture, the viewer's eyes basically get stuck on the subject.

When you place a subject off-center (when you set up the photograph)—as I did when composing the opening picture of the cowboy in front of the barn on the Ponderosa Ranch in Oregon—your picture immediately takes on a more creative look. What's more, the viewer's eyes subconsciously roam around the frame, checking out the other elements in the scene.

I also used the off-center composition technique when I photographed the man riding a donkey in Trinidad, one of Cuba's most picturesque cities, and for the roadside picture of a man posing with his '57 Chevy (also taken in Cuba). In both shots, you look first at the subjects and then for other interesting elements in the scene.

All three of these shots and the preceding shot illustrate a very basic but effective rule of composition. It's called the "rule of thirds." Here's the idea: imagine a tic-tac-toe grid over the frame, and then place the main subject where the lines intersect.

Use that technique and I think you'll find it quite effective in creating effective people pictures.

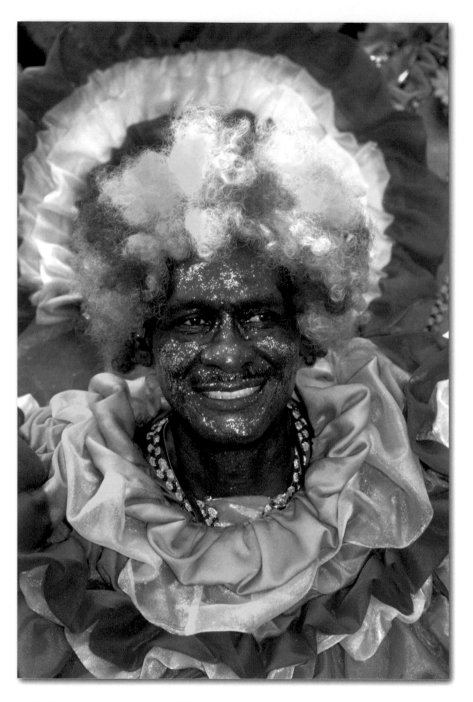

Of course, like all rules, the "rule of thirds" has exceptions at times. When framing this picture of a performer at a carnival in St. Maarten, I composed the scene with the man's face in the dead center of the frame. In this case, dead center was the way to go, because I wanted to emphasize his costume along with his beaming face.

Off-center or dead center is up to you! Just think carefully about your choice, as it affects how people looking at your photographs will react to them.

Horizontal and/or Vertical

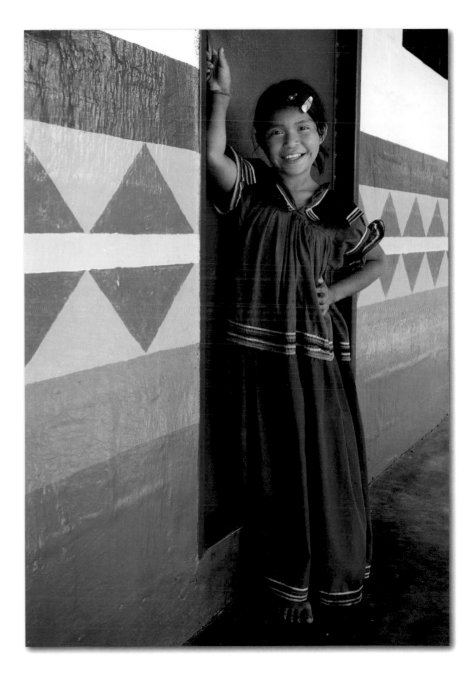

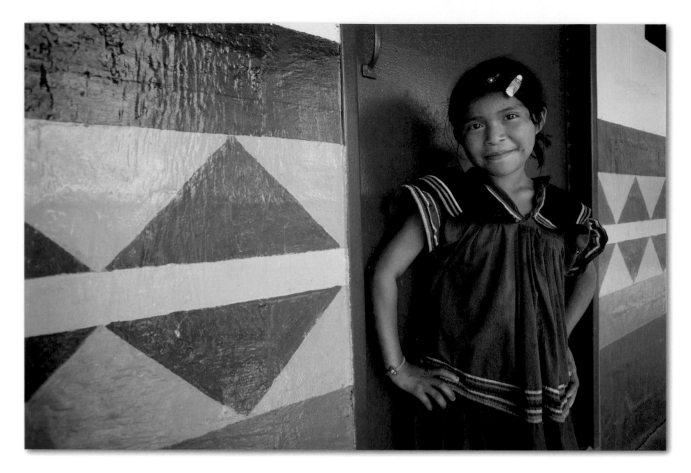

This may be the most basic tip in this book. However, during my workshops, I find that I need to remind novice photographers of the benefits of the technique of shooting both horizontal and vertical pictures of a subject.

In appropriate situations, I shoot a subject both ways. I did that when I was photographing this little girl in Panama so that I would have a choice of pictures to use in my books and magazine articles. I also used this technique so that I would give art directors a choice when it comes to using the pictures in a publication, because sometimes there is only room on a page for a horizontal picture, or vice versa. In fact, you may be surprised at how much you like an alternative version!

Shooting a subject both ways saves you from saying, "I wish I had taken a vertical (or horizontal) picture of the subject," after the photo session.

Here's the horizontal shot of the little girl. It's OK, but I like the vertical one much better. Still, it's good to have the choice.

Silence Is Deadly

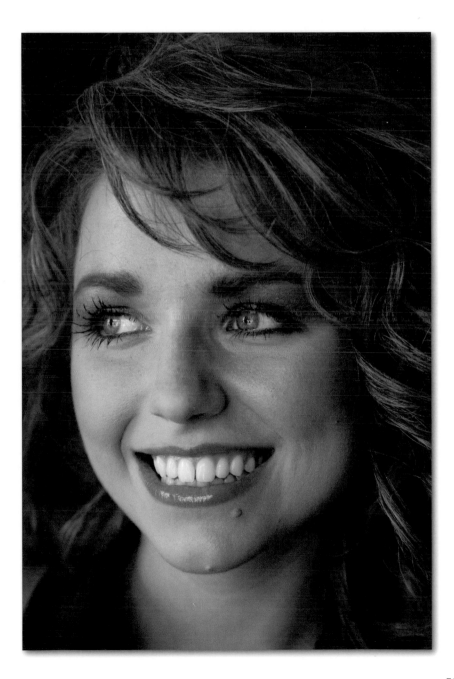

During a photo session, it's very important to establish a relationship with your subject. That's easily accomplished by talking constantly to your subject about something of particular interest to him or her. If you stop talking, for even a few seconds, your subject may become self-conscious and your photo session could end abruptly. What's more, if you stop talking and stop giving the subject direction, he or she will not know what you want.

I photographed the young woman in this lesson in Marrow Bone Springs, Texas. When I took the picture of her that appears on the preceding page, I was talking to her about something in which she was very interested, namely her boyfriend. The glow on her face is a reflection of how she feels about him.

What you say to your subjects greatly affects their facial features. I wanted to get a big look of surprise out of the young woman. So, unexpectedly, I asked her, "When was the last time you kissed your boyfriend?" I was ready for the shot (above left), and captured exactly the expression I had anticipated.

To capture a serious side of the young woman, I then asked her, "What would you do if you saw your boyfriend kissing someone else?" Again, I was ready to capture a different look, this time of sadness (above right).

Keep talking to your subjects during photo sessions and think carefully about what you say, and you'll have more control, and more fun.

Being There and Being Aware

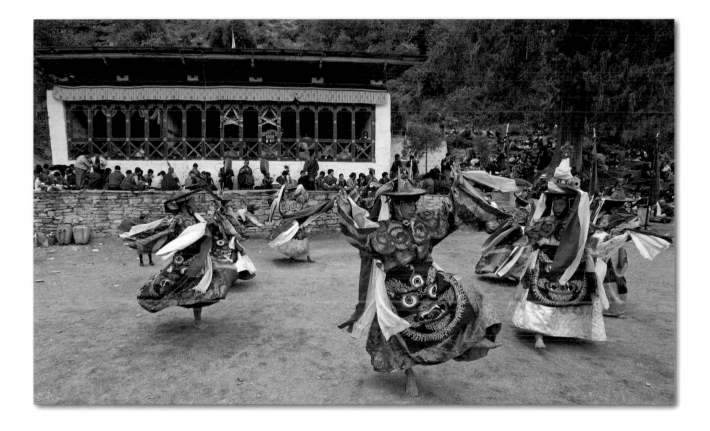

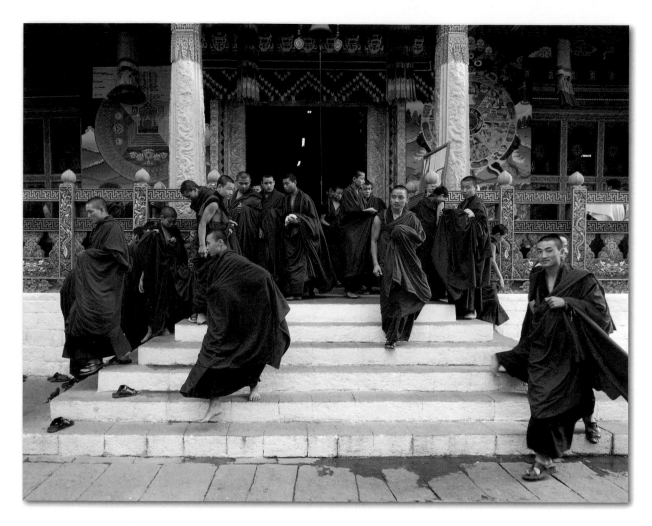

Most of the photographers I know agree with this expression: the hardest place to take pictures is in your own backyard. I agree too, and that's why I travel to different locations around the United States and the world: to get inspired.

I took the pictures for this lesson in the Kingdom of Bhutan, which sits on the right shoulder of India. I took the shot on the preceding page in the countryside outside one of Bhutan's major cities, Paro. How could you not get inspired, and be driven to taking the best possible pictures, when experiencing a scene like that one?

So, being there, in a new, interesting, and inspiring location, is important for many photographers. If you can't get to places like Bhutan, go someplace that is new to you where something interesting is happening, something that will motivate you to take pictures.

Being aware of everything that is going on around you is important, too. You must have your "radar" activated, looking not only for interesting subjects, but also for interesting scenes. What's more, you need to anticipate what might happen—and what to do when something does happen.

This picture of several Buddhist monks was the result of my anticipating what might happen. Moments before I took this picture, all the monks were praying inside the temple. I was observing quietly. A bell rang and they all jumped up quite quickly and put on their sandals. I anticipated that they would be outside in a flash. I dashed outside and grabbed this shot.

Being there and being aware will help you get good pictures.

Portraits Versus
Environmental Portraits

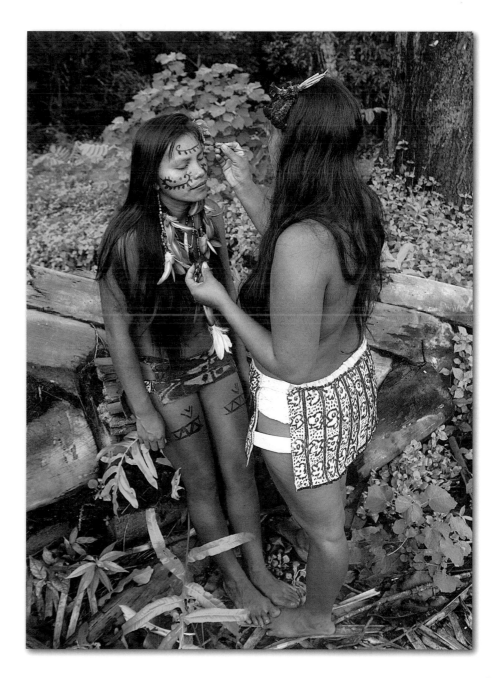

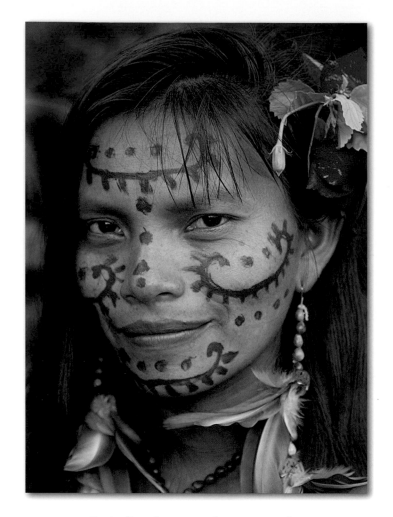

Basically, when you take pictures of a person, you have two choices. You can take a portrait (head/head-and-shoulders shot), or you can take an environmental portrait, that is, a picture that shows the subject in his or her environment. Both types of portraits can be effective, and I often photograph a subject both ways.

However, if I had only one choice, and only a split second to shoot, I'd take an environmental portrait. That way, I'd get a picture that tells more of a story of the person in his or her environment or situation. I'd also be able to crop the environmental picture into a portrait if I wanted. However, the cropped image may prevent me from making a very large print.

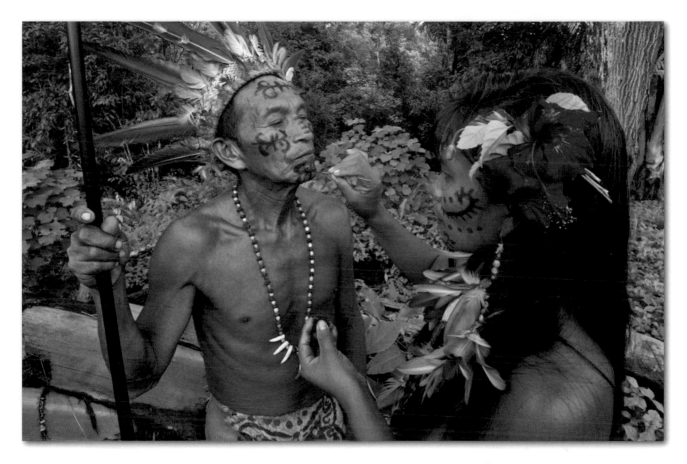

The picture on page 55 of the two Taraino women, taken in Amazonas, Brazil, is my favorite environmental portrait from my brief photo session in the village, which lasted only about an hour. Looking at the photograph, you can see the surrounding rainforest, and you get an idea of the women's clothing and body painting. Those elements help tell the viewer something about the women and where they live.

Take a look at the photo on the opposite page. It's a portrait of the woman on the right in the photo on the lesson opener page. However, because we can't see the environment, we don't feel as though we are "on location," so to speak, with the photographer.

Here is another shot from this photo shoot. I've included it to share with you another important point about portraiture: learn about your subject. When you learn about your subject, the photograph becomes more interesting to you—and your viewers.

The man in the photograph is the woman's father. She is painting his face so that when he and his family venture into the rainforest to hunt and gather food, the spirits of the rainforest will recognize and protect them from evil. She is using the nectar of a local flower as her paint.

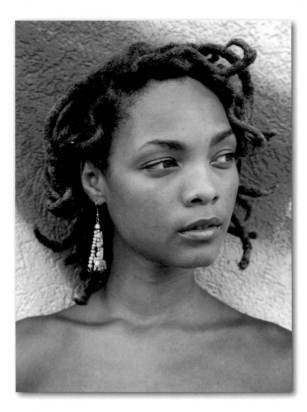

Of course, you don't have to go all the way to Brazil to practice your portraits versus environmental portraits technique—and to see how very different the pictures can be from each other.

In this picture, taken in Atlanta's Little Five Points, the colorful background does not tell the viewer anything about the location in which I took the picture. For all the viewer knows, I could have taken the picture in my studio.

It's not until we see the environmental portrait below that we realize the young woman is standing against a wall painted with colorful and lively graffiti.

When taking environmental portraits, think carefully about how much of the environment you want to include in your picture. The more you include, the smaller the subject appears in your photograph. That's not good or bad. It's just something to think about.

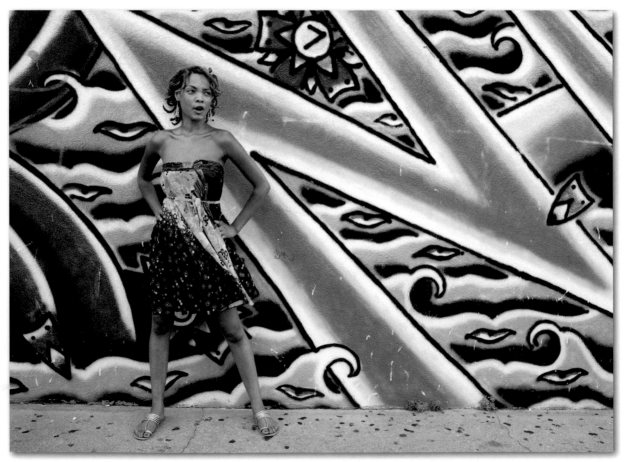

The All-Important Background

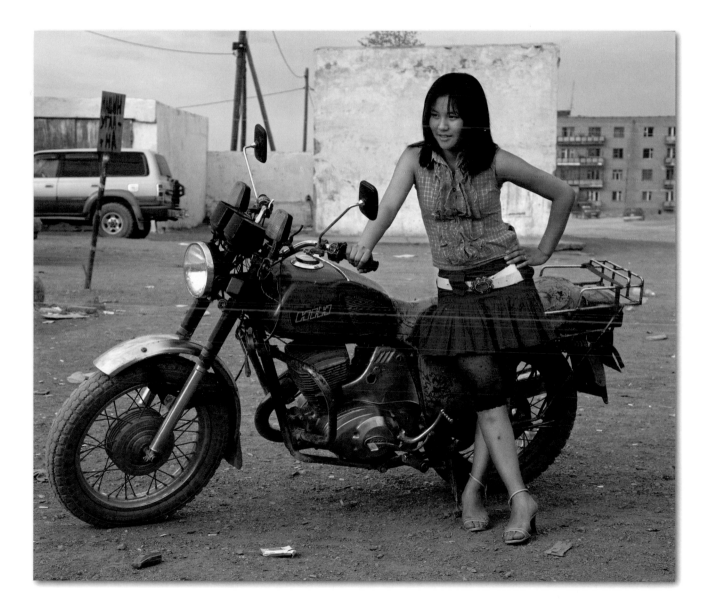

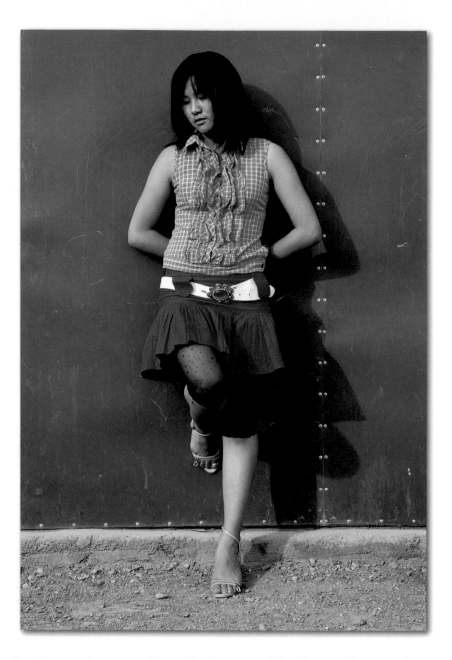

The background in a picture is of utmost importance, for two reasons: one, the background can make or break the scene; two, the background helps to tell the story of the subject and establish a setting.

Compare the opening picture on the Lesson 10 title page with this picture of a girl I photographed in a town in the Gobi Desert in Mongolia. This picture is nice enough, but I've seen red walls like that in Brooklyn, New York. What's more, the background is rather boring. Even if you didn't know the location of the shot on the preceding page, you may have wondered where it was taken because it's a much more interesting photo.

In the motorcycle picture, notice how the girl's head is framed by the wall in the background. That was not an accident. I carefully composed the picture so that her head and upper body stood out in the photograph. Whenever I frame a person, I try to isolate his or her head in a similar manner.

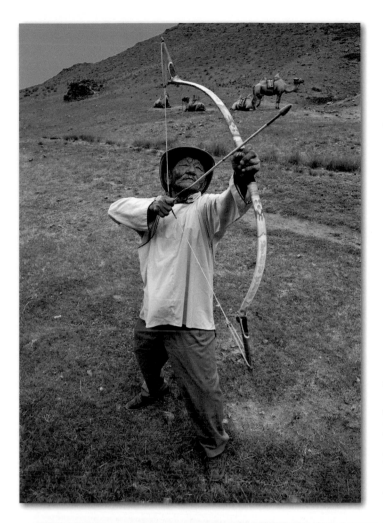

Here is another example of how important the background is in helping to tell the story of a subject. I also encountered this man in the Gobi Desert. I could have taken one of these pictures in my backyard; the other I could have taken only in a place where they have camels, such as Mongolia.

So, watch your backgrounds. Your pictures will be better if you do.

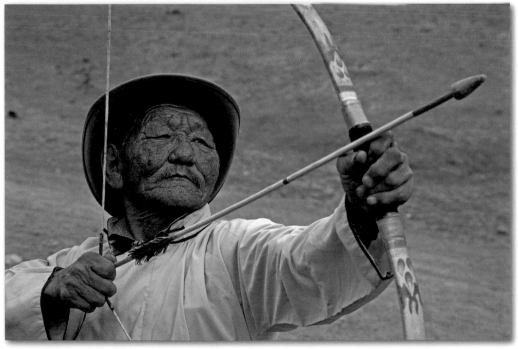

Paying People

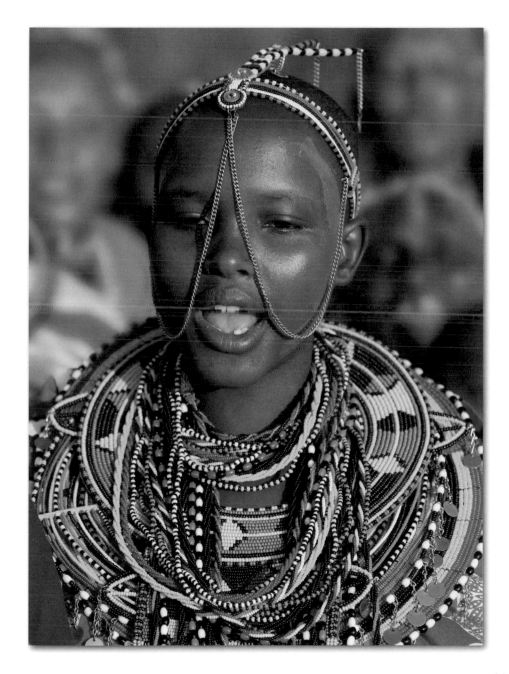

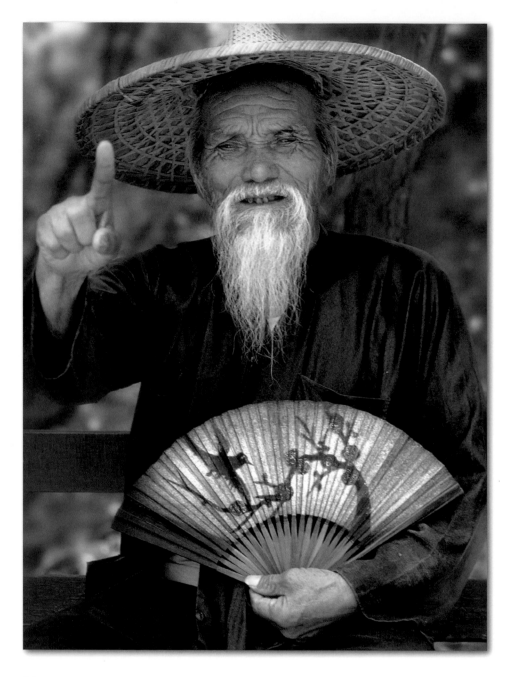

This picture of an old man that I took in Hong Kong in 1975 is one of my very first travel portraits. The man was posing for pictures and charging $1. After paying him $1, I raised my camera to take another picture, and he immediately raised his arm and gestured, $1 more. I gladly paid the fee and took another shot.

In my travels, when it comes to photographing adults, I pay them—anywhere from $1 to $10, depending on the subject. I figure that I am getting something out of the photo session, and so should they.

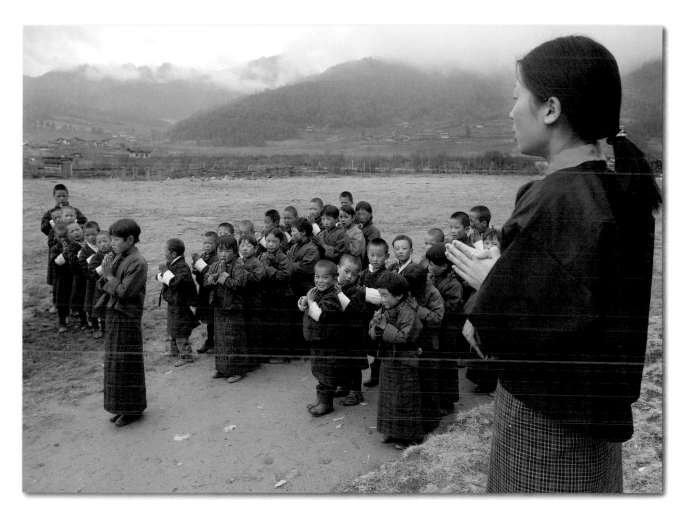

I never pay children, because it promotes begging. Rather, through my guide, I ask about making a donation to the local school, which is what I did here while photographing this class assembly in a remote village in Bhutan. That way, I am happy and the school is happy. We both get something out of it.

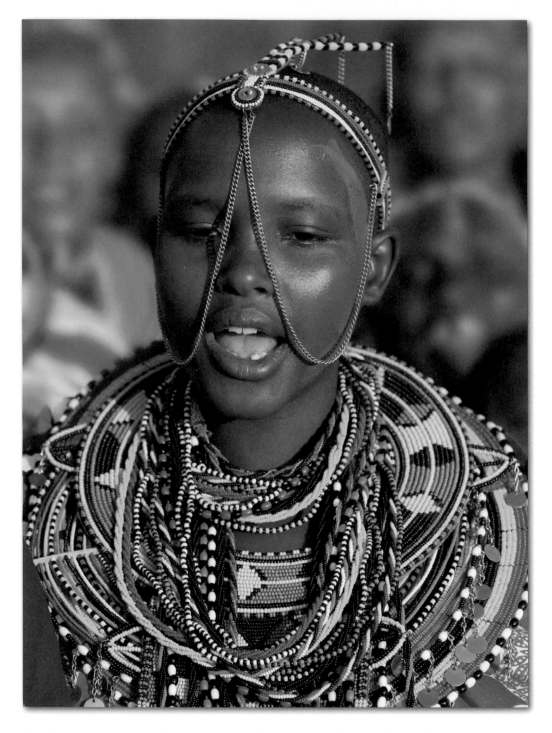

When I travel with a group on one of my workshops to a remote location, we often make a contribution to the village, town, or community in which we are shooting. That's what we did when we took this photo on one of my Kenya workshops, where we each contributed to a fund to help the Massai people.

If you plan to photograph people in foreign lands, travel with a bunch of "singles" in your pocket. Keep them separate from your wallet so that you have easy access to them.

Dress for Success

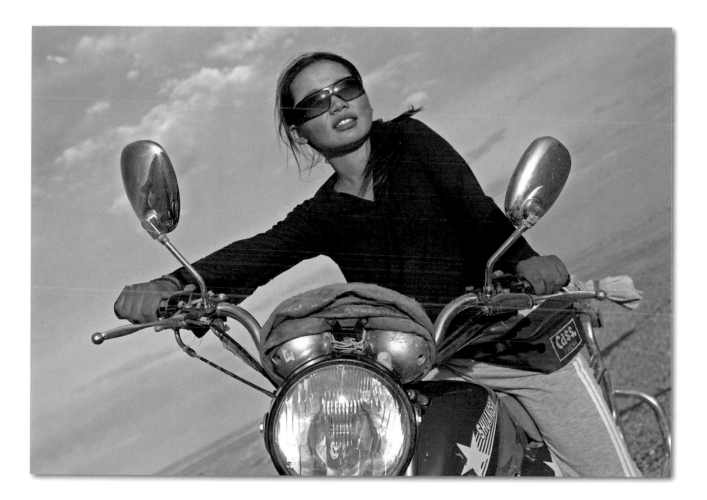

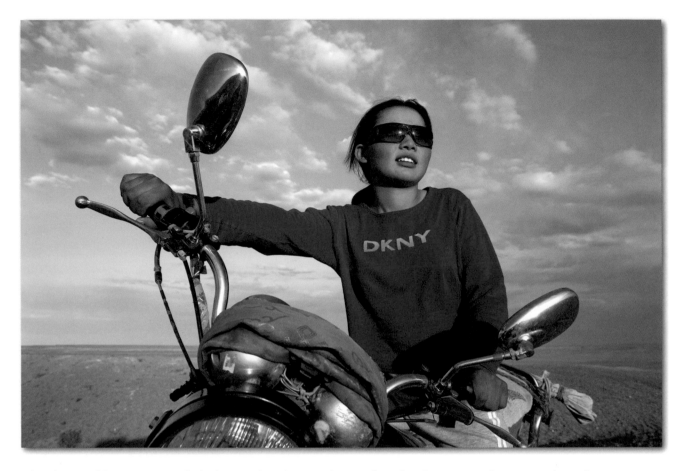

There's an old expression: "Clothes make the man." Well, I don't know if that's really true, especially today, when some millionaires walk around in jeans, T-shirts, and sneakers. However, clothes are important when it comes to photographing people. What a person is wearing not only says something important about him or her, but it can also change the appeal and mood of the photograph, and, of course, the subject.

I took the two pictures in this lesson of the girl on the motorcycle in the middle of Mongolia's Gobi Desert, believe it or not. When I first encountered the young girl, who was selling souvenirs at a site called the Flaming Cliffs, she was wearing a brown shirt. Through my guide, I asked her to pose on her brother's motorcycle. I took a few shots and was pleased with the results.

Then I thought about something I read in the 1978 edition of *National Geographic's Guide to Photography*. The author suggested that when photographing a person, have the person wear something red (or another strong color) so that he or she will stand out in the scene. Usually, that's a practical idea. So, I asked the girl to change shirts with her nearby girlfriend, who was wearing a red shirt. She complied with my request and we did a second photo session.

Well, although the picture of the girl wearing the red shirt has more impact, I actually prefer the photograph of her wearing the brown shirt. It looks more earthy and more "Gobi."

Here is another example of how color can affect a picture. I took both of these pictures during Carnevale in Venice. Which one do you think has more impact?

When you are photographing a person, keep in mind the importance of the person's clothes.

Body Language and Hands

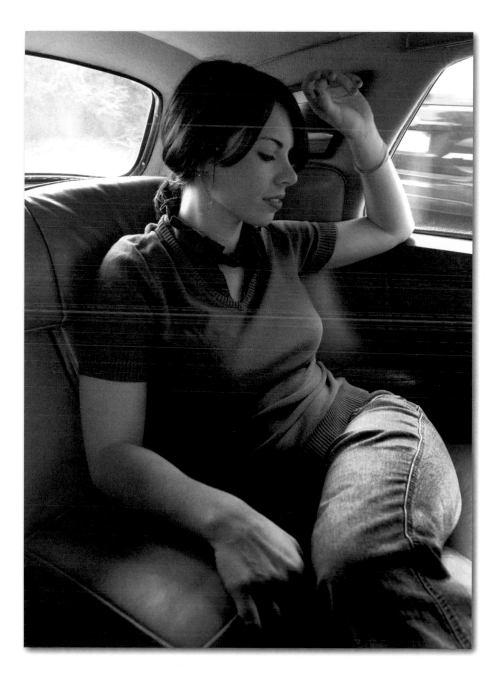

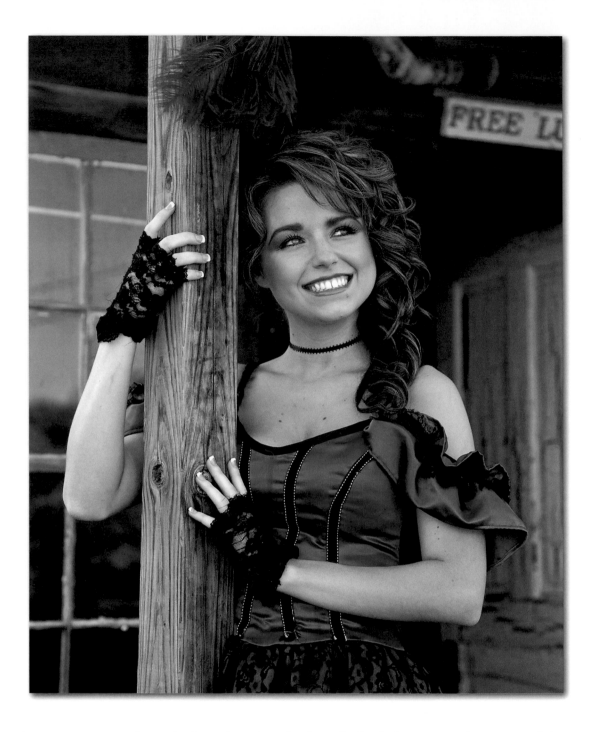

Sometimes we get so caught up in the technical aspects of photographing people and their facial expressions that we forget two other important aspects of people photography: body language and hands.

Look at the body language and position of the hands in the opening photograph, which I took of my friend Andrea Laborde during one of my workshops in Salem, Massachusetts. This photograph is all about confidence and openness.

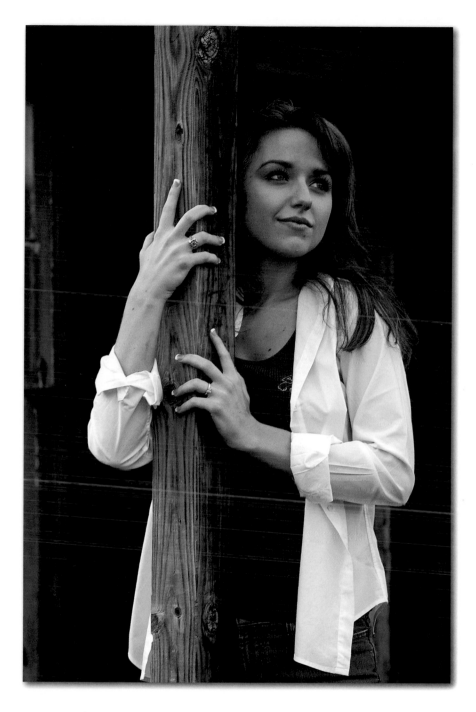

Compare these two pictures of a woman I photographed in Marrow Bone Springs, Texas. In the dressed-down photograph, the girl is gripping the pole with "man hands." As you can see, she is holding the pole in a feminine manner in the other photograph. By the way, the woman is a model, and is actually the person who taught me about "man hands."

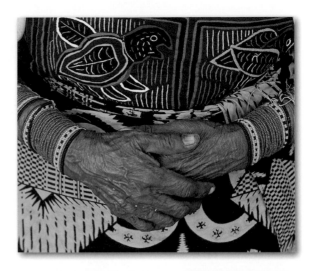

Sometimes taking a close-up of just hands can result in an interesting picture. Here I zoomed in on the hands of this woman, whom I photographed in Kuna Yala, Panama. The deep wrinkles tell the story of a life spent in the harsh sun.

In case you are interested in seeing how the Kuna women dress, below is a picture of a different Kuna Indian. These women exude dignity each and every day.

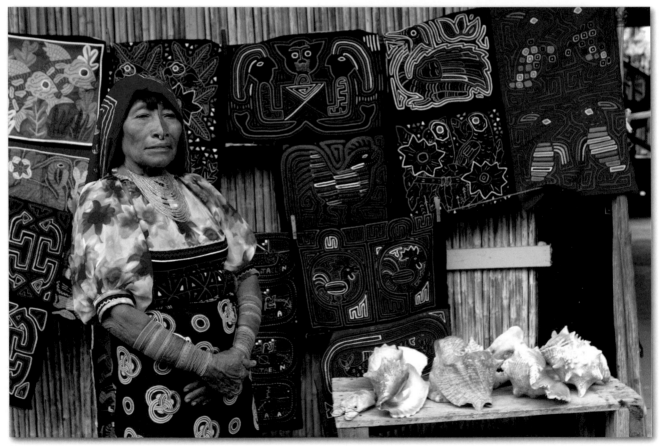

Seeing Eye to Eye

When you photograph a person, one of the many things you should think about is the camera's relationship to the subject's eyes, specifically the level at which you are shooting: at, above, or below the subject's eye level.

In most cases, shooting "eye to eye" is a good idea, because it puts viewers of the photograph on the same "level" as the subject, helping them to identify with the subject.

As you can see in the opening portrait for this lesson, which I took in Marrow Bone Springs, Texas, my camera was positioned at the subject's eye level.

Look at what happened when I photographed my subject from a higher and a lower angle. The higher-angle photograph looks like a snapshot to me. I've seen that kind of "above the subject" photograph many times, most often when parents photograph their kids. The lower-angle photograph is OK, I guess, but it lacks the camera-to-subject communication that we see in the opening picture.

Of course, there are exceptions to all of my suggestions (and to all rules in photography). Seeing eye to eye is no exception. Following are three examples.

When you photograph a subject from a lower angle and have the subject look directly at the camera, you give the person in the photograph a sense of superiority. Fashion and glamour photographers often photograph models from a lower angle for that very reason, and that's why I took this photograph of a model in a studio on Miami's South Beach from a lower angle.

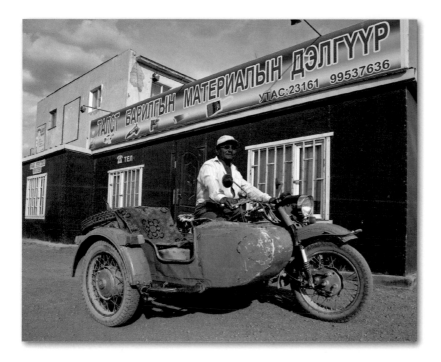

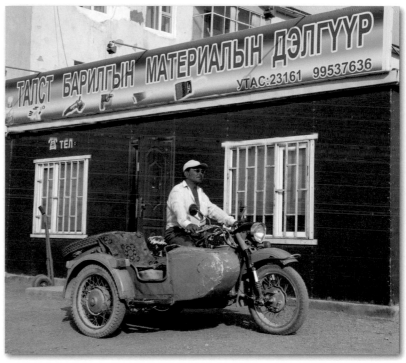

There are other reasons why you may want to photograph a subject from a lower angle. First, a picture can look more creative, which was the goal I was trying to achieve when I photographed this man in Dalanzadgad, the main town in the Gobi Desert, Mongolia. Second, from a lower angle, you'll be able to include, as well as exclude, different elements in the scene. Plus, photographing a person from a lower angle gives him or her an implied sense of power over the view of the picture, which is why you see this in fashion ads.

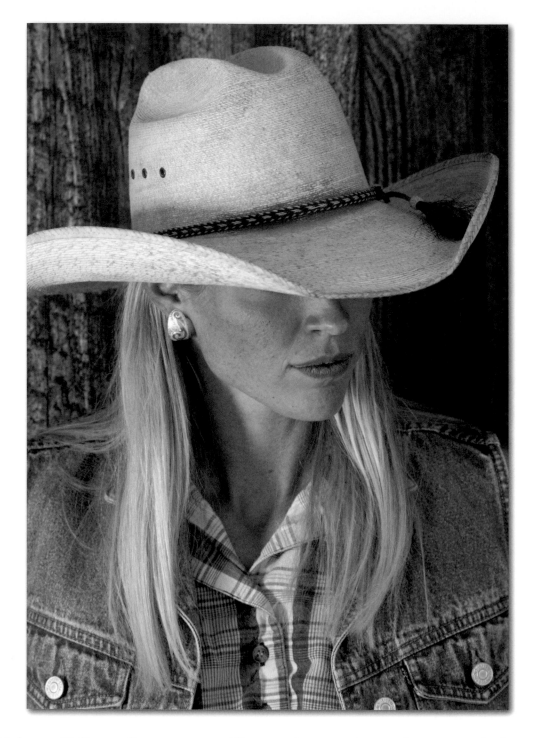

In closing this lesson, I'd like to offer one more idea on seeing eye to eye. Sometimes you don't even have to show the person's eyes to achieve a creative photograph, as illustrated by this picture of a cowgirl I photographed in Montana.

The next time you photograph a person, think carefully about seeing, or perhaps not seeing, eye to eye.

Choose a Location

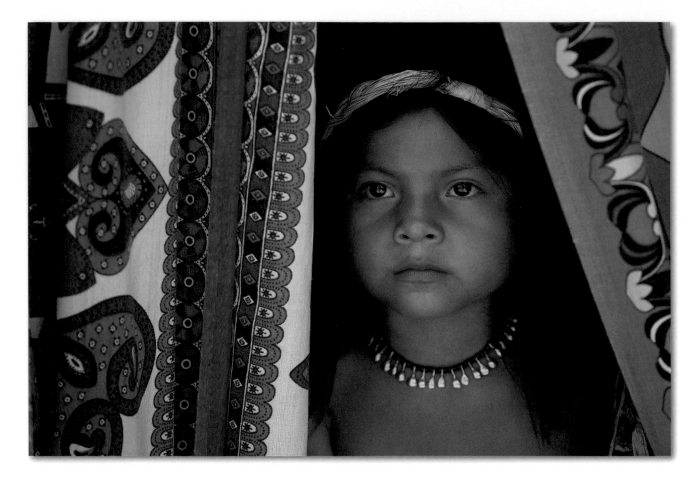

When you take a picture of a person, you basically have two location choices: you can photograph the person in the existing location, or you can choose the location first and then move the subject into position in that location.

I used the latter technique for this shot of a young Embera girl I photographed in Panama.

When I was walking through her village, I noticed that hanging from a hut were two beautiful pieces of material (shown on the opposite page) that I thought would be a perfect frame for a subject. So, after seeing the little girl, I asked her, through my guide, if she would move into that location. The result was this picture, one of my favorite Panama pictures.

Here is another example of finding the location first, this time the balcony of a hotel in Panama. Once again, I framed the subject, here with the open door.

Looking for backgrounds before you shoot can open up a new way of photographing people. Plus, it's fun!

Adding Props

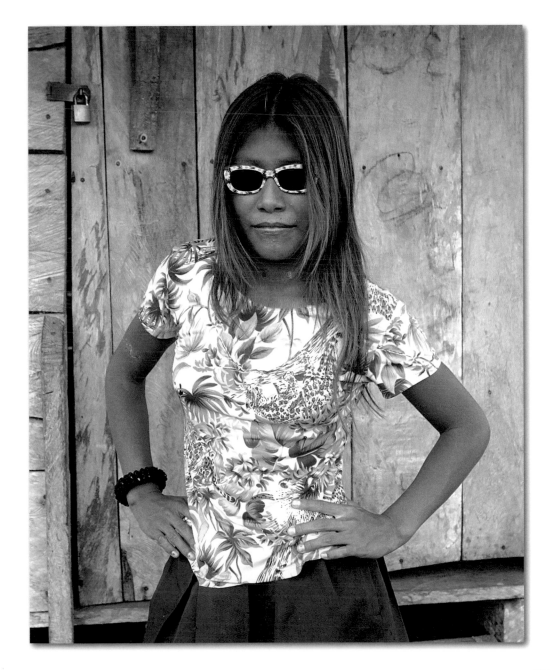

Props can transform an ordinary portrait into one that is more interesting and captivating. Compare these two pictures of a man whom I photographed in Italy during one of my workshops.

Without the hat, the man does not look as distinguished. What's more, the simple prop of the hat makes the photograph look more professional and can even help you to achieve a look or mood that helps to tell a story.

I met this young man in a small Massai village in Kenya. He told me that he had just killed a lion, something required of young Massai men. So, for his portrait, I had him wear the lion's mane and hold the stick that he had used to kill the lion. Those props help to tell the story of the young man's life.

When I travel, I always carry a pair of inexpensive sunglasses with me to use as a prop. The sunglasses came in handy when I visited a small village in Panama. The sunglasses transformed a snapshot photo session with this girl into a fashion shoot, Panama style.

Props can also make a photo session fun for the subject, as well as for the photographer, by giving the subject something to do, rather than just standing there.

Compare these two pictures. In which picture do you think the subject was having more fun?

Play around with using props, such as a cell phone or hat, and you'll see how they can enhance your pictures.

Seeing Pictures Within a Picture

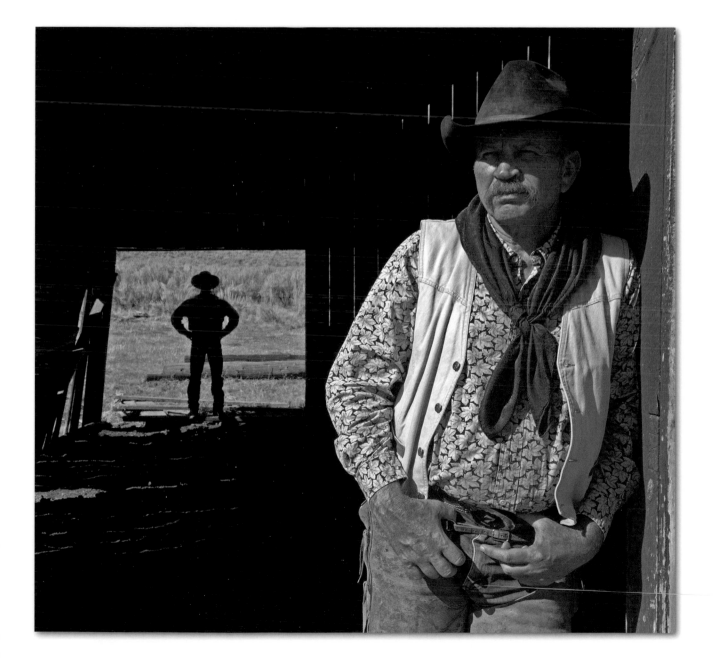

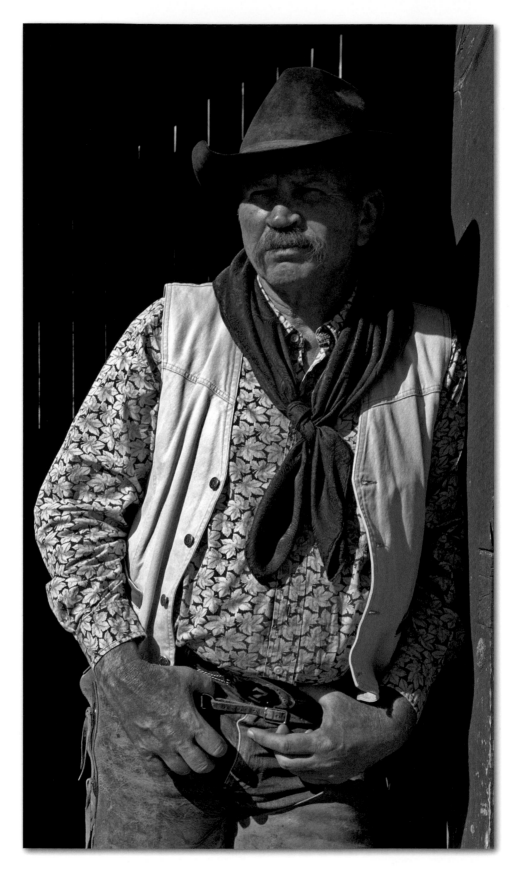

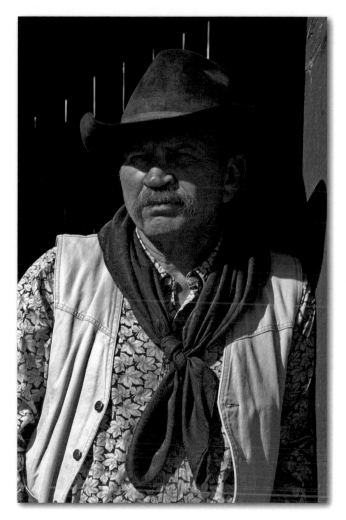

After we take a picture, it's a good idea to think about what additional pictures we can see (and create) within that picture. But if I may back up a bit…it is also a good idea to look for pictures within a scene when you are actually looking through your camera's viewfinder.

I took the picture on the title page of this lesson on the Ponderosa Ranch in Oregon. I like the composition, and how the different elements in the scene are arranged. As I usually do, I then tried to see additional pictures within the picture. I "found" the rest of the pictures in this lesson in that single picture.

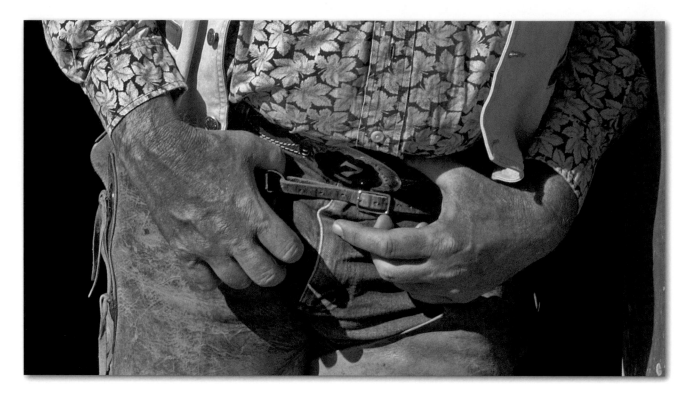

This "seeing pictures within a picture" philosophy is actually a good reason to shoot RAW files. With RAW files, you'll get the best-quality image, an image that lets you crop out smaller sections of a picture that can be enlarged (to a point). If the cropped image does not have the resolution for making a big enlargement, Genuine Fractals, a Photoshop plug-in from onOne Software (*http://www.ononesoftware.com*), is designed for that very purpose: upsizing images without losing quality.

So, look for pictures within your pictures. You may be surprised at what you'll see that will make a good picture on its own!

Adding a Person Adds
Scale to a Picture

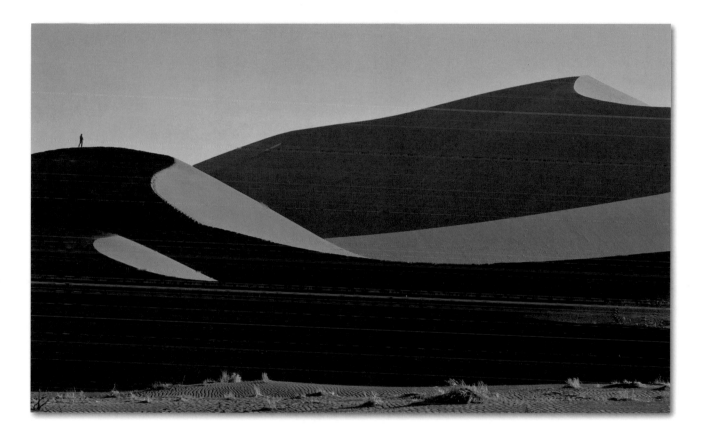

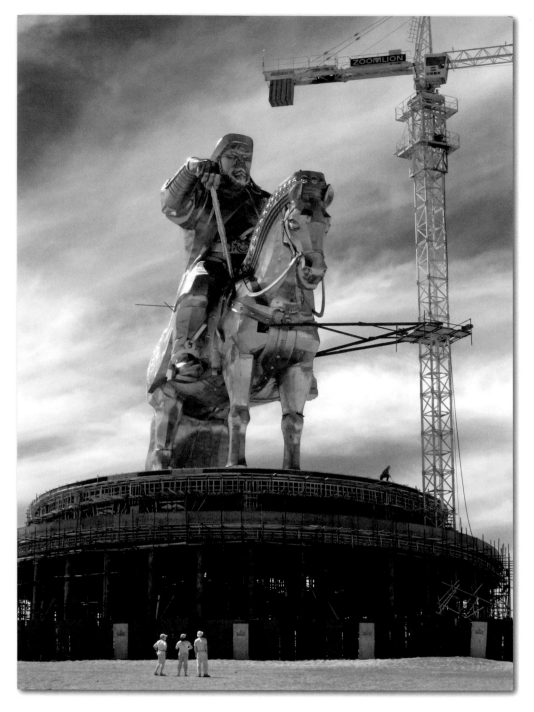

When you include a person in a picture, you add a sense of scale to the subject or the scene. That's true even if the person takes up only a tiny fraction of the image. What's more, seeing a person in a scene gives the viewer of the picture the opportunity to picture him or herself in the scene.

For example, in this image, the lone worker on the 90-foot-high structure that features a statue of Chingis Khan, which I photographed in Mongolia, illustrates the enormity of the structure, as do the tourists in the foreground.

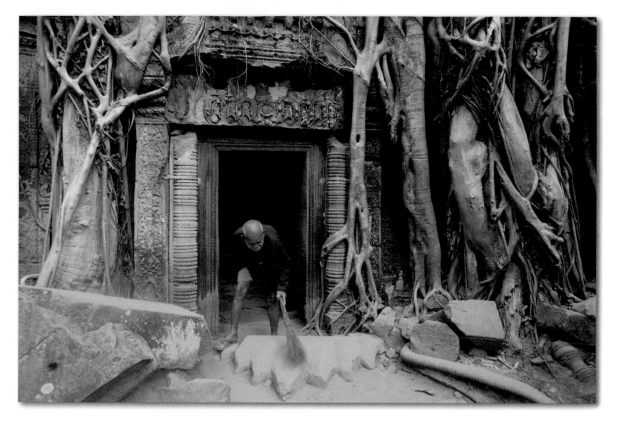

Including people in architectural and landscape images also adds a human quality to an image. I took these pictures in Angkor Wat, Cambodia.

Do you agree that the picture with the man has much more impact than the picture without him?

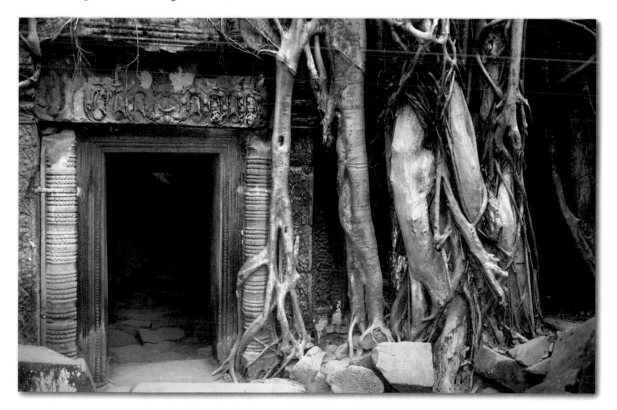

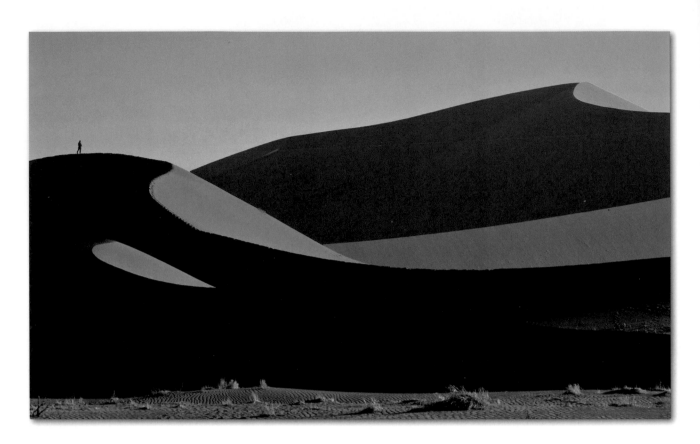

Here is a photograph that I took in Namibia while exploring the magnificent sand dunes—the oldest sand dunes on the planet. I could easily have waited for the climber to move out of the scene, or taken him out in Photoshop. However, his presence in the photograph illustrates the enormity of the dunes. Quite frankly, I would not have this picture any other way.

The next time you look at a scene and say to yourself, "I wish the person would move out of the scene," think about how you can use that person to your photographic advantage.

Thinking Creatively

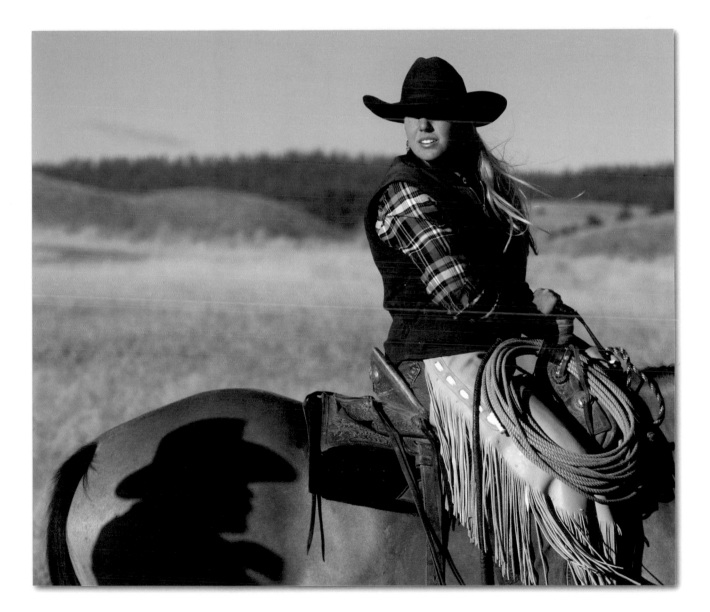

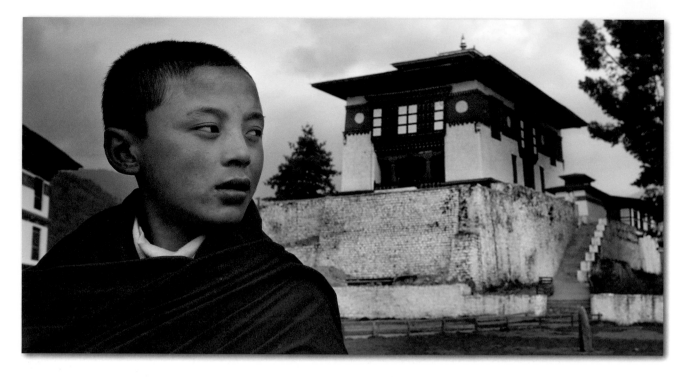

Here is an assignment. Set out tomorrow to photograph someone whom you have photographed many times before, and try to come up with a more creative picture. Start by asking yourself this simple question: "How can I create a more interesting, creative, and memorable picture than I have created before?"

That's exactly what I was thinking when I took the picture of the girl on horseback that appears on the title page of this lesson. The workshop participants were given that challenge. Some of the students took action shots, some took head shots. Others went for a silhouette, and still others focused on the details. All the images were creative. But the shot on the title page of this lesson, an image that tells the story of a cowgirl looking at a cowboy, with his shadow falling on the horse's rump, won out as the most creative image. The image sets a mood, and asks the question, "What is the cowboy doing, or what is he about to do?"

The key is to think about all the elements that go into the making of a portrait that you have read about on the previous pages. Challenge yourself to make the best picture possible. If you need more encouragement, imagine that a client is willing to pay you $5,000 for a picture of a familiar subject with a totally different look.

The photo on this page is another example of thinking creatively. I was visiting a dzong (a temple and fortress) in the Kingdom of Bhutan when a young monk strolled into the scene. I thought that getting both the monk and the dzong in the picture—with both in sharp focus—would make a creative photo. I posed the monk so that he filled the left side of my frame, while the dzong filled the right side. I was pleased with the arrangement of the subjects in the scene, but I knew the trick was to get them both in focus. Here's how I did it.

I used a wide-angle setting (24mm) on my zoom-lens. I set the f-stop to f/11 for good depth of field. I used the focus lock on my camera and locked in the focus one-third into the scene, or one-third the distance from my camera to the dzong. After locking in the focus, I recomposed the scene and took the picture. In effect, what I did was set the lens to the hyperfocal distance—the ideal setting to get the maximum amount of the scene in focus. (SLR lenses used to have hyperfocal distance settings.)

I think you'll agree that this picture is a lot more creative than if I had just taken a picture of the monk standing in front of the dzong.

It's a touch like that which makes the difference between a snapshot and a creative picture.

Taking Fun Shots

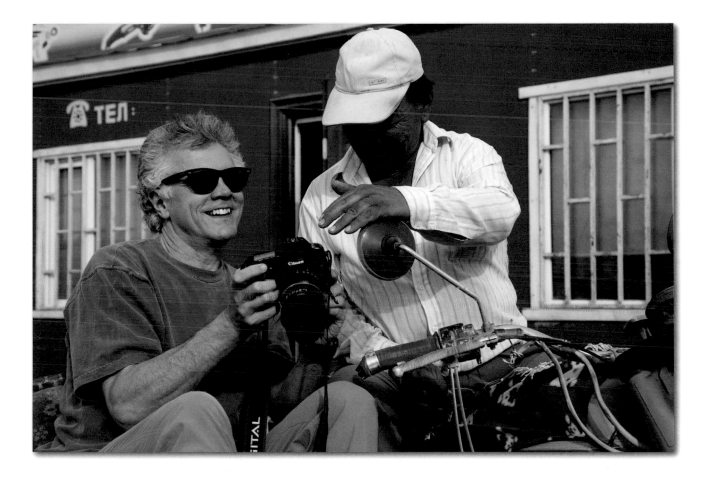

I've been taking people pictures for 30 years. One of the important things that I have learned is that the more fun I have during a photo session, the more fun the subject has, and the more the subject feels at ease.

That feeling of fun, ease, and enjoyment results in my achieving the pictures I envision before I snap the shutter.

The first step in having fun is to project a positive attitude of friendship and to interact with the subject. Digital cameras, with their LCD monitors, help enormously with the interaction process.

Before I go for the "keeper," I usually take a grab shot or two and show them to my subject. That's what I'm doing in the picture on this lesson's title page, which my friend Jack took of me during a photo session in Mongolia. As you can see, I am having a blast and the subject is interested in seeing his picture.

After I feel as though I have gained my subject's trust, I go for the "keeper." The shot on this page is the photo I had envisioned when I first saw the man, his motorcycle, and the red building in the background.

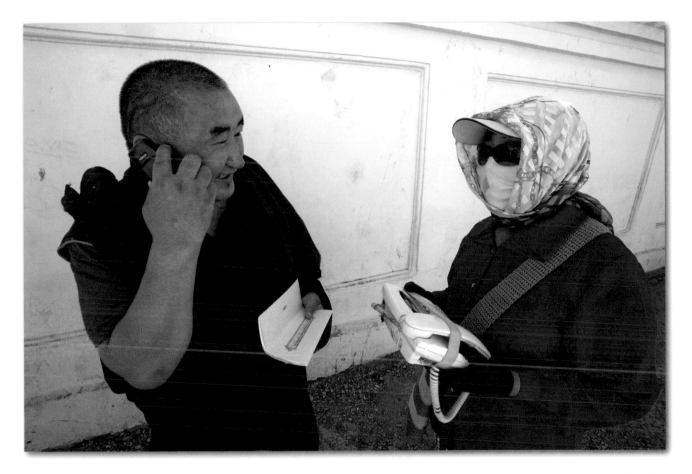

Gaining a subject's trust and making him or her feel at ease has another important advantage: you can get very up-close-and-personal photographs—photographs that almost put the viewer right there in the scene with you.

I took this picture in Mongolia with my 17-40mm lens set at 17mm. (I took the portrait of the man on his motorcycle with the same lens set at 40mm.) At such a close shooting distance, the subject has to trust you.

What drew me to this scene was the idea that the picture was somewhat funny: a monk outside a Buddhist temple, wearing a T-shirt under his robe, talking on a cell phone.

The monk, by the way, is using his cell phone to call a friend to tell him to call the cell phone that the woman is holding. He was running out of pre-paid minutes, and using the woman's phone was cheaper than buying more minutes. The woman is in disguise because she has another job and doesn't want anyone to recognize her. You see many women like this in Ulan Bator, Mongolia's capital.

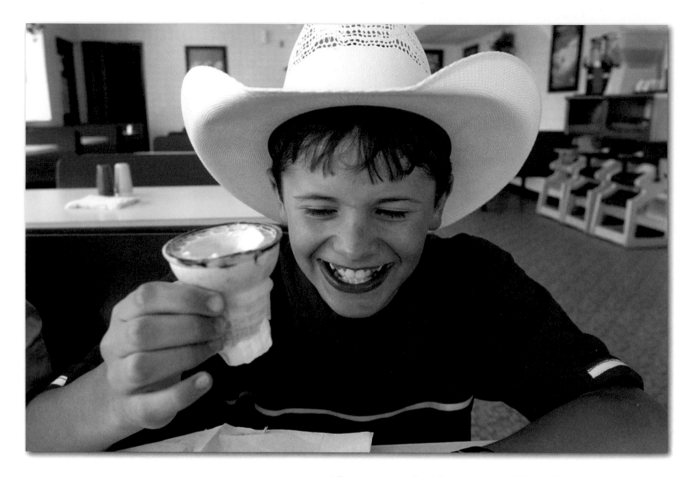

Of course, you don't have to go to Mongolia to get fun shots. You can take them around your house, in your neighborhood, and on family vacations. I took this shot of my son, Marco, in an ice cream shop moments after the bottom dropped out of his ice cream cone. Not only is it a fun shot, but it's also my favorite fun shot.

Carry a camera with you all the time, and you will not miss out on fun shots—photographs that will bring a smile to your face in future years.

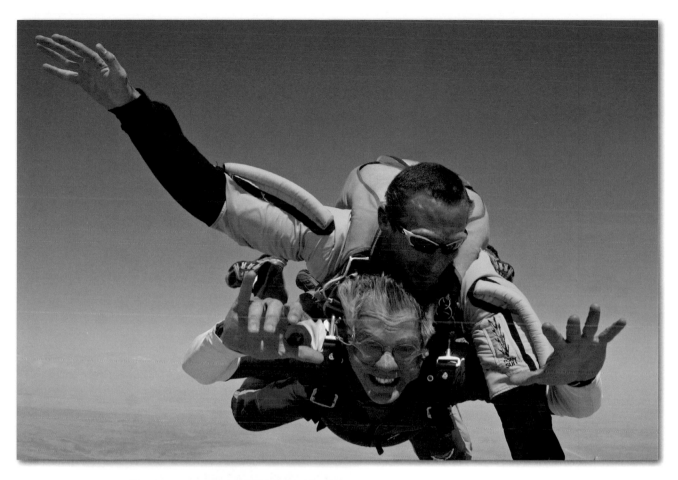

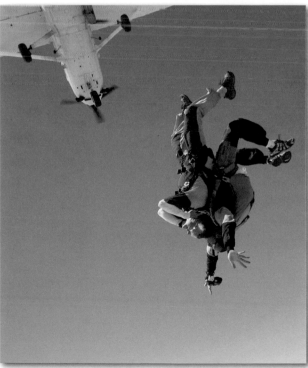

Wherever you are, you should think about having some fun shots taken of you having fun. That is exactly what I did before I jumped out of a plane at 10,000 feet above sea level during a break in my Namibia photo workshop. These photographs bring back the unbelievable feeling of "flying" at 125 miles per hour, as well as the shear panic of seeing the ground soooooo far below!

Sure, I like my other Namibia photographs that you see in this book, but none make me smile as much as these two!

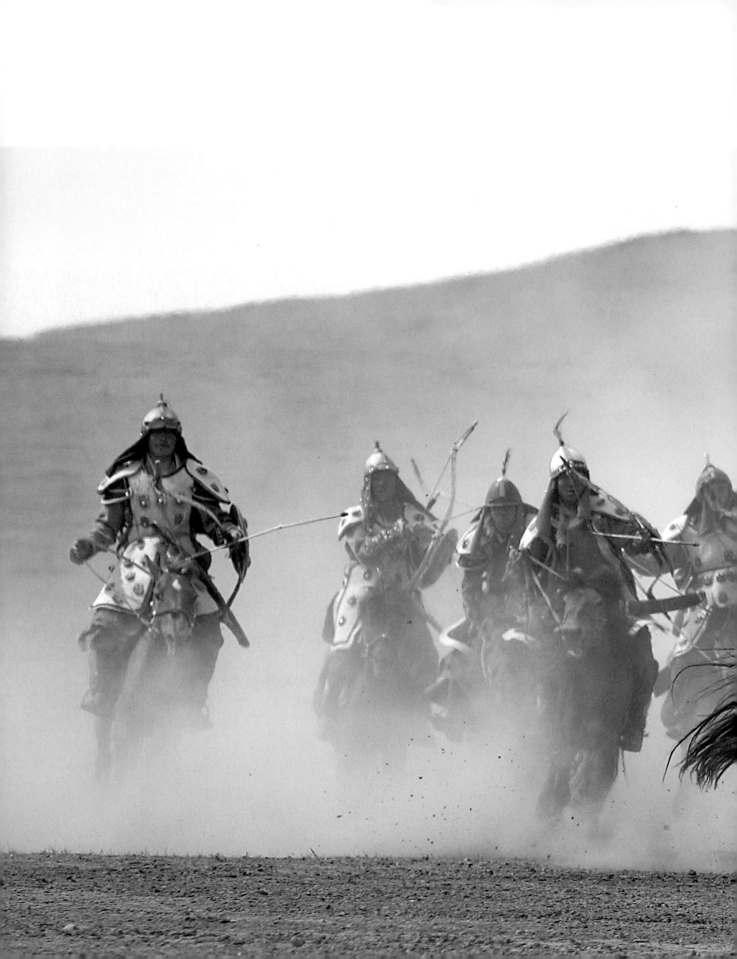

Outdoor Photography

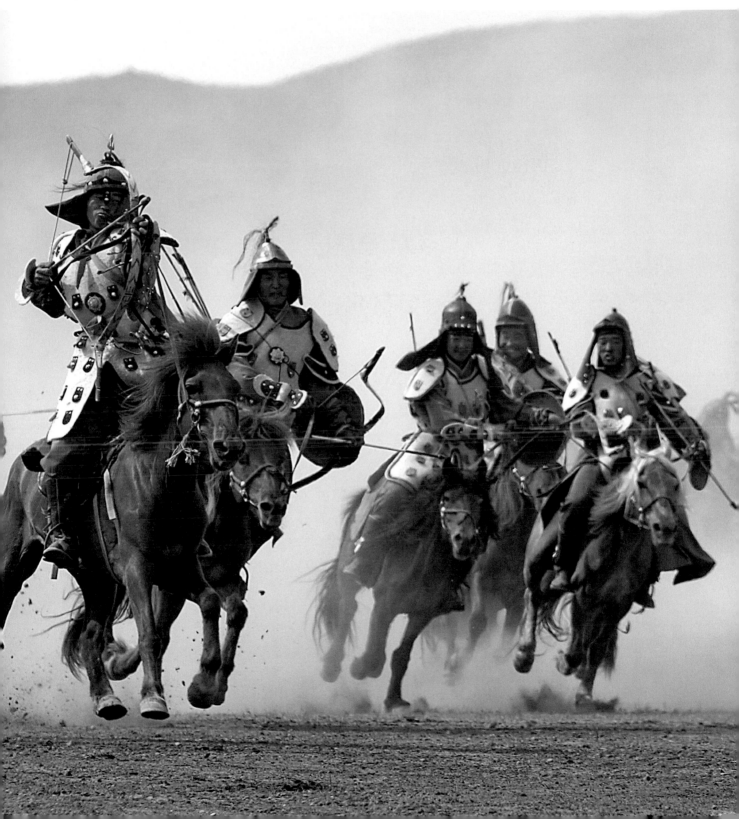

Capturing Action

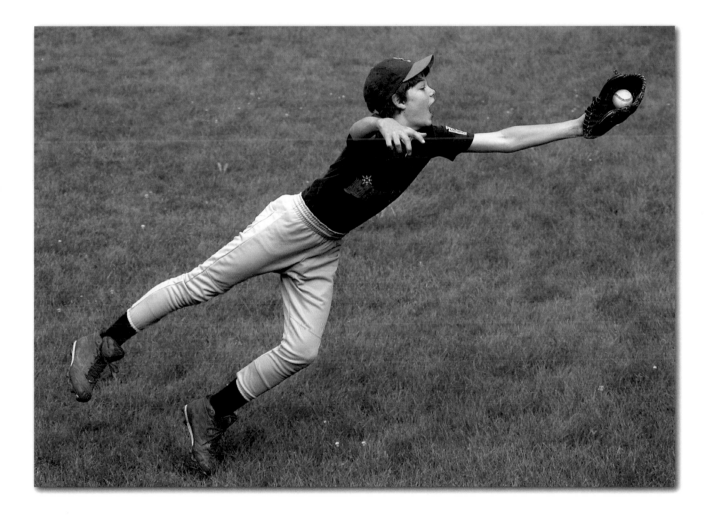

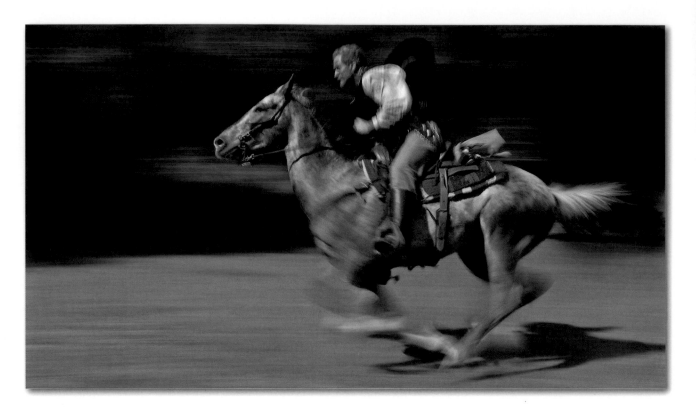

One of the cool things about digital SLR cameras and cameras that offer full creative control is that you can choose the shutter speed to stop or blur action. The choice is yours, and that choice makes a big difference in the feeling of a picture.

First let's talk about blurring the action, as I did for this horse-and-rider picture that I took in Marrow Bone Springs, Texas. Blurring the action creates a sense of motion and speed in a picture. For this picture, I used a technique called *panning*. Here's how to do it.

Select the shutter priority mode on your camera and set a slow shutter speed, perhaps 1/15 to 1/30 of a second. The best shutter speed to use will be determined by how fast the subject is moving. So, you need to experiment with different shutter speeds to get just the right effect. That may take several "runs."

You want to shoot in the shutter priority mode because even if the light level changes, by the sun going in and out of the clouds, the shutter speed will remain constant while the camera changes the aperture to maintain the correct exposure.

Once your camera is all set, it's time to shoot. Basically, you want the fast-moving subject to move in front of you from left to right or right to left. You want to photograph the subject when he or she is directly in front of you.

To begin the panning process, you need the subject to be far enough away from you so that he or she can gain speed. As the subject starts to move, start to follow the action in your viewfinder. When the subject is almost directly in front of you, start shooting. Setting your camera on a rapid frame advance (several frames per second) will help you to get the shot you want. After the subject moves past the point directly in front of you, keep following the action for a few seconds and keep holding your finger down on the shutter release button. If all goes well, you'll get a picture in which the background is beautifully blurred and the subject is relatively sharp.

To help steady your shot during panning, try using an image stabilization lens or a tripod with a panning head.

For an evenly blurred and streaked background, it's important to envision your shot with the subject against a relatively plain background.

In addition, to ensure a good exposure in tricky lighting conditions (a light subject against a dark background in my horse-and-rider situation), before I started the actual photo session I asked the cowboy to move into the position at which I was going to take the shot. Then I asked him to stand still, took a meter reading, and set my camera accordingly. By predetermining the exposure at the point of action, the only thing I had to think about was getting a good pan and capturing the peak of the action—the horse with all its hooves off the ground at the same time.

Here is a shot of the same horse and rider in the same location. Here I used a shutter speed of 1/500 of a second to "freeze" the action. Sure, it shows a clearer shot of the cowboy and horse, but I think you'll agree that it does not convey the same sense of speed and motion as my slow-shutter-speed shot.

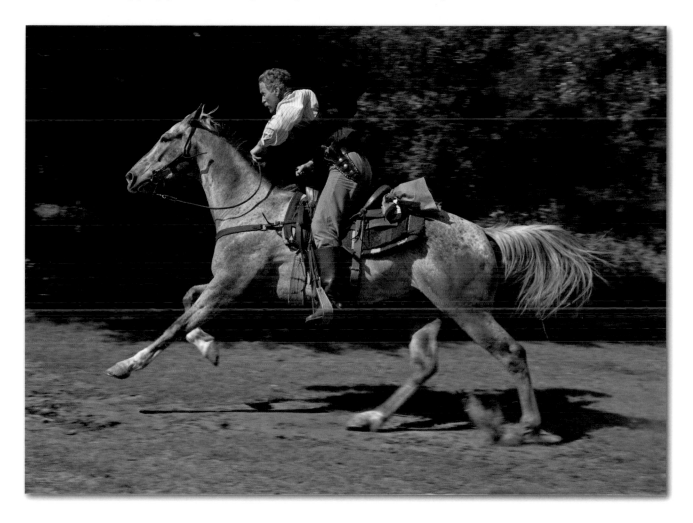

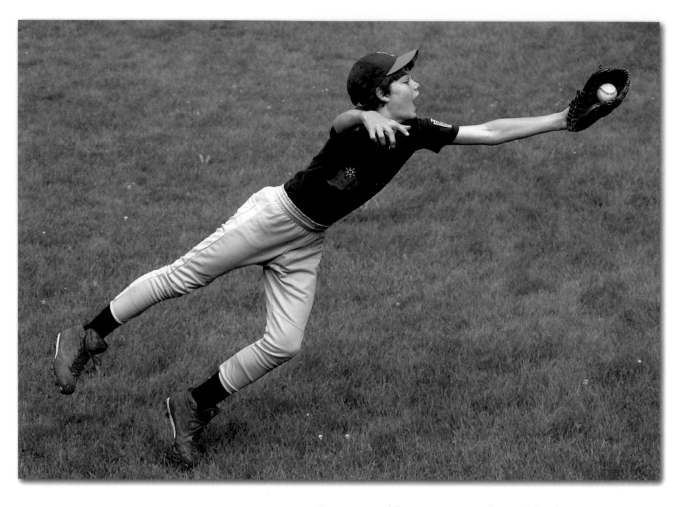

Freezing or blurring is your choice. Think care-
fully about which effect to use to capture a sub-
ject. In the case of this young baseball player,
freezing the action was the only way to go, in my
mind anyway.

Using Reflectors

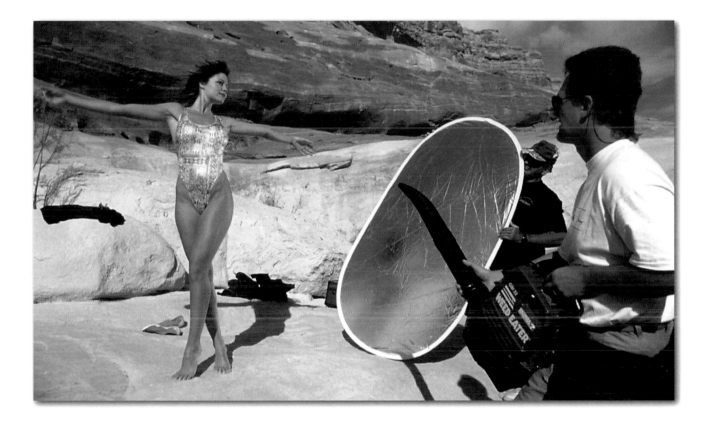

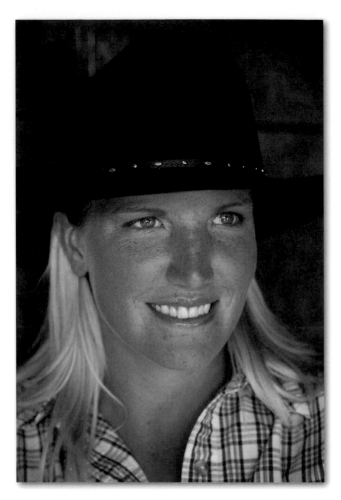

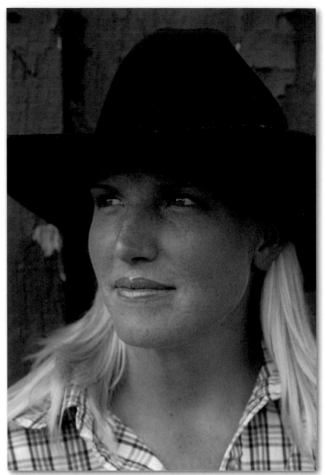

Reflectors, which collapse to about one-half their full size, are invaluable accessories for serious people photographers. Reflectors usually have two sides: a gold/warm-light side and a silver/cool-light side. When angled correctly, reflectors bounce light onto a backlit subject or a subject who is positioned in the shade. That bounced light adds color, contrast, and brightness to the subject's face. It also adds a nice "catch light" to the subject's eyes, making the eyes sparkle.

The cowgirl, whom I photographed at the Double JJ Ranch in Rothbury, Michigan, was standing in the shade when I took her picture. The photo on the left is bright thanks to a reflector.

As you can see in the photo on the right, without the reflector, the picture looks flat—the brim darkens the girl's face and there is no "catch light" in her eyes.

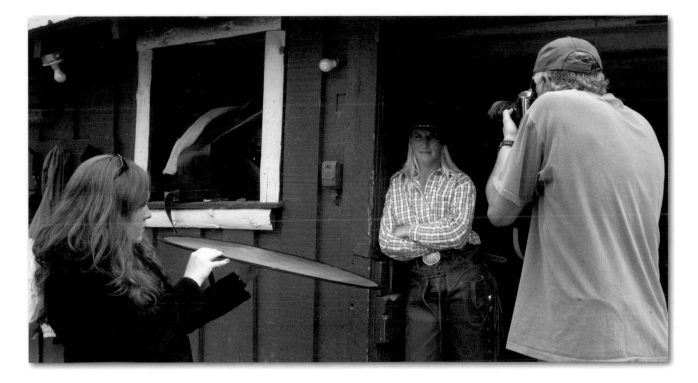

Here's a behind-the-scenes shot that shows my assistant holding the reflector. Again, positioning the reflector at the proper angle is important. You need to have the sun either behind the subject or off to the subject's side, and you need to watch the reflection on the subject for the optimum amount of illumination. On an overcast day, when there is no direct sunlight, a reflector is virtually useless. (Unless you want to use a reflector as a big bounce source for a daylight fill-in flash shot. See Lesson 29 for information on daylight fill-in flash, and Lesson 25 for information on bounce flash.)

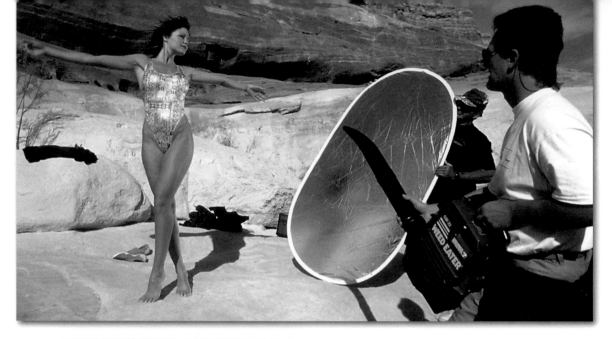

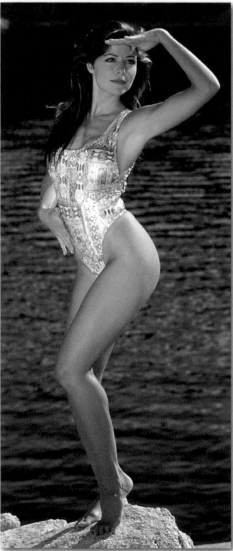

Reflectors are available in different sizes, from about 3 feet in diameter to about 8 feet in diameter. For full-body shots, such as this model shot I took near Lake Powell, Arizona, you'll need a large reflector, as shown. For head-and-shoulders shots, a smaller reflector, like the one you see my assistant using in the previous photo, is fine. For full-body shots, 6-foot reflectors are available.

In the photo on the left, you see the effectiveness of using a reflector. The model is backlit by the water (also Lake Powell). However, thanks to the reflector, you can see the details on her body and face.

Reflectors often come in kits with diffusers, which we'll cover in the next lesson.

Don't leave home without either accessory!

The Beauty of Using Diffusers

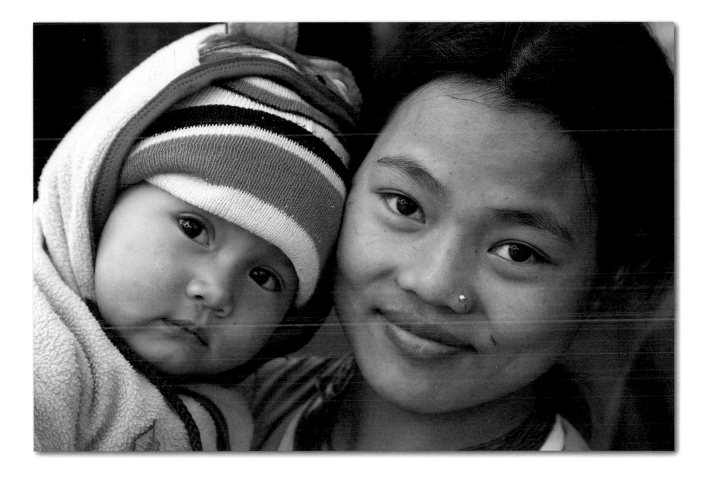

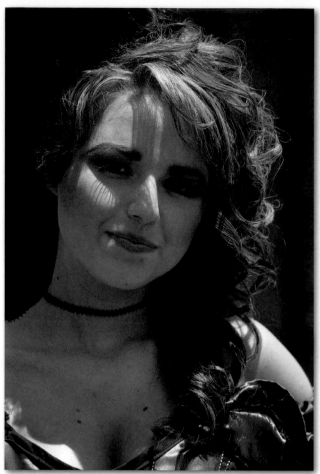

In Lesson 1, you saw me holding a diffuser for my friend Jack during a portrait session in Mongolia. You also saw the dramatic results that using a diffuser offers.

To reinforce the importance of never leaving home without this accessory, I'll share some more illustrations. The two pictures on this page were taken in Marrow Bone Springs, Texas. To soften the harsh light of the midday sun, I had an assistant hold a diffuser between the sun and the subject. The result was soft and flattering lighting.

The photo on the right shows what could happen if you don't follow my suggestion … and you leave your diffuser home, again on a sunny day.

Like reflectors, diffusers are collapsible and come in different sizes, from small (3 feet in diameter) to large (6 to 8 feet in diameter). And as I mentioned in the previous lesson, they often come in kits with reflectors.

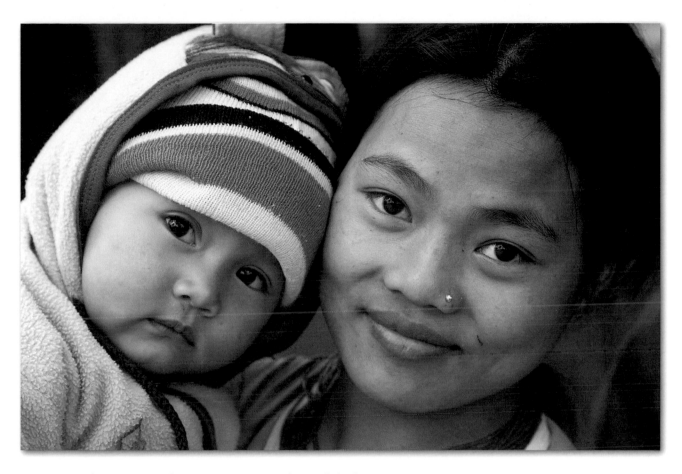

If you are out shooting on a sunny day and don't have a diffuser, or if you don't want to look too "professional" (which can be intimidating to a subject), you can use a natural diffuser: position your subject or subjects in the shade, as I did with this mother and child whom I photographed in Bhutan.

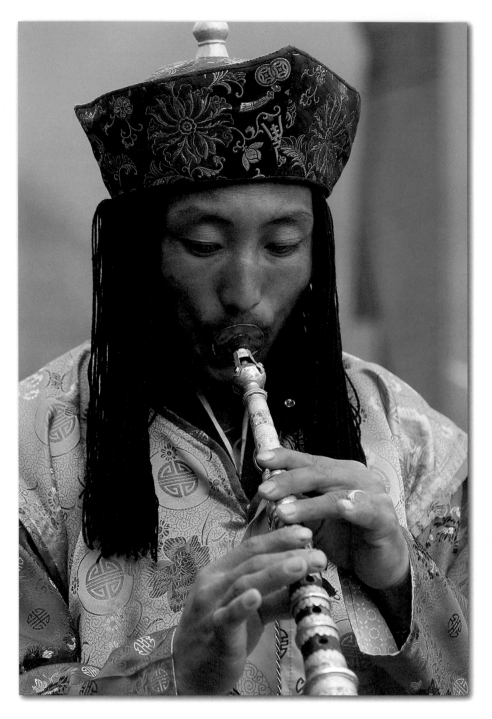

On an overcast day, you don't need a diffuser, as was the case when I photographed this musician performing at a festival in Bhutan.

Garage Glamour

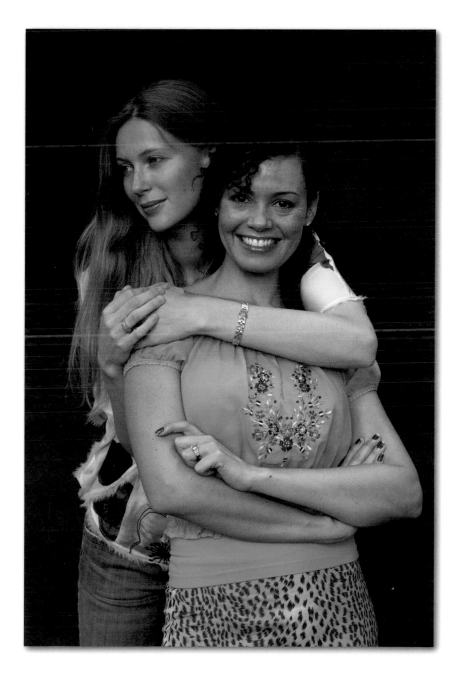

For every lesson in this book, I've tried to start each lesson with a pretty picture. What's more, I've tried to select a picture that illustrated the message of the lesson.

For this lesson, I still use an illustrative picture, although it's not that pretty. It's a snapshot of my garage/storage area during some reconstruction at my house.

I'm sharing this photo for a good reason. You can turn your garage into a studio that offers very nice lighting, just as I did. Hey! I did not come up with this concept. Photographers have used their garages for years for what's been called *garage glamour*.

The idea is to have one large light source, the light coming in through the open garage door. If you have windows in your garage, you'll need to cover them.

Look at this photo and you'll see a black cloth on the floor. That's important! It eliminates the light that might bounce from the white cement on the garage floor onto your subject's face, which would otherwise create unflattering lighting, what pros often call *Halloween lighting*.

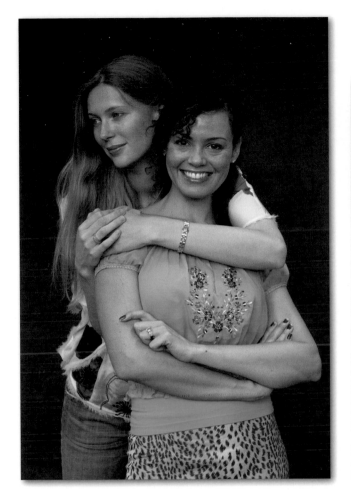

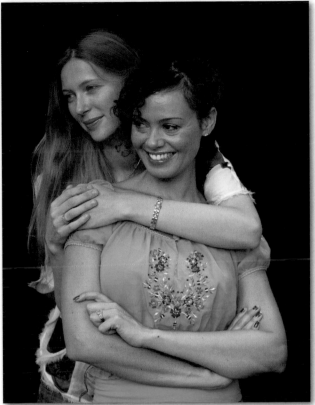

I like to work with collapsible, dark green or blue or brown, 6-by-7-foot backgrounds from FJ Westcott (*http://www.fjwestcott.com*). With an attarctive background and nice soft light, I can get professional studio lighting results, as I did when photographing my friends, Chandler (in the back) and Lauren (wearing the bright blue shirt).

In garage glamour photography, subject and background placement is very important. I like to place my subjects about 6 feet inside my garage, while I stand outside, usually shooting with my Canon 70-200mm IS lens set at 200mm. That setting lets me shoot tight so that I don't get any garage items in the picture. In the photo on the left, the background is about 2 feet behind the subjects.

In the photo on the right, the background is about 7 feet behind the subjects. As you can see, it's much darker, almost black. If you want a black background, place the background several feet behind the subject. The farther back you place it, the darker it will be.

If I had to choose between the two Chandler and Lauren pictures, I'd choose the one with the lighter background, because Lauren's black hair gets lost in the photo with the black background.

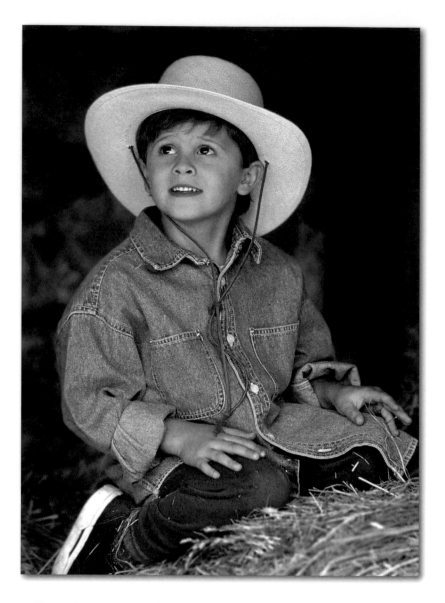

In garage glamour shooting, you'll need to set your ISO to 400, or maybe even higher, if you want to use a) a shutter speed that is fast enough to prevent a blurry picture caused by camera shake, and b) an aperture that is small enough to get the entire subject (or subjects) in focus. For the pictures of Chandler and Lauren, taken on a slightly overcast day, I set my ISO to 640, which gave me an exposure of 1/125 of a second at f/5.6. I set my 70-200mm IS lens at 200mm.

Another relatively low-light shooting option is to use a tripod. A tripod will let you use a lower ISO (for an image with less digital noise than what you'd get at a high ISO setting) and shoot at

a slower shutter speed. Either way, you'll need to ask your subject(s) to keep fairly still.

I did not take this picture of my son, Marco, in a garage. I took it in a barn. Still, the picture illustrates the same technique: positioning the subject in the shade of a big open door, a barn door in this case. Because the sun was shining brightly, my wife, Susan, held a reflector outside the barn and bounced light onto Marco's face. (See Lesson 22 for more information on using reflectors.)

Keep the garage glamour technique in mind, and you'll get professional studio quality results without spending big studio photography bucks.

Daylight Fill-in Flash

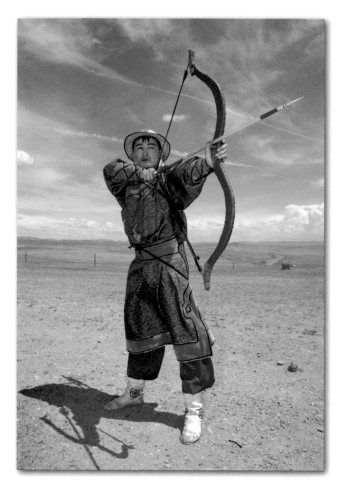 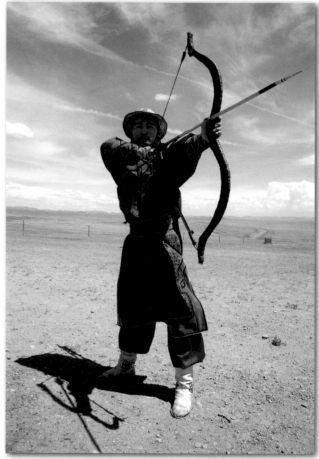

Compare these two pictures of an archer that I took in Mongolia. For the picture on the left, in which you can clearly see the subject's face, I used my flash for what's called daylight fill-in flash photography.

I took the picture on the right with the flash turned off. It's a natural light shot. As you can see, the subject's face and his costume are hidden by the shadow created by the midday sun.

In situations like this, you could use a reflector to bounce light onto the subject, but you'd need a large reflector to bounce the light onto his entire body. What's more, you'd need someone to hold the reflector. So, for most people, using a flash is a more practical option.

In addition, you could use your camera's spot exposure meter, and set the exposure for the subject, but then the sky would be way overexposed. Therefore, daylight fill-in flash is the way to go.

Here's an easy technique to achieve a well-balanced, daylight fill-in flash photograph, that is, a photograph in which the light from the flash is balanced to the available light.

Before you begin, you'll need a flash with variable flash output control, that is, +/− flash compensation. Or you'll need a camera with a built-in flash and built-in flash exposure compensation. All SLRs have this feature, as do some compact digital cameras that let you control the flash output with the camera's built-in flash or accessory flash.

Here is the step-by-step technique:

1. Set your camera to the Manual exposure mode and have your flash turned off.

2. While in the Manual mode, set the exposure for the existing light condition. Take a shot to make sure you have a good overall exposure for the background. Don't mind the shadows at this point. Just make sure the highlights are not washed out (overexposed).

3. Turn on your flash and take an exposure with the flash set at –1 1/3. If your picture on the camera's LCD monitor looks too much like a flash shot, reduce the flash output to –1 1/2. If it's still too "flashy," continue to reduce the flash until you are pleased with the results. If the subject is too dark at the starting point of –1 1/3, increase the flash output to, say, –1. If your picture is still too dark, increase the flash exposure until you are pleased with the results.

This techniques works, because even in Manual mode, the flash operates in TTL (through the lens) Automatic flash metering mode. Also keep in mind that for a more dramatic photograph (from a lighting standpoint) you can select a faster shutter speed to darken the background. In essence, the f-stop determines the exposure for the subject and the shutter speed determines the exposure for the background.

Some newer digital SLRs and flash units help the flash metering system determine the main subject's distance, and actually calculate the aforementioned settings automatically for damn good daylight fill-in flash shots. Still, I suggest you master the aforementioned technique if you are serious about your photography.

Here is another example of the benefit of using daylight fill-in flash. In this situation, the light behind the subject was much brighter than the light falling on the subject, maybe three times as strong as in my archer example. Again, daylight fill-in flash saved the day.

Learn how to see the light—the dark and light areas in a scene—and you'll know when you'll need to control the natural light with a flash (or with a diffuser or reflector).

The Disequilibrium Technique

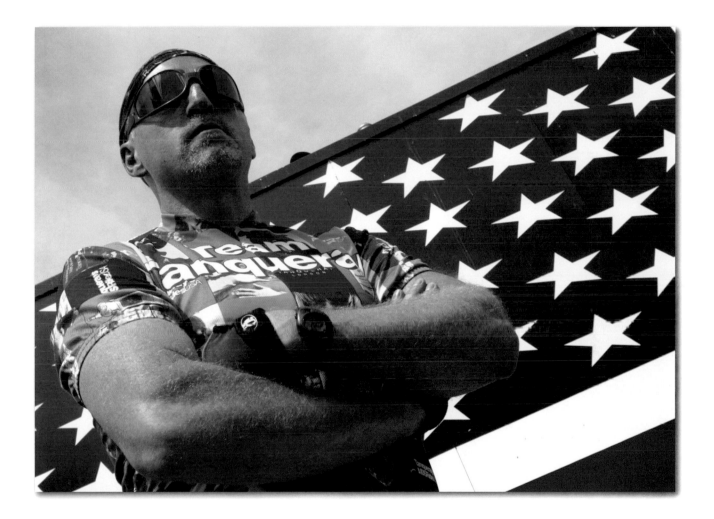

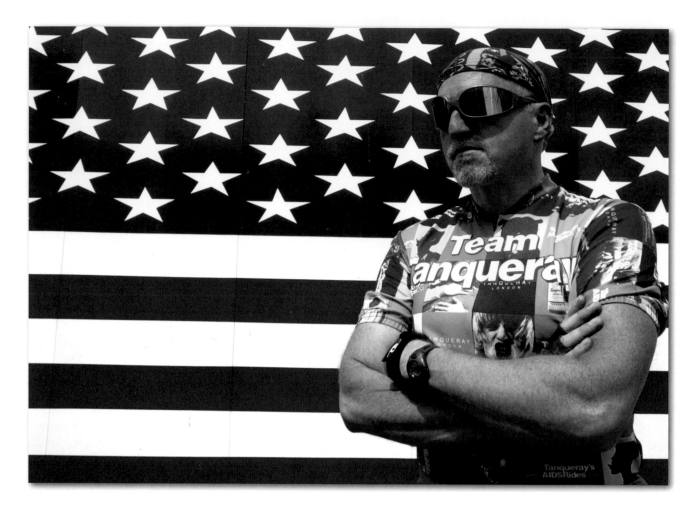

If you watch music videos on television or read fashion magazines, you may have noticed that some of the images look off-balance—tilted down to the left or right. According to my good friend, professor emeritus at Rochester Institute of Technology, Dr. Richard Zakia, tilting the camera down to the left or right creates a sense of disequilibrium, and draws extra attention to a picture.

I photographed the cyclist shown on these two-pages here at New York's Coney Island. At a quick glance, you can see the difference between the fairly static shot on the preceding page (taken with the camera held level) with the picture shown on this page, which has more visual appeal (taken using the disequilibrium technique).

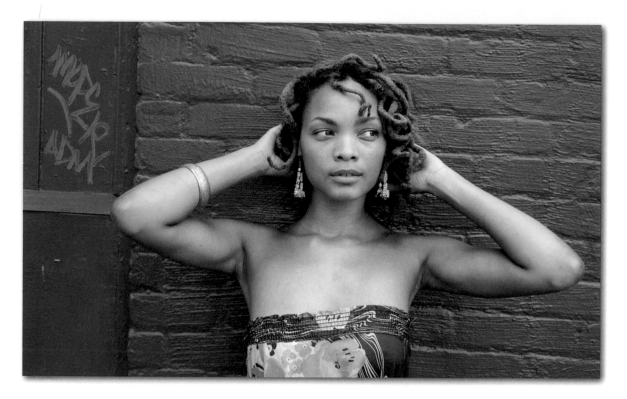

Of course, you can create a disequilibrium effect in Photoshop. I'll show you how to do that in the Photoshop part of this book. However, when you do, make sure you are not defying gravity.

For instance, take a close look at the Photoshop disequilibrium effect I created from my straight shot of this young woman, and you'll notice that her earrings are defying gravity.

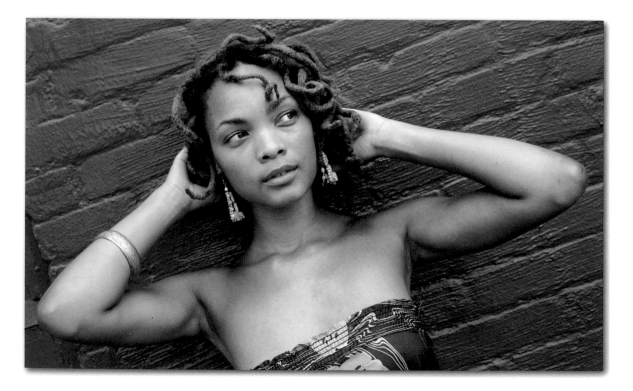

The Key to a Good Profile

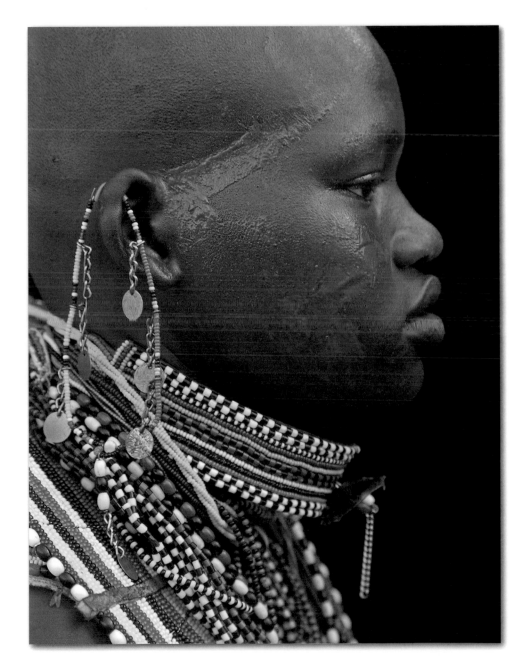

Believe it or not, one of the important keys to getting a good profile of a subject is the background in the picture. You want to select a relatively plain background, one without distracting elements such as trees, branches, signs, and so on.

Solid color backgrounds work well, as illustrated by the picture that appears on this lesson's opener page of a Massai woman posing in the doorway to her hut.

When the background is dark and there is plenty of light falling on the subject's face, you'll get a well-pronounced profile.

For a correct exposure, you'll need to set the exposure for the subject's face, because the dark area behind the subject could fool your camera's exposure meter into "thinking" that the scene is darker

than it actually is, resulting in the subject being slightly overexposed.

To set the exposure, use your camera's spot meter and meter the subject's face, or move in close and lock the exposure on the subject's face, then move back, recompose your picture, and shoot. If you want to add just a bit of light to the subject's face, use the daylight fill-in flash technique that I described in Lesson 26.

The opposite is true, too. If the background is bright and there is not a lot of light falling on the subject's face, as was the case when I photographed this young woman in the Gobi Desert at sunset, you'll get a nice silhouette.

To intensify the silhouette, I set my camera on the Av mode and set my exposure compensation to −1.

Photographing People in Low Light and at Night

When you photograph people at night with a digital SLR and a flash (built-in or add-on), you can actually control the light from the flash and the available light independently—and therefore, the balance between them.

That means you can get a picture like the one shown below, of two girls on a motorcycle that I photographed in Vietnam. You can see that both the subjects and the background are illuminated. Let's take a look at two techniques for accomplishing that goal.

Cameras with a Night Portrait mode are designed to help you get a good exposure of your subject and the background. They do that by setting a slower-than-usual shutter speed, which lets more available light into your camera. In many cases, that works just fine.

For more creative control, and to fine-tune your exposure (of the background and the subject),

here's the technique I recommend. Set your camera on M (manual exposure) l and dial in the correct exposure for the background. Take a shot and check your exposure on your camera's LCD monitor. If you think it's too light or too dark, use your camera's exposure compensation feature to darken or lighten the picture.

Now, turn on your flash and take a shot. If the subject is too dark or too light, adjust the flash output in-camera or on your accessory flash. (Most digital SLRs and even some high-end compact cameras allow you to vary the flash output over and under the "correct" exposure.)

In both situations, you'll need to hold your camera very steady (because of the slower shutter speed); use a tripod or an image stabilization lens to steady your camera during the exposure.

I used the manual exposure technique for the opening picture for this lesson.

If you want a dark background, for impact or if the background is otherwise distracting, you can take a photograph in which the background goes black, as shown here. Again, there are two ways to accomplish that goal.

If you set your camera on one of the automatic modes, you'll probably get a dark background, because most cameras select a faster shutter speed (than in the Night Portrait mode) to help prevent camera shake.

To almost ensure a dark background, set your camera's ISO to 100, set your shutter speed to 1/125 of a second (or the highest flash synch speed, which you'll find in your camera's instruction book), and set your f-stop to f/8 or f/11. The combination of low ISO, relatively fast shutter speed, and small f-stop should underexpose the background. When you shoot with a flash, if the subject is not close to the background (such as a wall), the flash should illuminate only the subject.

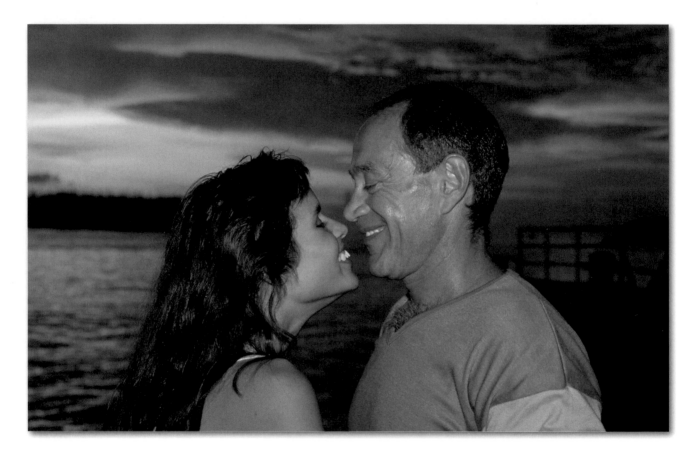

You can also use the aforementioned manual flash technique (or Night Portrait mode technique) when you photograph a subject at sunset and you want to capture the beautiful light of the setting sun and the subject's face. For this picture of a couple in Key West, Florida, I used my manual exposure technique.

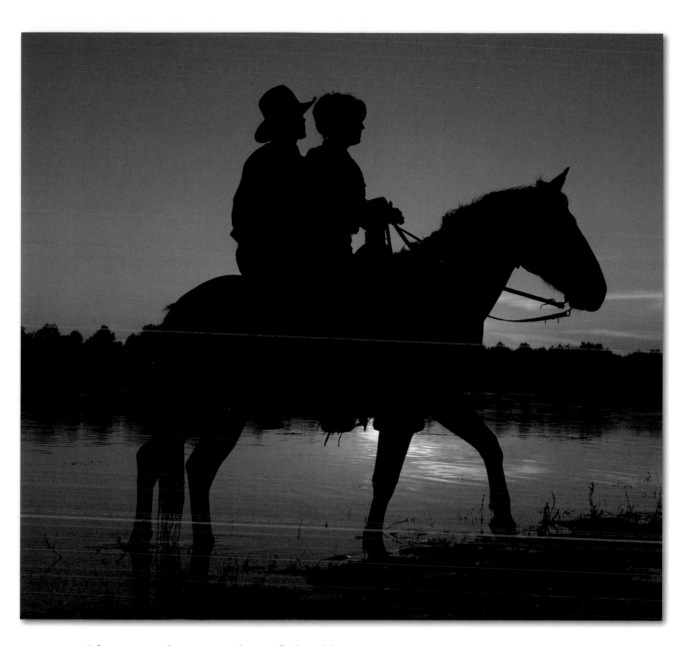

Of course, just because you have a flash and know how to get a good exposure of the subject and the background does not mean you have to use a flash! Sometimes a natural light shot is better, as was the case when I photographed this couple on a lakeside in Michigan. For this image, I set my camera to Av mode (aperture priority) and then set my exposure compensation to –1 for a more dramatic silhouette and more colorful sky.

Keep in mind that quite late in the day and even after the sun has set and the sky has darkened, your photo opportunities have not ended.

Group Photography

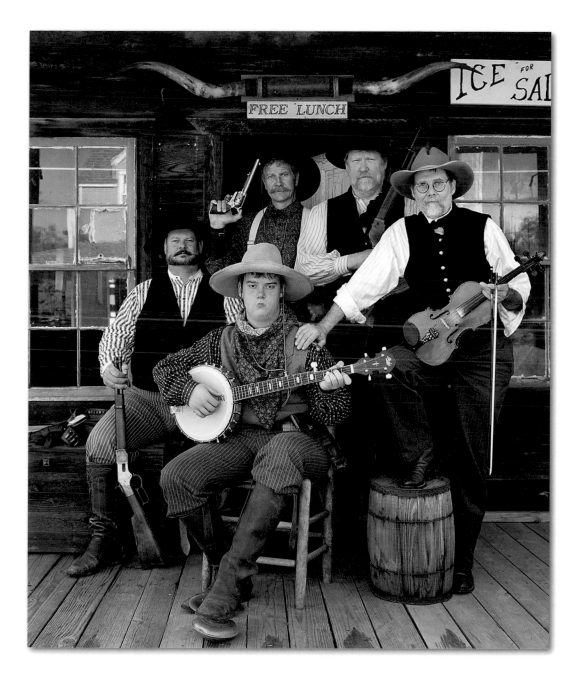

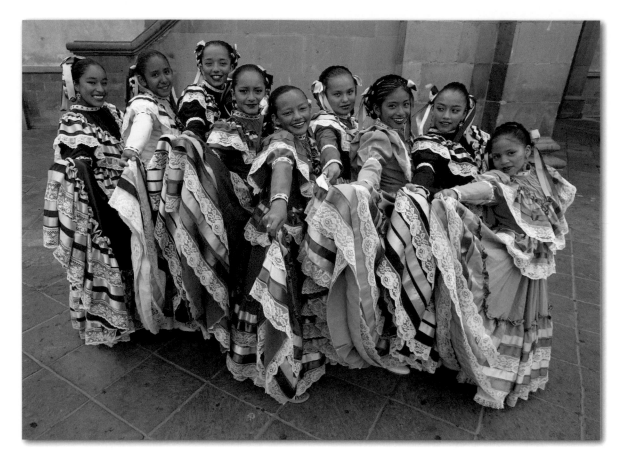

"If you can't see the camera, it can't see you." That's perhaps the most important tip, for the group, in group photography. In other words, if all the subjects in the group can't see the camera, some of the faces may be blocked by other faces. Still, you, as the photographer, need to take special care to make sure you can see each subject's complete face. That was one of the things I was thinking about when I photographed this group of performers in San Miguel de Allende. Mexico.

Other group photo techniques include:

- Take one picture for each person in the group. That helps to ensure that everyone's eyes are open for at last one picture.

- Select a pleasing background/location. Personally, I like to shoot in the shade, which offers soft and flattering lighting, or on overcast days, which also offers flattering lighting. I also try to select a location that is not distracting or compliments the group.

- Make sure that each subject's face is evenly illuminated. Shooting in the shade and on overcast days helps. So does using a flash, as illustrated in the group photo at the end of this lesson that I took of several gunfighters in Marrow Bone, Texas.

As you may have noticed, it does not look like a flash photo, that is, a photograph with the harsh shadows that are usually associated with flash photography. That's because I followed my own advice on daylight fill-in flash photography, which you'll find in the Daylight Fill-in Flash Photography lesson.

My gunfighters' photo on the Lesson opener page illustrates another important technique. When posing a formal group, balance is important. The picture looks balanced because I carefully arranged the subject photograph. Basically, you don't want a lopsided photograph or one in which too much attention is drawn to only a few subjects.

On this page and the next are a few more of my favorite group photographs. They all have something in common. When I was taking/making the photographs, I kept this old photo adage in mind: the camera looks both ways. Picturing the subject, you are also picturing a part of yourself.

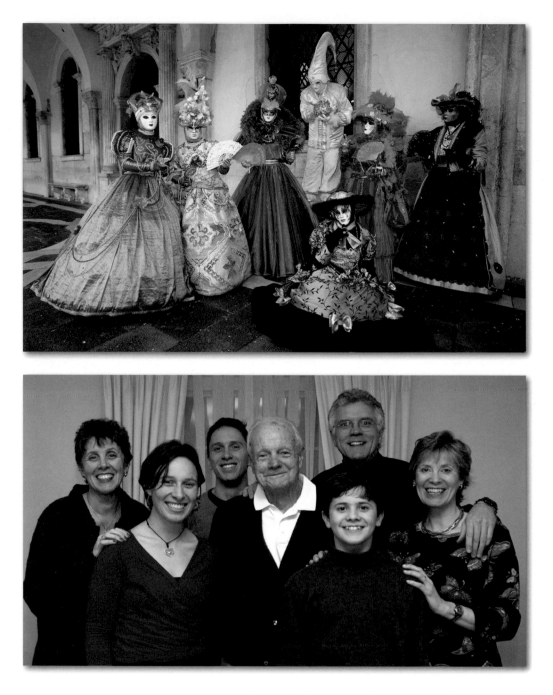

As I took these group shots, I knew that the mood, emotion, and energy that I projected would be reflected in my subjects' faces, and their eyes.

Keep that photo adage in mind, and you'll get a higher percentage of group photo "keepers."

Take Advantage of Backlight

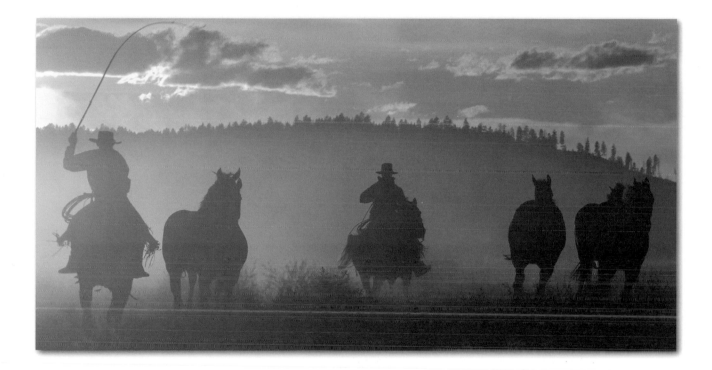

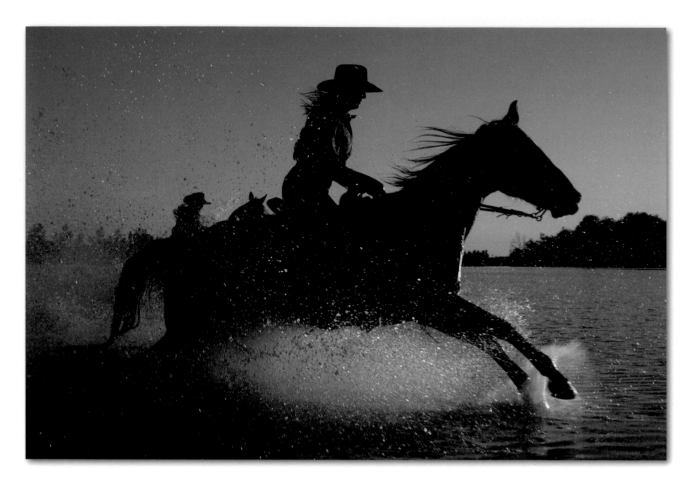

Here's a joke about being a professional fashion photographer. A client asks the pro, "What is your day rate?" The pro responds, "Well, it's $5,000 a day, but if you want me to shoot into the sun, it's $7,500 a day."

What the pro is saying is that it's harder to get a good exposure when shooting into the sun, and that he or she has to work hard to control the light—with reflectors, with flashes, and after the shoot in Photoshop—in order to see the subject.

Earlier in this book, in Lessons 22 and 25, we explored how to use reflectors and a flash to control the light outdoors so that we can see the subject's face. However, there are times when we can take advantage of backlight and actually have fun with

it. That's what I was doing when I took the shot of a cowgirl riding at sunset at the Double JJ Ranch in Rothbury, Michigan.

For this picture, I set my camera on the shutter priority mode and set the exposure compensation to –1. By underexposing the image, the color became more saturated and the silhouette more dramatic.

When you are shooting a silhouette, try underexposing the scene. However, keep in mind that digital noise shows up more in underexposed areas (especially in shadow areas), so you don't want to underexpose the scene too much, probably not more than one f/stop.

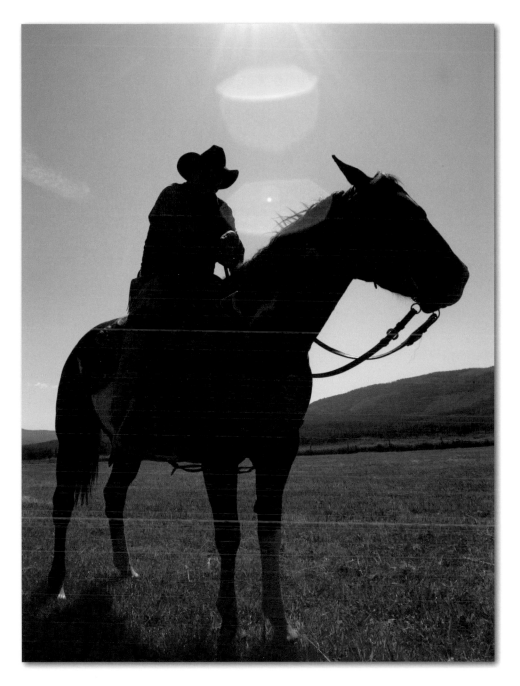

When you are shooting into the sun, one of the main challenges is to avoid lens flare—direct light hitting the front element of the lens (or filter) for undesirable effects. At its worst, lens flare looks like this: a big white spot in your image.

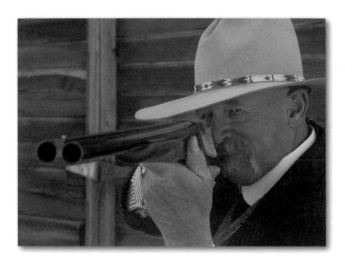

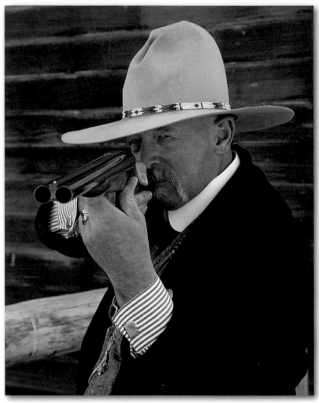

Sometimes lens flare is not immediately noticeable when you are framing a subject but can have a drastic effect nonetheless. I photographed this "sheriff" at one of my workshops in Montana. In the photo tat the top, direct light was hitting the lens, which reduced the contrast in the scene and caused the picture to look soft.

Compare the image at right, which was not affected by lens flare, to the image at the top. Notice how the contrast has been improved and how the picture looks sharper. That's because I eliminated

the lens flare by asking a nearby cowboy to shade my lens with this hat.

Try to avoid lens flare at all costs. Use a lens hood, or shade your lens with your hand or hat—or have a friend shade your lens for you with a hand, hat, piece of cardboard, or other object.

When using a polarizing filter on your lens, a lens hood may not fit. In that case, you'll have to shade your lens manually.

Lens flare is not always a bad thing. The lens flare in this picture, which I took at a nighttime concert in Barbados, actually adds to the mood of the scene.

When you want to take advantage of lens flare on a stage, compose your picture so that the flare does not cover your subject's face.

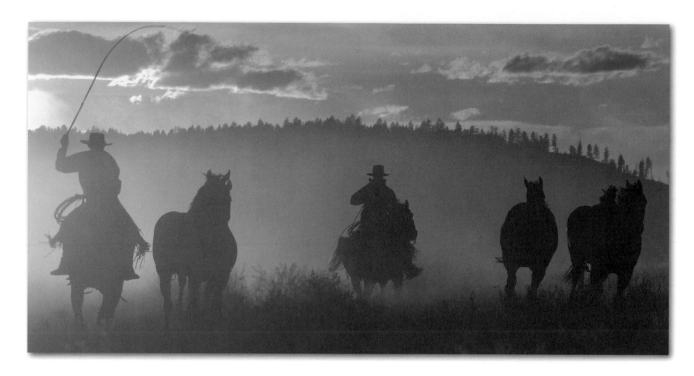

This photograph, which I took at a workshop that I taught at the Ponderosa Ranch in Oregon, is one of my favorite backlight images. The backlight creates a mood and adds drama to the image. This picture and the picture of the cowgirl shown at the beginning of this lesson have something in common: the sun is not in the picture. I composed the images in that manner for two good reasons. One, the bright sun would have created an extremely wide contrast range in the pictures, and the sun would have been grossly exposed or the shadows would have been filled with tons of digital noise—depending on my exposure. Two, as you saw in the cowboy set of pictures in the Introduction to this book, lens flare would have been a serious problem.

When shooting into the sun, as with all your photography, try not to look at the situation as a problem. Rather, see it as a challenge.

Photographing Festivals

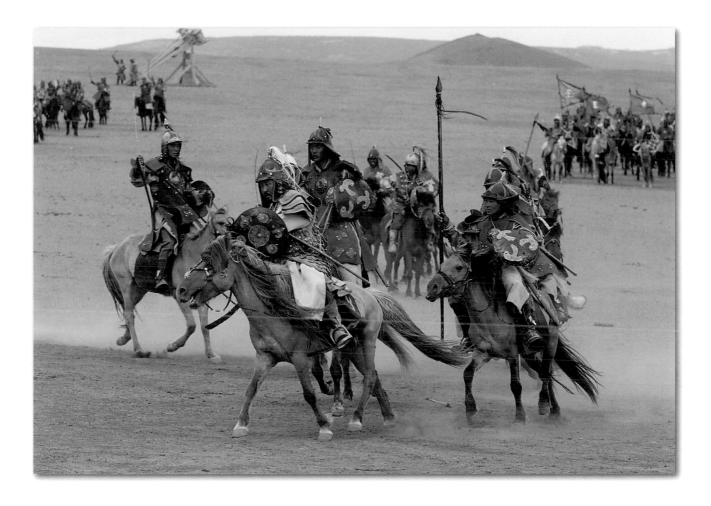

The action, costumes, colors, and performances at festivals, special events, and reenactments make them a ton of fun to attend and photograph. Having fun and taking snapshots is easy.

If you want to turn your snapshots into great shots, however, you have to pay careful attention to everything that is going on around you, as well as realizing the importance of your camera settings and lens choice. After all, you may get only one chance to photograph the event.

That was the case for the Chingis (whom we used to call Genghis) Khan Cavalry Ride performance in 2007 in Mongolia. Sure, I had great fun and worked hard to get good pictures. But going back to the other side of the planet (a two-day trip) for this yearly event is not in the near future for me.

If seeing 500 real-life Mongolian soldiers outfitted like Mongolian soldiers of 800 years ago charging into battle is not in your future, don't retreat from reading this lesson. You'll find tips here that will help you take command and charge right into taking pictures at festivals close to home.

Ready to go? Let's ride!

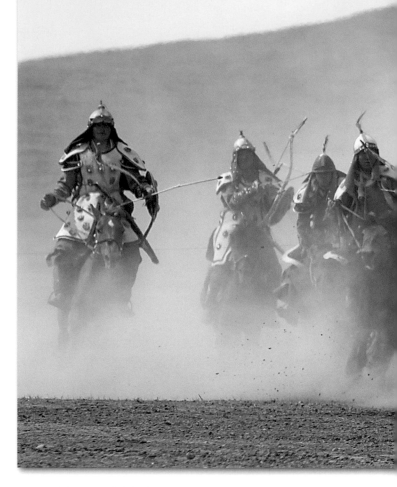

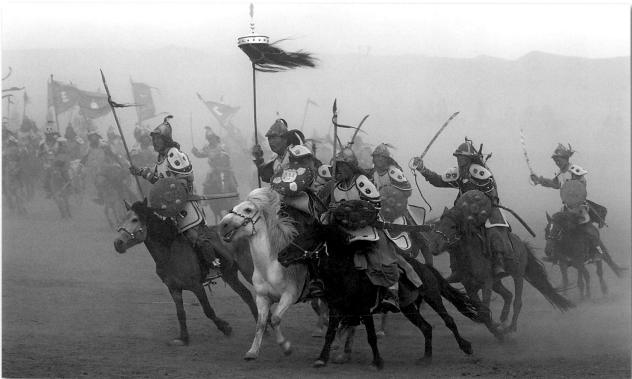

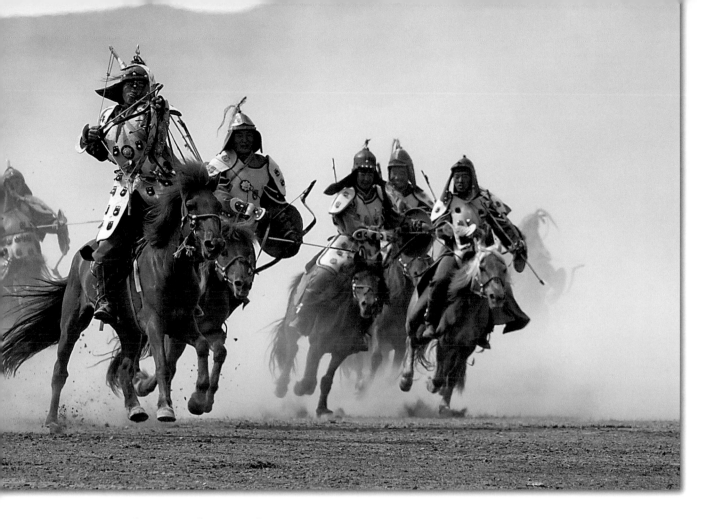

Make a Plan, Choose a Location

Before you start shooting, you need to make a plan of what you want to photograph and where you need to be to get the best possible shots. If feasible, before you get on-site, contact the festival organizers and ask questions about the event, including the types of activities and number of performers, a timetable of activities, and access to the field or arena (which may be restricted, as it was for me in Mongolia).

Of utmost importance is to ask about the direction (north, south, east, or west) in which performers may be positioned. On an overcast day, that may not matter too much. On a sunny day, however, that information will help you to choose a position. In most cases, you'll want the sun at your back, so your subjects' faces will be illuminated.

Here's another tip about lighting: the night before the event, pray for an overcast sky so that you don't have to deal with strong shadows and highlights.

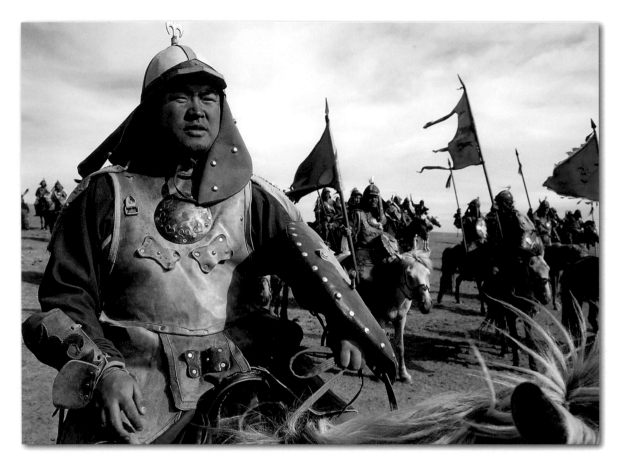

Important Camera Settings

Fast-paced action, moving subjects, and unexpected maneuvers require point-and-shoot photography. No! I am not suggesting that you put your camera on Program and point and shoot, by any means. What I am suggesting is that you know how to adjust your camera settings in an instant, maybe without even looking at the camera, so that you can basically point and shoot and not miss a shot. If you can't do that, you may want to practice on your living room couch until you can.

To stop fast-paced action, you'll need a shutter speed of at least 1/500 of a second. You can keep that shutter speed constant if you choose the Tv (shutter priority) mode. In that mode, even if the light level changes the shutter speed remains the same (while the f-stop changes).

Using high shutter speeds means using higher ISO settings, if you don't have a fast (f/2.8) lens or when you are shooting on an overcast day or in low light. I took all the pictures at the Mongolian festival with my ISO set at 400. If it had been bright and sunny, I would have set my ISO to 100, because I always choose the lowest possible ISO setting for the existing lighting conditions. By doing that, I get the cleanest possible image, that is, a picture with the least amount of digital noise.

A high ISO setting lets you use a smaller aperture than a low ISO setting. The smaller aperture provides good depth of field, so you have a better chance of getting subjects in front of and behind the main subject (your focus point) in focus.

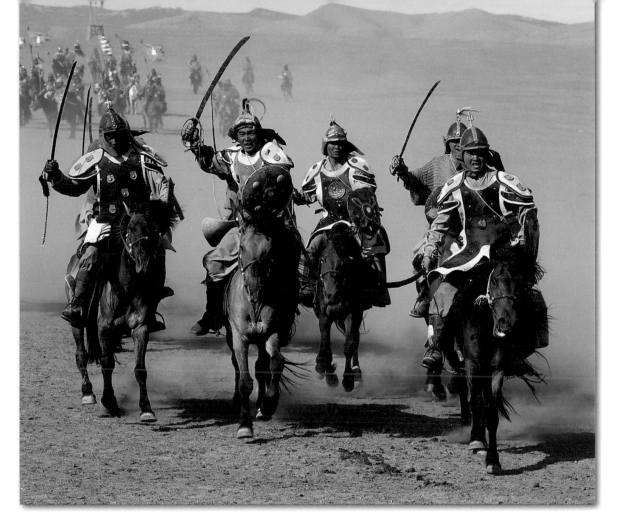

When it comes to the image quality setting, I recommend shooting RAW files. With a RAW file, you can recover up to one stop of an overexposed area. With a JPEG file, overexposed highlights are much harder, if not impossible, to recover. If you do shoot JPEGs, bracket your exposures to make sure you have at least one good exposure.

The focus mode you choose is also important. When photographing moving subjects, the AI Servo mode (Continuous Focus on some cameras) tracks a moving subject right up to the exact moment of exposure—helping to ensure a sharp shot. For stationary subjects, you can switch to the one-shot AF mode, which locks the focus on the subject and will not let you take a picture unless the subject is in focus.

For capturing action sequences, such as when capturing the peak of action during an event, set your camera on rapid frame advance and take several shots.

Key Zoom Lenses

When you shoot a festival, I suggest using two Canon camera bodies, one on each shoulder: one with a wide-angle zoom (Canon 17-40mm) and one with a telephoto zoom (Canon 70-200mm IS or Canon 100-400mm IS). With those lenses, you can get wide-angle and telephoto shots of the performers. If you want to "get closer" to your subjects, pack a 1.4X or 2X teleconverter.

If you have only one camera, be super careful when changing lenses. Dust and other particles love to jump into open cameras and stick to the filter that's over the image sensor, resulting in marks in the final images. With that in mind, bring a blower or other sensor cleaning device to clean the filter.

As you can see, dust was the real enemy during the Mongolian festival. That's why I never changed lenses. I used my 70-200mm for this event, and set it at 200mm to take the picture shown above.

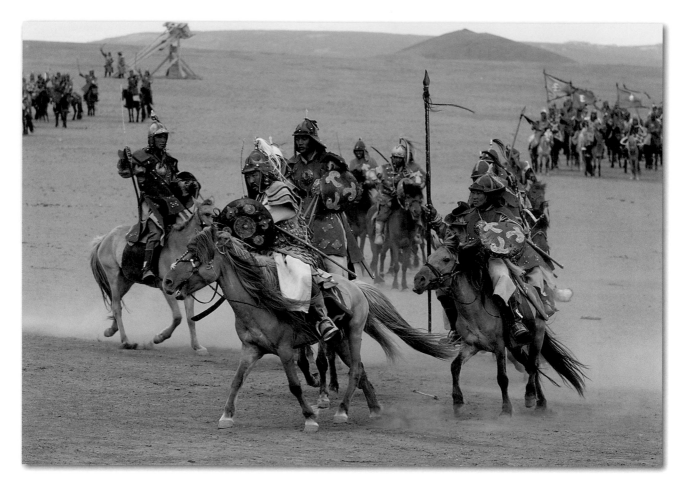

Be Aware of the Background

Check out the group of warriors in the background of this image. As you can see, they are not intruding into the space of the foreground warriors. That separation enables the foreground warriors to stand out and not get lost in the scene.

Therefore, this photograph is the result of careful composition, watching the background carefully, choosing a wide aperture (f/5.6) to blur the background, and shooting at exactly the right moment.

Be aware of the background when you shoot. It can make or break a shot, and it's just as important as the main subject.

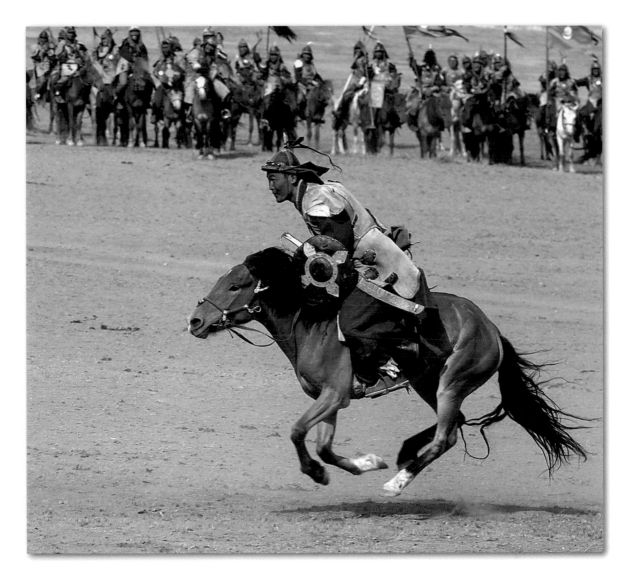

Set Goals

Before you take your first shot, try to set goals for your shoot. Of course, as the event progresses, you can change your goals. If you have a certain set of goals, you'll know what pictures you really want to take.

At the Mongolian festival, I wanted to get the one shot that every professional horse photographer (I am not one of them) wants to get: a shot of a horse with all four hooves off the ground. So, I kept my

eyes open for that opportunity, and following the tips I offered earlier for capturing fast-paced action, I got the shot.

As an aside, here's a "setting goals" story: during one of my workshops, I asked one of the participants what his goal was. He said, "I want to take 700 pictures a day." I replied, "I want to take three good pictures a day." My point: think carefully about what you want to shoot and how you need to shoot, and don't shoot haphazardly.

Tell the Whole Story

Wherever you go, whether to a local festival or on safari in Africa, try to "tell the whole story" with your pictures. So, in addition to taking action shots at a festival, take portraits, such as this portrait of one of the "warriors."

Tell the whole story with a diversity of shots, and your web galleries, photo books, and slide shows will be more interesting than if you have pictures that all look the same.

For portraits, you may want to shoot with a flash to fill in shadows on a subject's face, as I did for this portrait. A diffuser (to soften shadows on a sunny day) and a reflector (to bounce light onto the face of a subject that is backlit) are also useful accessories.

In addition to taking posed portraits, close-ups of details—the man's sword, hands, and armor in this case—can also help to tell the story of the event.

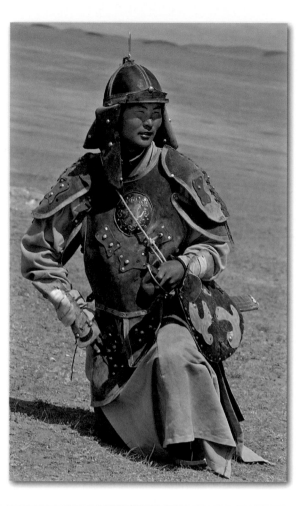

Have Fun and Be Courteous

Hey, don't forget to have fun at the festival! Sure, do your best to get great shots, but if you have fun and enjoy the moment, my guess is that you'll get better shots than if you are stressed out over an ISO setting!

Also, be mindful of other serious photographers and attendees at the event. You don't want to get in their way and ruin their shots just for the sake of a picture.

Speaking of fun, the Mongolian festival was a blast. I have fun wherever I go. Here I am wearing a warrior's outfit—and joining the party, so to speak.

Below is an example of another real fun shot: a Mongolian warrior using his cell phone, perhaps checking in on the latest battle plan.

Follow these tips and you'll have all the "ammo" you need to come away with winning images from a festival.

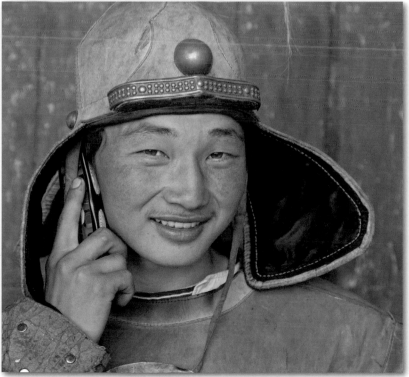

Creating a Sense of Depth

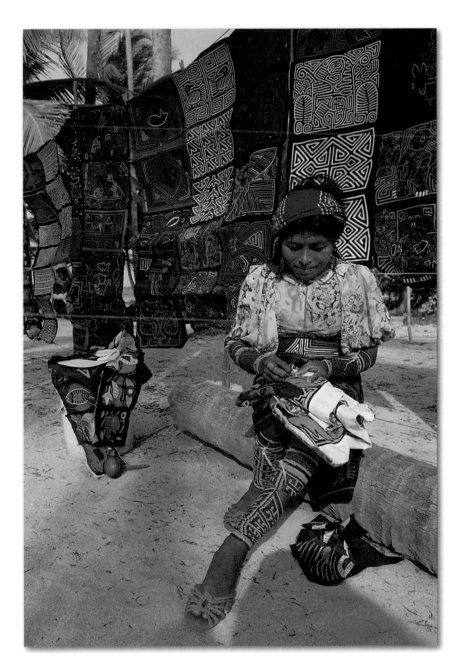

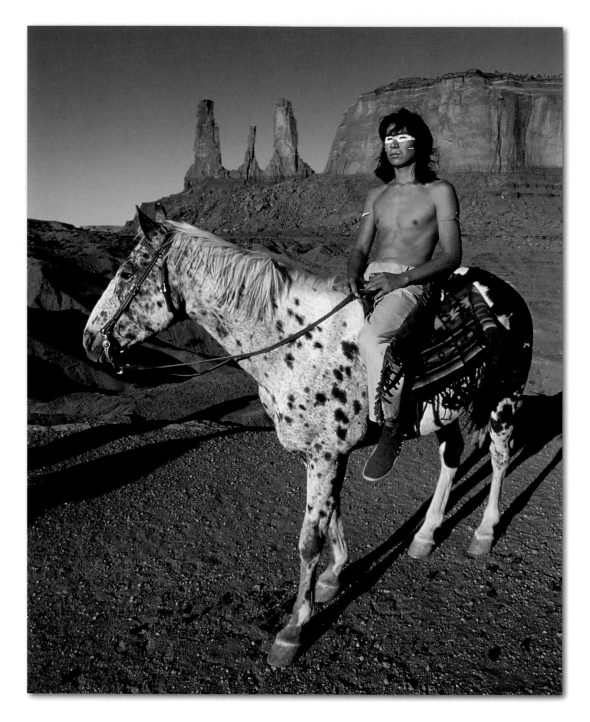

We see the world in three dimensions: height, width, and depth. Our cameras see only two: height and width. One of your goals as a photographer is to try to create a sense of depth in your photographs—when possible and when desirable.

This lesson's opening shot, which I took in Monument Valley, has a great sense of depth, for two reasons. One, I used a Canon 24mm wide-angle lens set to a small aperture (f/11) to get everything in the scene—from the close foreground to the distant background—in focus. Two, I took the picture in the early morning when long shadows added a sense of depth to the scene.

This picture, which I took on the Ponderosa Ranch in Oregon, does not have a great sense of depth. That's because I used the 200mm setting on my Canon 100-400mm IS lens and a wide aperture (f4.5) to blur the background.

Compared to the background in the picture on the page 146, the background in this picture was boring. What's more, I wanted the subject to stand out in the scene in this picture. Creating a sense of depth was not my goal when taking this picture.

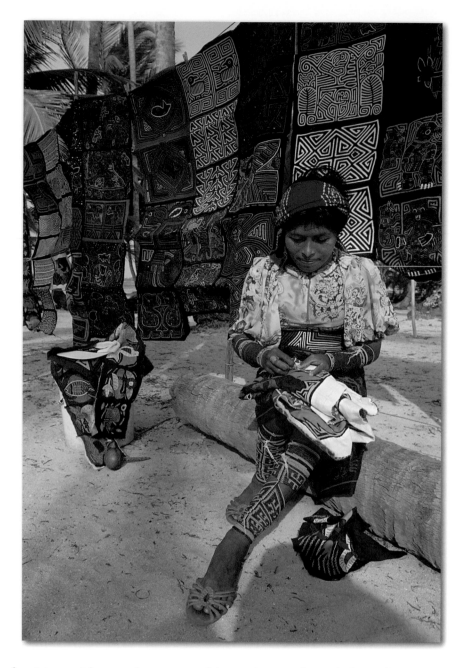

Here is another example of a picture with a good sense of depth. I photographed this woman sewing a mola (layered cotton material used for dresses, shirts, and wall hangings) in Panama. Careful composition, using a wide-angle lens, choosing a small aperture, and choosing a shooting position that let me photograph the subject at an angle, all added to the sense of depth in this photograph.

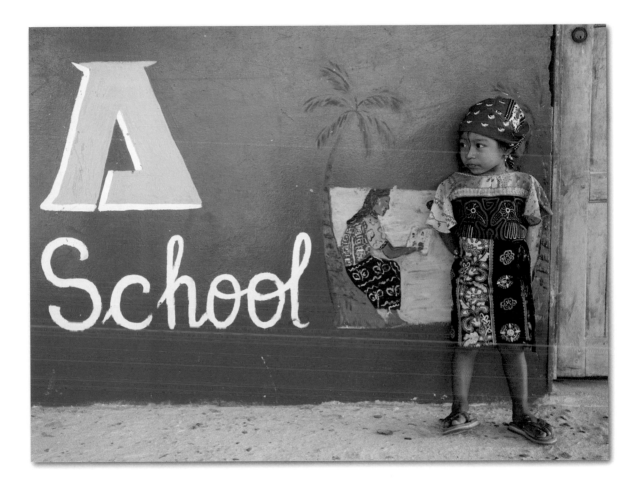

This picture, which I also took in Panama, has no sense of depth. The subject and the background are in the same plane. Sure, I could have photographed the scene on an angle for a greater sense of depth. However, I liked the way the background and subject looked when photographed straight on.

Keep in mind that our cameras see differently than we do. And remember that sometimes it's good to create a sense of depth, and other times a "flat" shot is OK. Also keep in mind that telephoto lenses compress the elements in a scene, whereas wide-angle lenses expand them.

Rembrandt Lighting

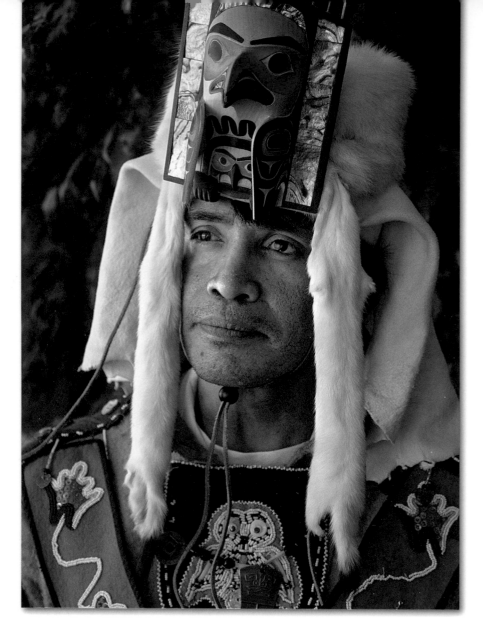

Rembrandt, considered one of the greatest paint-ers of all time, used a simple light source when he created many of his masterpieces: side lighting. That light, created by a huge window in the mas-ter's studio, cast a beautiful, soft quality of light on his subjects.

As the light fell off from one side of a subject's face to the other, ratio lighting (the difference between one light level and another, such as 1:2 or 1:3) was created, and that added a sense of depth and di-mension to Rembrandt's paintings.

You can use side lighting to create your own mas-terful portraits. All you need is an open window or a door to use as your light source.

While on an Alaskan cruise, I used the light from a large window in the ship's lounge as my light source for this portrait of David Ramos, a native Alaskan, who was giving a lecture on the history of Alaska natives. Looking at the picture from your left to right, you can see the light falloff that creates the Rembrandt lighting.

Because I positioned David close to the window (about 3 feet from the glass), and because it was a sunny day, the light was fairly strong, revealing all the details in David's face and his headgear.

For a softer lighting effect, you can position the subject farther away from the window or door. That distance diffuses the light for a softer effect.

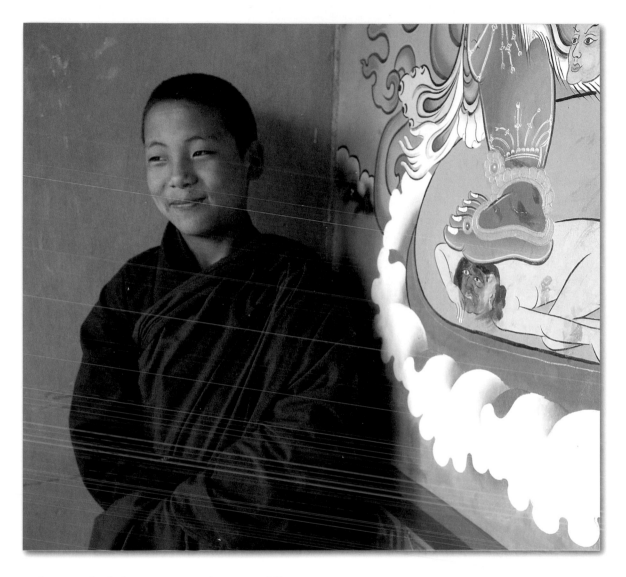

I photographed this young monk in a Buddhist temple in Bhutan. The soft lighting effect was created because he is standing about 10 feet from a large door. Overcast days will produce soft side lighting even when a subject is standing close to a window or door.

The photo above is another example of Rembrandt lighting. Once again you can see the light fall off from one side of the frame to the other, in this case from right to left.

I created the portrait of my friend, Lauren, playing guitar in my kitchen, which has floor-to-ceiling windows. I leaned a large, collapsible cloth background against a countertop, moved Lauren into position, and was almost ready to shoot.

As I mentioned in Lesson 24, placing a large piece of black material on the floor eliminates bright reflections that would otherwise create unflattering bottom lighting, sometimes referred to as "Halloween lighting" by professional photographers. Once the material was in place on my kitchen floor, I started my photo session.

As with garage glamour photography, you'll need to pay attention to your ISO, shutter speed, and aperture when shooting in the relatively low-light conditions of indoors.

Shooting Silhouettes

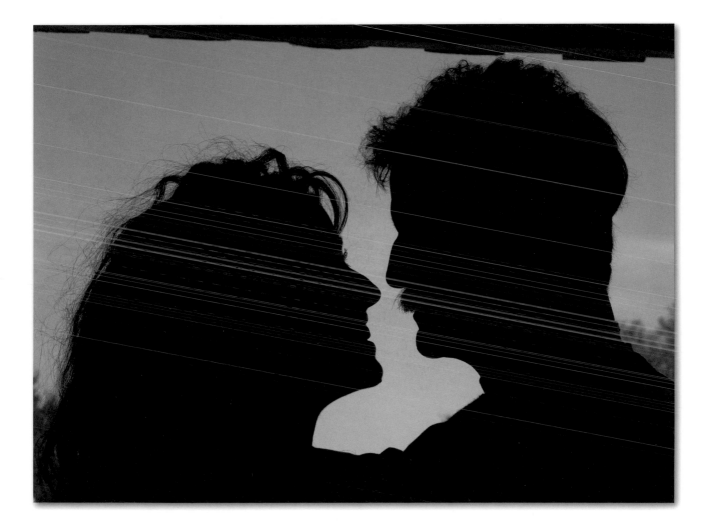

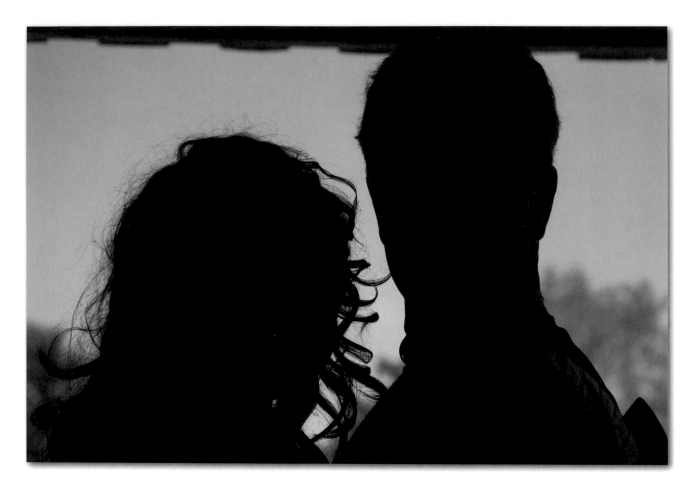

It's fun to look at silhouettes, because without seeing any details in a person's face, we still recognize him or her—if the silhouette shows the person's profile, as is the case with the picture on this lesson's title page, of a Wild West couple that I took in Marrow Bone Springs, Texas.

To get a good profile, several factors come into play. First, you need to select a location in which the subjects are strongly backlit, such as in a doorway or standing in front of a sunrise or sunset.

Also, you want a side view (profile) of the subject or subjects. If the subject or subjects are looking at you, as they are in this photo, you will not be able to tell who the heck is in the picture.

In addition, you need to see a clean profile, that is, you don't want any distracting elements behind the subject. In this lesson's opening shot, you see I have a clear, blue-sky background.

Finally, you want the subject or subjects to be completely silhouetted. Here's how you can do that. Set your camera on the manual exposure mode and set the exposure for the background. Because the subjects are backlit, they will be underexposed. For a more dramatic silhouette, try using the exposure compensation dial on your camera, and reduce the exposure by one f-stop.

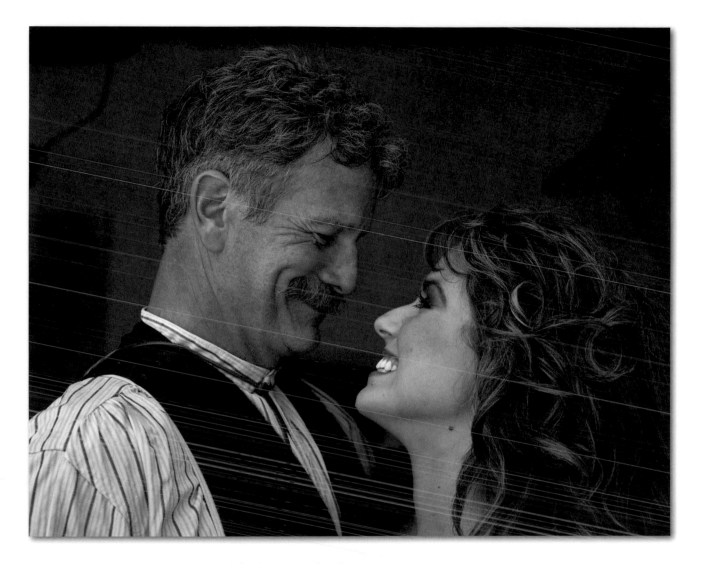

Here is the same good-looking couple photo-
graphed from the opposite side from where I
took the silhouettes. It's a nice shot, but not that
creative.

So, the next time you are in a situation in which
a silhouette is a possibility, perhaps at your front
door or at the doors to a church at a wedding, try
making one. My guess is that your subject will
think that you have an artistic flair.

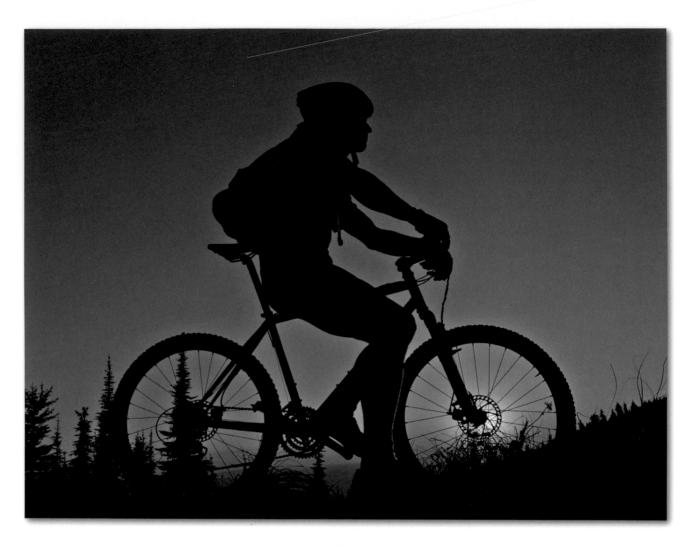

Of course, you can take silhouettes outdoors, too. You'll need to shoot at sunrise or sunset. And you'll need to place the sun behind your subject, as I did when I photographed this mountain biker on a mountaintop in Montana.

Basic Flash Techniques

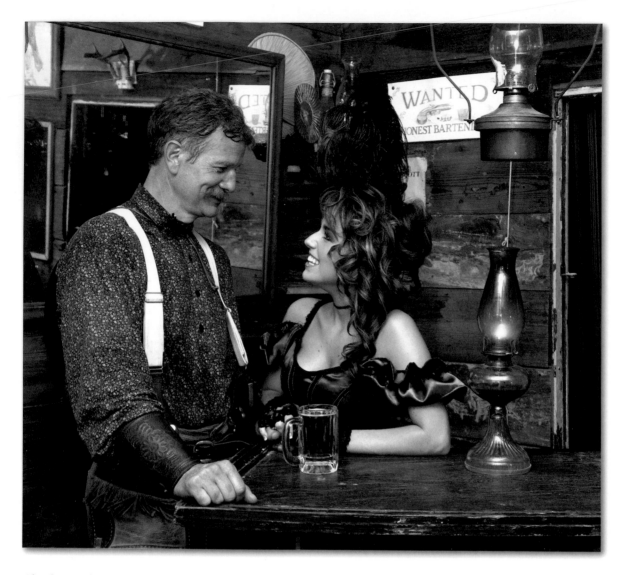

Check out this shot of a Wild West couple that I took in a saloon in Marrow Bone Springs, Texas. Notice the soft and even, natural-looking lighting. Even though I used a flash to take the picture in the extremely dark room, which was illuminated only by the two oil lamps, it does not look like a flash picture, that is, one with harsh lighting and strong shadows. That's because in that situation, as in all my indoor flash photography situations, I strove for natural-looking shots. I do that using one of the following basic flash techniques.

To help illustrate the techniques that I use—and that you can use—to get professional-looking flash pictures I enlisted the help of my son, Marco, who is shown in the following pictures holding the camera/flash setup in various good/bad positions.

In the opening picture, I softened and diffused the direct, harsh light from the flash by attaching a LumiQuest UltraBounce to my flash (with supplied Velcro). I swiveled the flash head upward so that most of the light bounced off the ceiling and just a bit of the direct/diffused light from the flash fell on the subjects. The concept here is to turn a small light source (the flash head) into a much larger, and therefore softer, light source (the ceiling). So, in effect, the ceiling is the main light source in the opening image.

Tilting your flash up without a bounce accessory is also an option. However, using the UltraBounce spreads out the light more evenly.

As you can see in these photos of Marco, the flash is mounted on a Stroboframe flash bracket and is attached to the camera via a coil cord. The bracket offers two advantages. One, it reduces redeye by moving the flash away from the lens. Two, it places any shadows behind the subject for both horizontal and vertical pictures, because the bracket has a swivel mount, so you can always shoot with the flash above the lens.

Using a diffuser (as well as the softbox and diffuser shown in the middle photo of Marco) and bouncing the light off the ceiling reduces the effective range of a flash. However, you can get back that range, or expand the range of a flash, by boosting the ISO setting—because you make the camera's image sensor more sensitive to light. So, the higher the ISO setting, the farther the flash will effectively travel.

Using a diffuser and bouncing the light off the ceiling does not affect the automatic metering systems of the camera and flash, so you can still shoot in an automatic mode.

Not all flash units offer swivel heads. If you are serious about your indoor flash photography, make sure you get a swivel head flash.

If you are shooting with a flash in a room in which the ceiling is too high (or so dark that there would be little bounced light), you can attach a softbox (such as the LumiQuest Softbox shown in the middle photo) to your flash for soft and flattering light.

Another way to spread/diffuse and soften the light is to attach a flash bounce (such as the Lumi-Quest 80-20 shown in the photo on the right) to your flash. Different color inserts are available for different qualities and colors of light. Gold metallic (as shown) produces strong, warm light; silver metallic produces strong, cool light; and white produces a very soft, cool light.

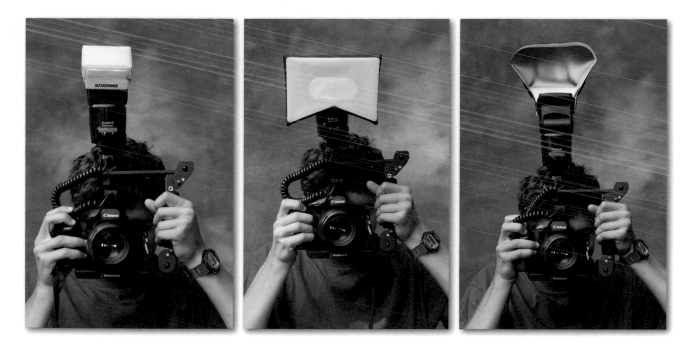

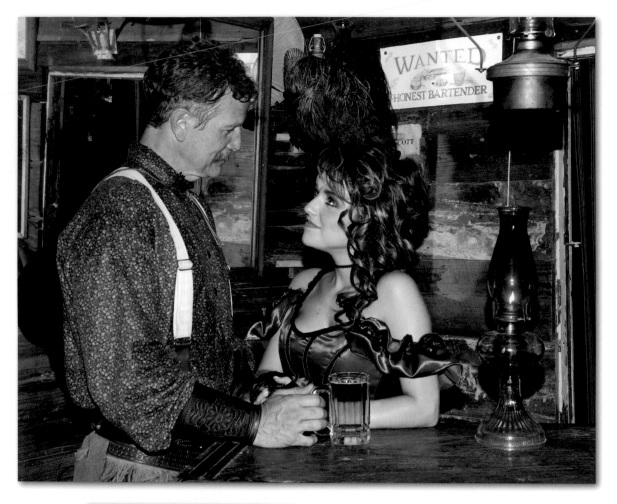

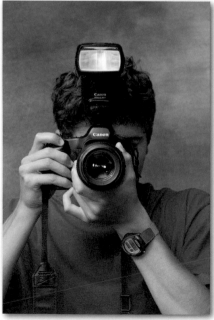

Here's a picture of our Wild West couple taken with the flash mounted directly on the camera. Notice the strong shadows and the harsh lighting.

For that harsh shot, I held my camera the way Marco is holding it in this picture.

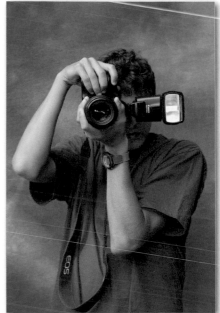

What's wrong with this picture, taken in my studio of my friend, Lauren? That's right! The harsh lighting is unflattering and the shadow makes the picture look very amateurish.

For that harsh shot, I held the camera the way Marco is holding it in this picture.

Compare this picture of a softer Lauren with the previous harsh flash shot. It's much nicer, don't you think?

For the softer Lauren shot, I held my camera the way Marco is holding it in this picture.

To sum up and to reiterate, strive for a natural-looking flash picture—a picture without harsh shadows and lighting that is too strong. Think soft, as I did when I put my camera on a tripod (and bounced the light off the ceiling) for this family photograph.

Practice Makes Perfect

If you are serious about getting good flash pictures (and good lighting kit pictures, which is covered in the next lesson), one fast, easy, affordable, and fun method is to buy a mannequin and to use it as your test subject. With an ever-ready, one-time-fee "model," you'll be able to practice the aforementioned techniques, as well as your own, at your own pace.

Mannequins, which you'll find on the Web by doing a Google search, sell for about $200 each. They never get tired of being photographed! What's more, their position and pose are consistent, so you'll easily learn how moving a flash unit/light—and adding flash units/lights—can make a big difference in your result.

Here are five examples of how I used different flash setups to light my mannequin, who my family came to know affectionately as Kim La Mannequin during this shoot…bad hair day and all!

For each photograph, I used a flash with a large diffuser to soften the light, and I mounted each flash/diffuser on a sturdy stand. I triggered the Canon 580 EX flash units from my camera with a Canon ST-E2 wireless remote control unit that fits into my camera's hot shoe.

In noting the positions of the flash units that I describe in this sidebar, keep in mind that those positions also work for hot light kits, as well as strobe light kits.

For this photo, I positioned one flash unit slightly above eye level, in front of Kim and to my left.

If you were to look at a diagram of this setup from above, and envision the face of a clock, Kim would be in the center of the clock face, I'd be at 6 o'clock, and my flash unit would be at 8 o'clock.

Kim and I were in the same position for the remainder of the pictures in this sidebar.

For this photo, I positioned one flash unit slightly above eye level—in front of Kim and to my left (at 8 o'clock). I positioned a second flash at shoulder level, directly behind Kim, to illuminate the background. That second flash unit provided some separation between Kim and the background, which is why the second light here is often called a separation light.

To light this photo, I positioned two flash units slightly above eye level, in front of Kim, one to my right and the other to my left (at 4 o'clock and at 8 o'clock). I set the flash unit at 8 o'clock at full power and the one at 4 o'clock at 1/3 power, for what's called ratio lighting.

In addition to the two main lights and the separation light, for this photo I added a fourth flash unit, set at 1/4 power, to light Kim's hair. I positioned that flash unit behind Kim and off to my right (at 2 o'clock). You have probably seen this "hair light" effect in movies and in fashion magazines.

Plus, I positioned two flash units slightly above eye level, in front of and above Kim, one to my right and the other to my left (at 4 o'clock and at 8 o'clock). I set one flash unit at full power and the other flash unit at 1/3 power. To get the "movie star" glow around Kim's hair, I swiveled the separation around and pointed it toward Kim's hair.

I hate to close this lesson on flash photography with a poorly lit picture, but I feel that it's important to show you the value of practicing on a dummy before a live subject shows up for a shoot. If you set up your light(s) and envision the result, during the photo session you can concentrate on capturing the subject's expression and emotion, rather than getting bogged down with the technical aspects of picture taking.

Here is the kind of result you'll get if you simply take a portrait with an on-camera flash mounted in the camera's hot shoe. Yuck! Harsh light and bad shadows are two aspects of flash photography that you can avoid with a little practice and know-how. Comparing this picture to the carefully lit pictures of Kim illustrates this point.

I also don't like to end a lesson with a cliché, but practice does, indeed, make perfect. So, get going and have fun practicing!

Using Lighting Kits

Professional portrait, fashion, and glamour photographers spend big bucks on studio lighting equipment that offers total creative control over lighting their subjects.

As a dedicated photo enthusiast, however, you don't necessarily have to break the piggy bank to get professional-quality results. In fact, for about $500 you can get a portable studio lighting kit,

such as the Photo Basic Kit from F.J. Westcott (*http://www.fjwestcott.com*) that you see in this lesson's opening shot.

Most kits include three lights (one light is placed behind the model in the opening picture), umbrellas (shown here) or softboxes (shown later in this lesson) to spread and diffuse the light for a flattering effect, and light stands to support the lights.

You can assemble a portable lighting kit in about 10 minutes (if you work quickly), transforming a den or a living room into a photo studio. For easy toting, the kit folds into a compact case. The case for my kit is about the size and weight of my wooden acoustic guitar case and guitar (20 lbs).

The lights in the opening shot are called "hot lights." The light source is a photoflood light bulb with a standard screw base that provides continuous light, just like the lights in your living room.

Most pros don't use hot lights. They use much more expensive strobe lights that provide a flash burst, just like a camera's flash only much more powerful. The high-power strobe lights let you shoot at low ISO settings for pictures without digital noise. The bright light also lets you shoot at small f-stops for good depth of field.

Hot lights are not as powerful as strobes. They are called hot lights because they get very hot—and so can subjects when positioned close to them. When using hot lights, you need to use a higher ISO setting than when using strobes, which may mean more digital noise in your pictures. In addition, when using hot lights you'll probably need

to use a tripod (or image stabilization or vibration reduction lens) to steady your camera at slow shutter speeds to avoid blurry pictures caused by camera shake. For the hot light pictures that I took for this lesson, even with an ISO setting of 400, my shutter speed was only 1/60 of a second when my f-stop was set at f/5.6.

When using strobes, camera shake is not a problem, because even at a shutter speed of 1/60 of a second, the flash fires at about 1/10,000 of a second to "freeze" any subject or camera movement.

One of the major advantages of hot lights is that you can check shadows and highlights as you move the lights around, toward and away from your subjects. With strobes, you need to wait until after you take the picture to check the results on your camera's LCD monitor—unless the strobes have modeling lights (lights that stay on and illuminate the subject so that the photographer can see where shadows may fall).

When affordable hot light or strobe kits are placed and used correctly, they can give you results that rival those of the pros! Let's take a look at a few examples.

The bottom left picture of my friend Lauren illustrates a classic three-light technique. If you were to look at the lighting setup for this picture from above, the light placement would look like this:

- The main light is positioned at about 4 o'clock to illuminate Lauren's face.

- The fill light is positioned at about 10 o'clock to add a glow to Lauren's hair.

- The background light is positioned at 12 o'clock to light the background.

If you try this setup and the subject's face is too dark, move the main light closer. If the subject's hair is overexposed, move the fill light back a bit. If the background is too dark, move the background light closer to the background. You get the idea.

When it comes to the height of the lights, position the main light and fill light above the subject's eye level, and place the background light a few feet off the floor.

Like all of the portraits in this lesson, I took the bootm-left portrait with my Canon 50mm f/2.5 lens. When working in close quarters and/or in low light, a 50mm f/2.5 lens (or any fast lens) is a good choice.

This portrait of Lauren looks flat compared to the preceding picture. I took it using only one light positioned at about 4 o'clock. As you can see, Lauren's hair is not glowing and there is no separation between Lauren and the background.

 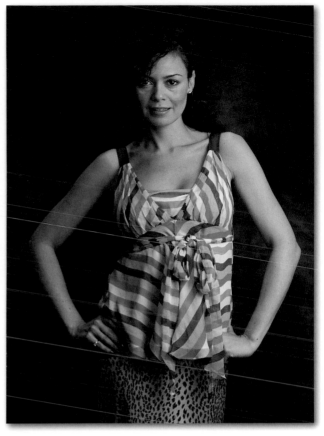

The three-quarter shot of Lauren (above left) uses the aforementioned three-light setup. In this example, however, I moved the 10 o'clock (fill) light slightly closer to Lauren and the 4 o'clock (main) light slightly farther away for a more pronounced back/side light effect. So, in effect, the 10 o'clock light became the main light source. In fashion and glamour photography, and in your portraits, this can be an effective and creative technique.

For this picture of Lauren, I turned off the background light and positioned one light at 4 o'clock and one light at 8 o'clock—I placed the 4 o'clock light a bit closer to the subject than the 8 o'clock light. That positioning produced Rembrandt lighting, which you read about (if you did not skip ahead) in Lesson 33.

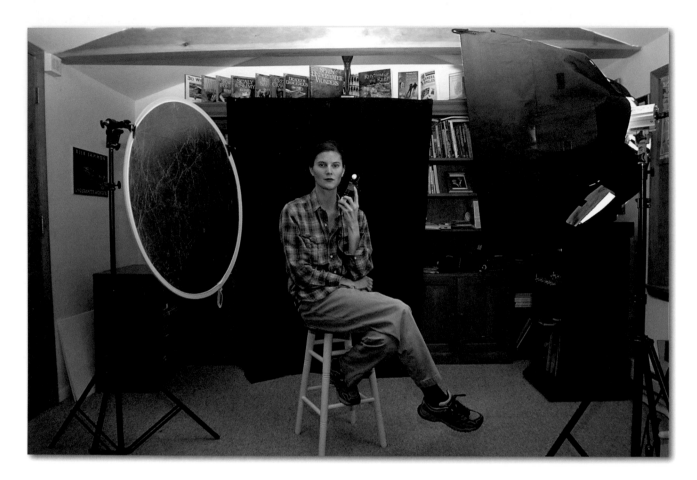

If you are on a tight budget and can afford only one light, here is an idea. Use a reflector on a stand (or have a friend hold the reflector) and position it opposite the one hot light (shown here in a softbox) so that the light bounces onto the other side of the subject's face. You can read more about reflectors in Lesson 22.

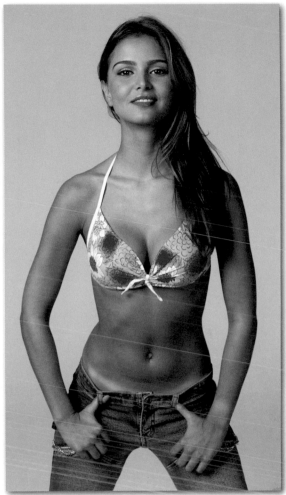

I took this picture of my niece, Brook, with a one-light-and-reflector setup. I used a $9 piece of black cloth as my background. Professional backgrounds, like the ones I used in the preceding pictures, can cost $200 or more.

Getting back to professional photographers, I took this picture of a model in a professional studio. The lighting is OK, but in this example, it's not as creative as the lighting you can get with a basic three-light kit. Sure, I could have created more dramatic lighting. I am simply trying to show you that bigger and more expensive are not always better.

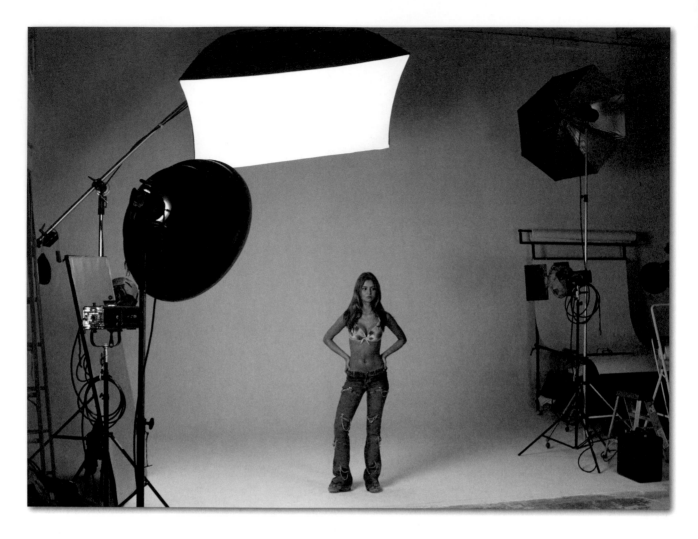

Here's a behind-the-scenes look at the studio in which I photographed my model. You are looking at about $5,000 worth of lighting gear—not to mention the cost of the studio. I'm sharing this picture with you to drive home the point that you don't have to be a pro, or have pro gear, to get professional indoor portraits.

Working with Mirrors

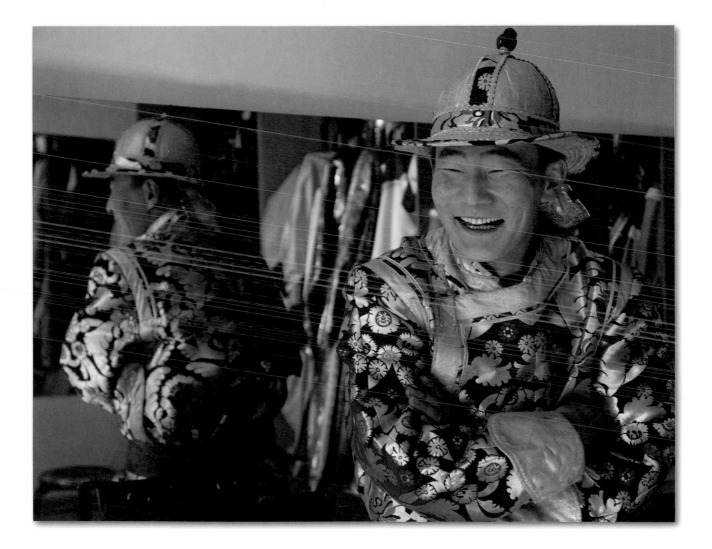

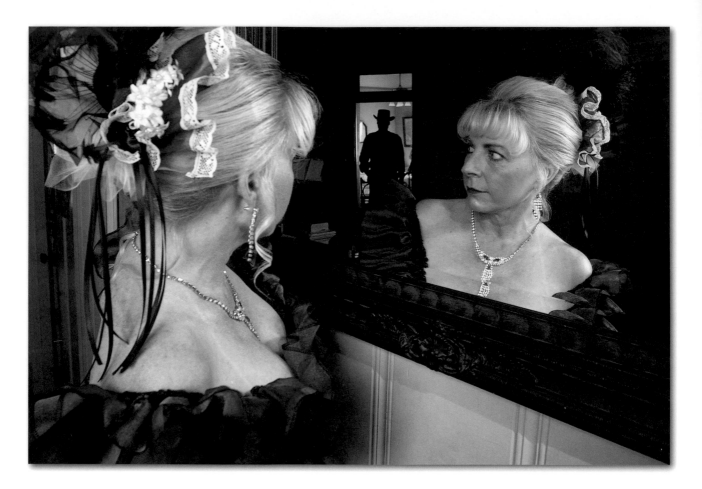

Working with mirrors is fun. By simply photographing a person with his or her reflection, you can create an interesting, artistic, and creative image, one that goes beyond a simple snapshot.

For the above photograph, which I took in Fort Worth, Texas, I had the woman look into the mirror and at a cowboy whom I had asked to pose in the doorway. Looking at the picture, you may wonder what the cowboy is doing in the doorway. As such, even though the cowboy is small in the scene, he plays an important role in telling the story behind this picture. My point: the other elements that are reflected in the mirror can add interest to (or detract from) the message of your picture.

One of the keys to this picture, and to all of the remaining pictures in this lesson, is the lighting. I bounced my on-camera flash off the ceiling to light the woman softly and evenly. I turned off all the other lights in the room and then opened all the shades in the room behind the cowboy to create his silhouette.

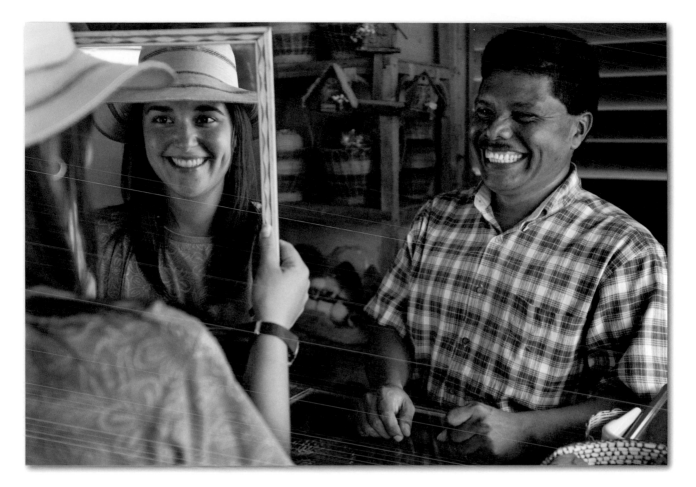

Another important key to mirror photography is to make sure you are not in the picture yourself. That usually means photographing the subject's reflection in the mirror at a 45-degree angle. Before I took this picture in a hat shop in Panama, I had the woman adjust the mirror so that her face filled the mirror and so that I could not be seen.

Getting back to lighting for a moment, this was a tricky shot to light. A large window to the girl's right illuminated the scene. That created a shadow on the right side of the man's face. To fill in the shadow, I had a friend hold a reflector behind the mirror to bounce light onto the man's face to even out the exposure.

When you plan to work with mirrors, be prepared for tricky and low lighting situations and conditions. Be prepared with a flash and a reflector. Also be prepared with a wide-angle zoom lens, because you'll most likely be working in close quarters. Finally, if you shoot at a 45-degree angle, you and your gear will not be in the frame.

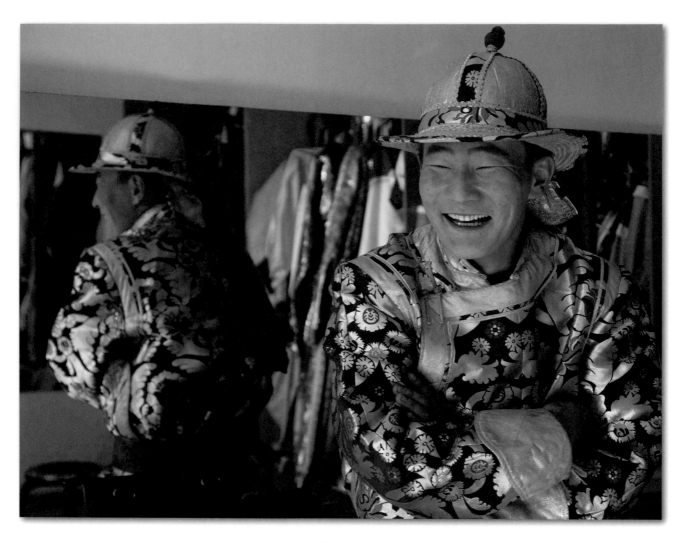

Working with mirrors has another advantage: you can see the front and back of a subject in the same photograph. You may not get to Mongolia to take a picture such as this one of a stage performer in his dressing room, but you may have an opportunity to photograph a bride, who would love to see her smile and the back of her veil in a photograph.

Photographing a Stage Show

I took the pictures for this lesson during a stage performance of the Rising Sun musical and dance troupe in Ulaan Baatar, the capital of Mongolia. However, you can use the same tips and techniques for photographing any stage performance, even one in your neighborhood—because all of the same principles apply.

Basically, photographing a stage show is an exercise in photographing in a low-light, non-flash situation. Available-light, low-light photography dictates using a high ISO setting. For the performance shown in this lesson, I set my ISO at 1000. Bear in mind that the higher the ISO, the more digital noise you'll get in your pictures. But what's worse: a bit of digital noise or a blurry shot caused by shooting at too slow a shutter speed?

Also note that high-end digital SLRs produce images with less noise at the same ISO setting than lower-end digital SLRs. What's more, different digital SLRs reduce noise differently (some on the image sensor and some in the image processor), as well as to a greater or lesser degree. You can learn more about digital noise by doing a web search on different digital SLR cameras.

Most digital SLRs offer the added option of reducing the noise in-camera (usually a custom function). Reducing the noise in-camera slows down the in-camera processing speed of an image (sometimes up to a few seconds), and may prevent you from taking a rapid action sequence. Still, if digital noise bothers you, it's a good idea to reduce it in-camera.

Digital noise shows up more in shadow areas than it does in highlight areas. So, even in low-light conditions, a brightly lit subject may not show a lot of noise.

Before moving on, keep in mind that you can also reduce the amount of digital noise in an image in Adobe Camera RAW (Detail tab→Noise Reduction), in Photoshop (Filter→Noise→Reduce Noise), and in Photoshop plug-ins such as Nik Software's Dfine (*http://www.niksoftware.com*). If you reduce noise I recommend it as an early step in image processing (as opposed to doing it as the final step, which should be sharpening). If you push the sliders in these noise-reducing applications to the max, you'll surely reduce the noise, but your picture will look soft. So, keep sharpness in mind when reducing noise.

And speaking of image processing, you'll probably need to sharpen your on-stage images, because stage lighting is usually soft and flattering. You should sharpen your images as the final step, because other adjustments you make (such as levels and contrast) also sharpen a picture, and you don't want to oversharpen an image.

Other low-light stage photography basics include the following:

- Use a fast lens (f/2.8) or image stabilization lens so that you can shoot at a shutter speed that will prevent blurry pictures caused by camera shake. With a non-image-stabilization lens, you should not use a shutter speed slower than the focal length of the lens; that is, don't use a shutter speed slower than 1/100 of a second when using a 100mm setting on a zoom lens. With an image stabilization lens, you can usually shoot at several shutter speeds below that recommendation. In fact, I took the stage shots in this lesson with my Canon 70-200mm f/4 IS lens—which is not considered a fast lens—using a shutter speed of 1/60 of a second, usually with the lens set at 150mm to 200mm.

- Use a wide-angle zoom for full-stage shots and a telephoto zoom for close-ups.

- Also consider using a monpod or tripod. But if you do, turn off the image stabilization feature on your lens. If you don't, the focusing mechanism will "jump around" during focus and you may miss a shot.

Enough tech talk already! Let's get to some shooting techniques.

Get Behind the Scenes

Hey, if I can talk my way into a dressing room in Mongolia, you can surely get behind the scenes and get some great setup shots. This behind-the-scenes shot helps to tell the story of the performance. Plus, it's so much fun photographing performers getting ready for the show.

Work with Mirrors

Behind-the-scenes stage photography sometimes involves working with mirrors. You can get very interesting images by shooting into a mirror. Here are two key things to remember. One, make sure your own reflection is not in the mirror; two, make sure no distracting elements are reflected in the mirror.

Choose a Location

More often than not, you'll be locked into a shooting location/seat, as I was when taking this photo. Therefore, it's important to choose your position carefully. Whenever possible, ask a per- former or the stage manager what will happen on stage. Try to plan your shots in advance. Also try to avoid microphones and their stands blocking your subjects.

See the Light

Stage lighting can be tricky. Even though the lighting may look even to your eyes, chances are that the subject or subjects will be spot-lit at some point, such as the dancer with the mask in this photograph. The key here is to see the overall light, the bright and dark areas of a scene, and expose for the spot-lit subject. There are two easy ways to achieve that goal.

First, if your camera has a spot meter, you can choose that metering mode and, using the exposure lock on your camera, lock in the exposure on the subject. Second, you can set your camera on average metering and, knowing that the subject is brighter than the surrounding area (if it does not fill the frame), use your camera's exposure compensation function to reduce the exposure, maybe by one more stop. For this photograph, I set my camera on the Av (aperture priority) mode and set the exposure compensation at −1.

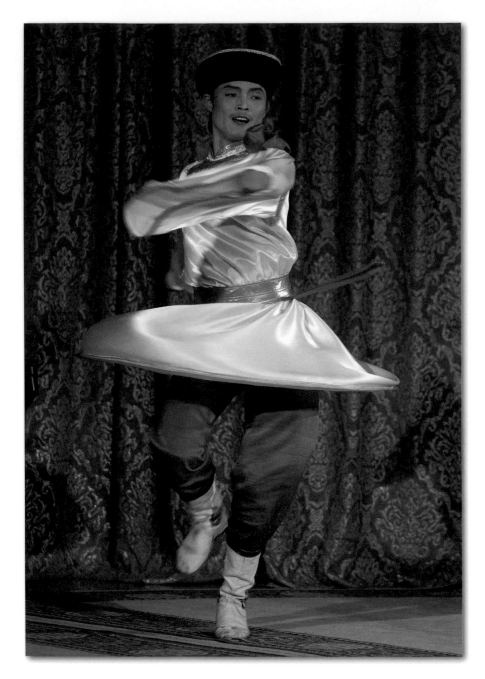

See the Color of Light

In addition to seeing the different light levels on stage, you need to deal with how spotlights affect the color of the performers. The color of light can change from scene to scene, which would mean that if you wanted 100% accurate color, you'd have to set the white balance on your camera manually for each scene, which for most people, including me, is impractical. So, although I rarely recommend using the automatic white balance setting, it's a good choice for stage shooting.

Of course, you can change the color of your image in Photoshop or in your RAW processing program—warming up or cooling off a picture to your liking.

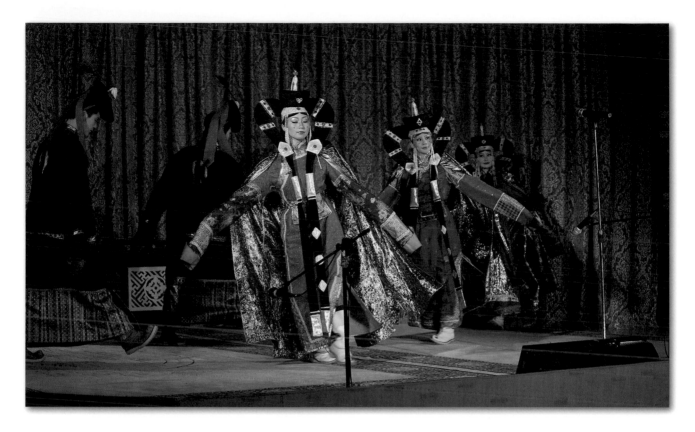

Separate the Subjects

In photography, as in life, timing is everything. When several performers are on stage, it's important to have some separation between them so that they don't get "lost" in each other. Setting your camera on rapid frame advance, anticipating where a subject or subjects will be, and taking lots of pictures helps, as does shooting at exactly the right moment.

I'd like to leave you with a final tip. Most people go to a performance to enjoy the show. Try your hardest to be unobtrusive. Otherwise, like a bad performer, you may get booed!

Create a Beautiful
Black-and-White Image

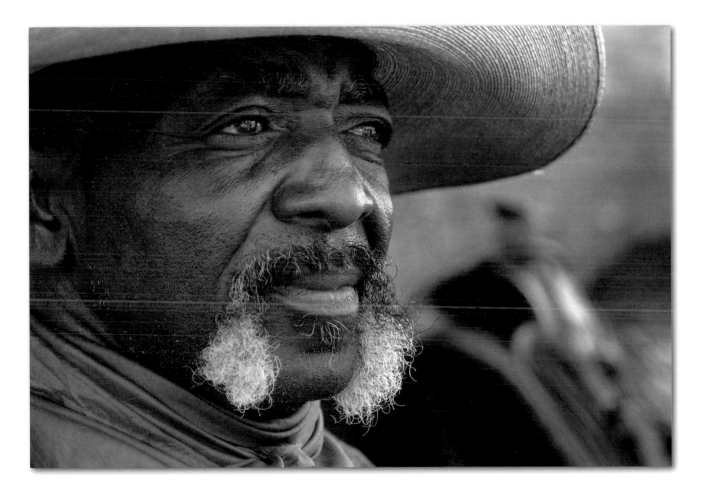

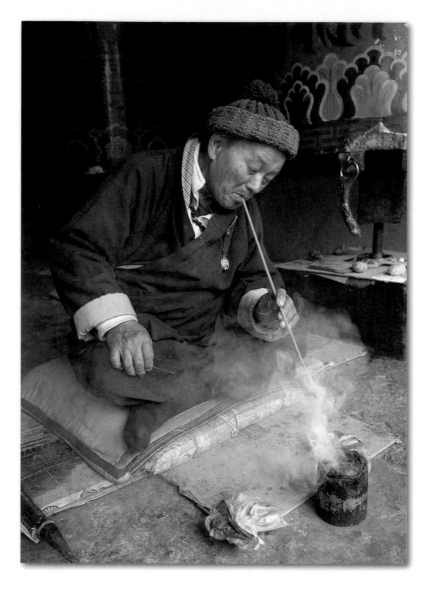

When you remove the color from an image and create a black-and-white image, you remove some of the reality from the scene. Removing some of the reality can create a more artistic image. What's more, a black-and-white image can, but not always, have more impact and look more dramatic than a color photograph.

In Photoshop CS3, it's easy to create a beautiful black-and-white image.

In this lesson, I discuss techniques for creating a black-and-white image from a color file, and more! To illustrate these techniques, I'll use a picture of a holy man whom I photographed in the Kingdom of Bhutan.

I used Adjustment Layers (Layer→New Adjustment Layer) for my enhancements, as I recommend to all my workshop students when making adjustments. However, to save time and to save having to write Layer→New Adjustment Layer for each adjustment, I will go right to the Adjustment.

Let's go.

The photo above is the original image. Sure, I like the saturated colors. However, as I do with all of my favorite images, I experimented with black-and-white imaging for creative possibilities.

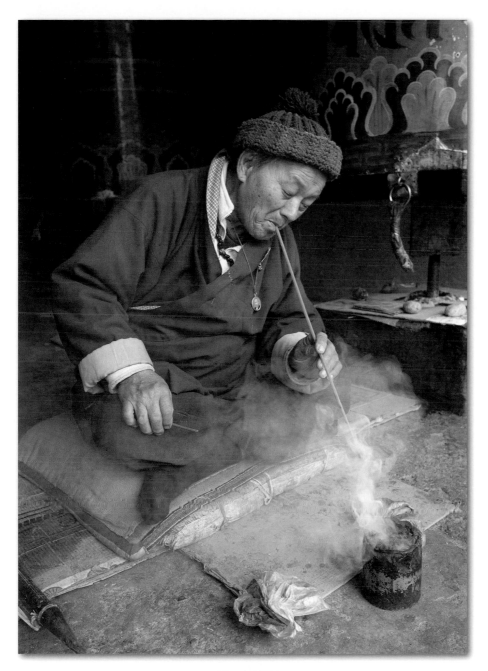

Hue/Saturation

Edit: Master

Hue: 0

Saturation: −74

Lightness: 0

OK
Cancel
Load...
Save...

Colorize
Preview

Subtle colors are the opposite of saturated colors—the kinds of colors we used to get when shooting super-saturated films. For a softer, subtler image, I used the Hue/Saturation adjustment in Photoshop CS3 and moved the Saturation slider almost all the way to the left.

As you can see, I still have a color photograph, but the less-intense colors produce a softer image.

With my full-color image opened once again, I used the Black and White adjustment and adjusted the sliders, one for each tone/channel, until I was pleased with what I saw. Experiment with these sliders. They give you total control over the color channels in your image. That's unlike using Mode→Grayscale, which changes all the channels in one fell swoop!

Even with all those channel sliders at my fingertips, I felt that the image looked a bit flat. So, I boosted the contrast using the Brightness/Contrast adjustment. You'll find that, by boosting the contrast of your low-contrast images, such as the one I am sharing in this lesson, your pictures will look stronger and brighter.

Here's the black-and-white version of my color image after applying all of the aforementioned adjustments.

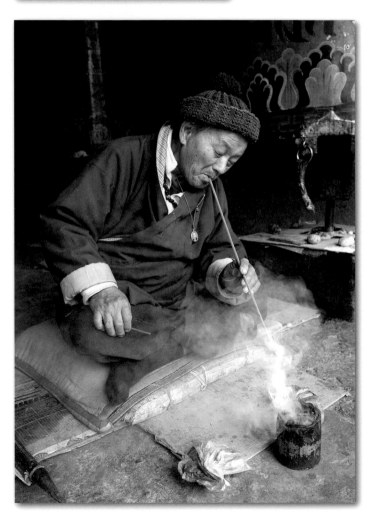

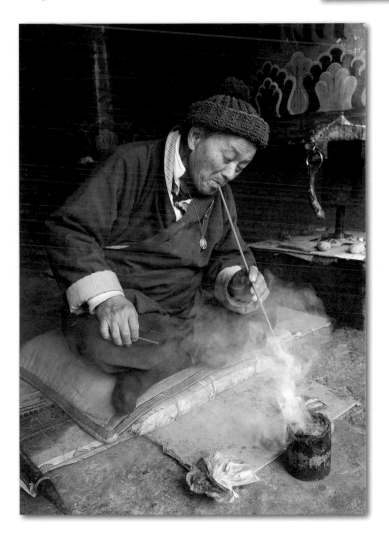

Other creative enhancements are available to you in the Black and White dialog box. Click on the Tint box and you can change the hue and saturation of the image.

After checking the Tint box, I played around with the Saturation slider to create this sepia tone image.

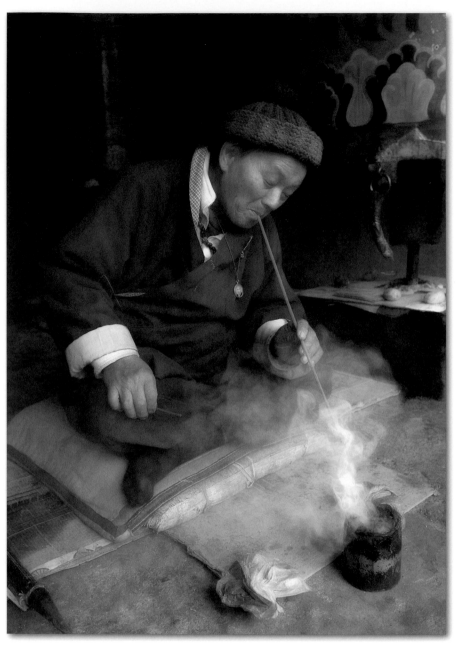

Photoshop also offers Image Effects—as Actions—to enhance your images.

However, upon opening the Actions palette, you will not see any Image Effects. You need to load them. That's simple; click on the small fly-out arrow at the top right of the Actions window. That opens a window in which Image Effects, along with other add-on Actions, are displayed. Simply click on Image Effects and they will now be listed, below your preloaded Actions.

Here is how the Aged Photo Action effect enhanced my full-color image of the holy man.

I encourage you to experiment with black-and-white photography. Not only can you see beautiful images on your monitor and showcase them in your website and web galleries, but with today's ink jet printers, you also can make beautiful prints.

The Renaissance Painter Effect

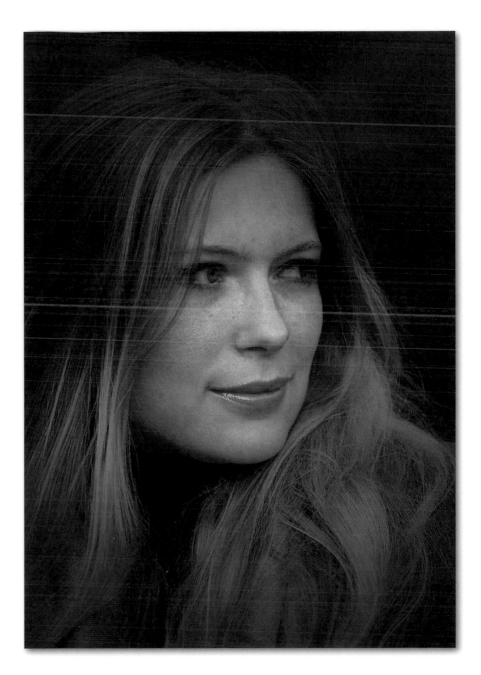

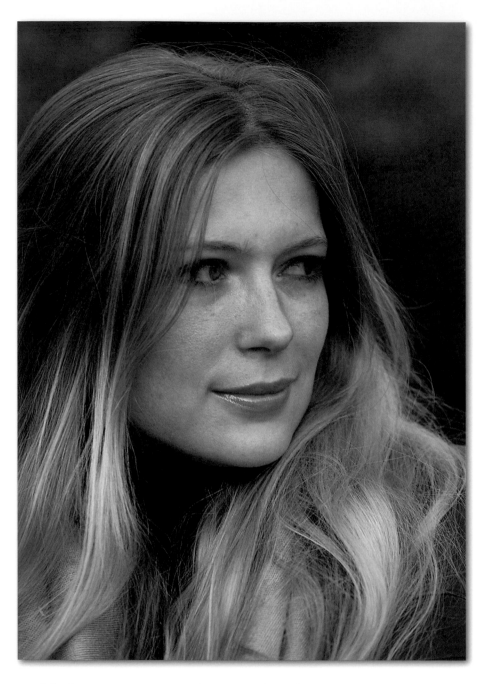

Take a close look at some of the famous paintings from the Renaissance. You'll notice that the artists often used darker shades of paint around the edges of their paintings to draw attention to the main subject in the center of the frame.

Today, photographers sometimes use the darkened edges technique for the same reason: to highlight the subject.

The photo of my friend, Chandler Strange, that appears on this lesson's title page illustrates this time-proven technique.

Compare the straight-out-of-the-camera image of Chandler shown above to the one shown on this lesson's title page. I think you'll agree that the opening image is more dramatic and perhaps more artistic, because the darker edges highlight the subject.

Here's a quick and easy technique for creating the Renaissance effect.

Open an image in Photoshop CS3. Select Window→Layers, and at the bottom of the Layers window click on the Create New Layer icon next to the Trash Can icon. That creates a new, blank layer above the original layer.

Next, you'll need to set the foreground color to black, if it's not already set. Go to Window→Swatches and select Black.

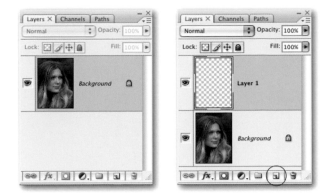

Now you'll need to fill that new (top) layer with 50% Gray. Go to Edit→Fill. Next to Use, select 50% Gray.

You are almost done! Go to Filter→Distort→Lens Correction. Under Vignette, move both sliders (Amount and Midpoint) all the way to the left. At this point, your top layer should look like this (if you have unchecked the Show Grid box).

Here is where those steps pay off. In the Layers window (at left), you'll need to change the mode from Normal (default) to Hard Light. Simply use the up/down arrows and change the mode from Normal to Hard Light.

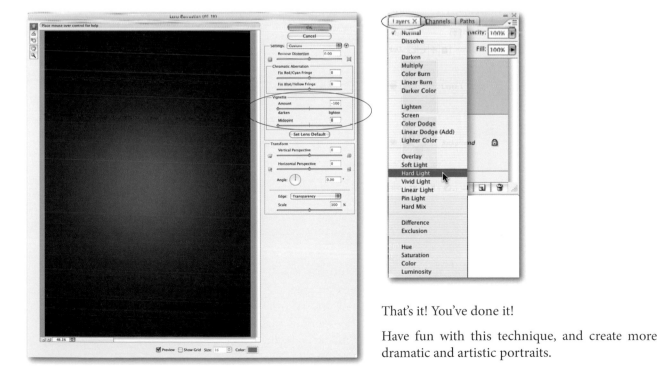

That's it! You've done it!

Have fun with this technique, and create more dramatic and artistic portraits.



Color and Black-and-White in the Same Image

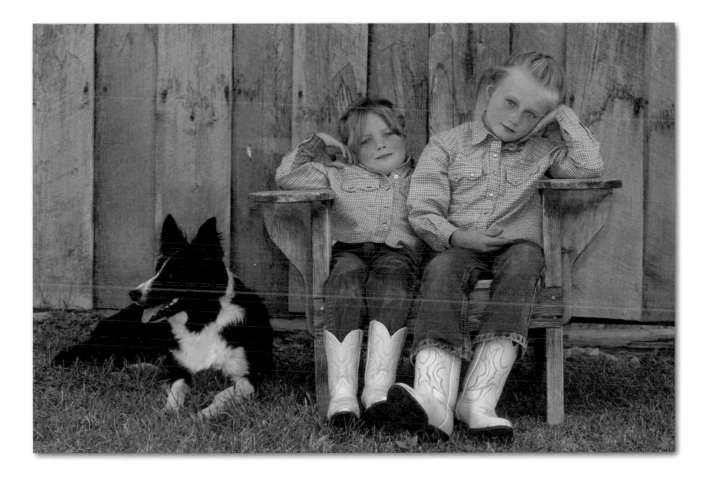

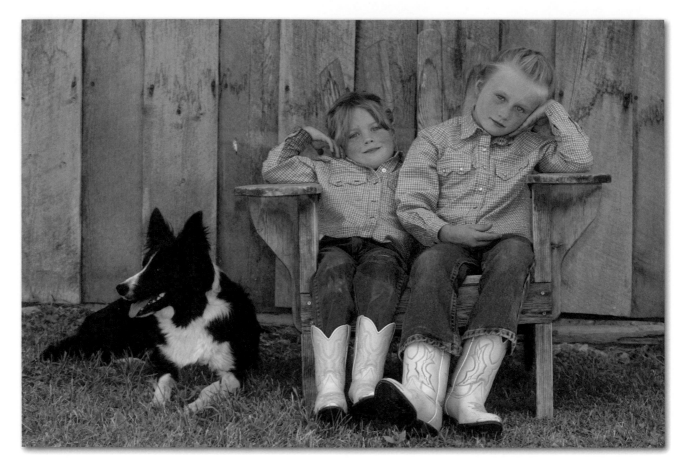

In Lesson 39, we explored some of the creative black-and-white options available in Photoshop.

You can get color *and* black-and-white subjects in the same image, as I did for the photo on this lesson's itle page of two young girls and their dog, taken on one of my Montana workshops. What's more, as with the Renaissance technique that we explored in Lesson 40, you can use this technique to draw attention to the subjects.

Here is my original, full-color image. Let's go through the easy steps for removing the color around the two girls and the chair.

Select Window→Layers, and at the bottom of the Layers window click on the Create New Layer icon next to the Trash Can icon. That creates a blank layer above the background layer, your original image.

With the foreground color set to black (default setting) select a soft airbrush and paint in the areas you want to be black-and-white.

At first, those painted-over areas will look black, as illustrated in this screen grab, which shows, by the way, that more painting is required.

Next, in the Layers window, change the Blending Mode from Normal to Saturation. Now those painted-over areas are black-and-white. Continue to paint over all the areas you want to be black-and-white, and you will have a color and a black-and-white image. How cool is that!

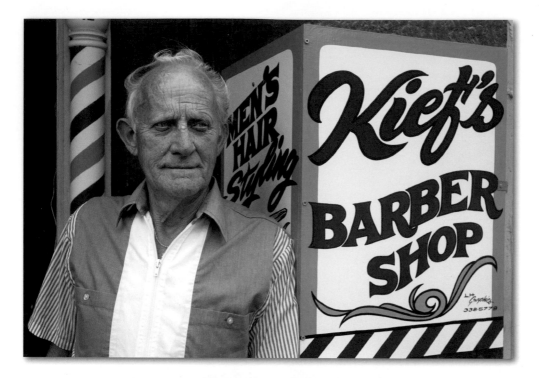

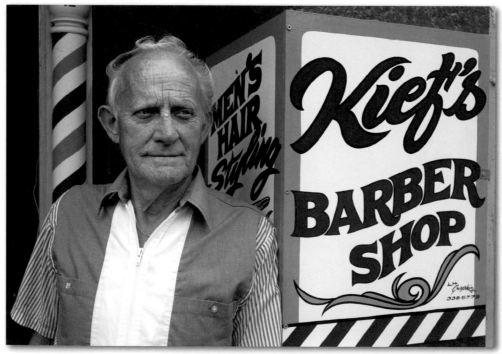

Of course, you can also create an image in which the subject is in black-and-white and the surroundings are in color. That's what I did for this photograph I took of barber Bill Kief in a small town in Maine. All you have to do is paint over the subject, rather than the surrounding area.

Experiment with this technique. See and share your world with a new, creative eye.

From Snapshot to Artistic Image

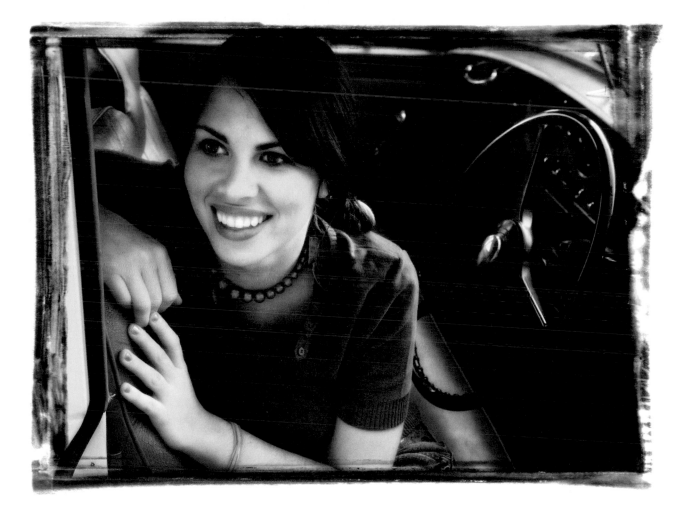

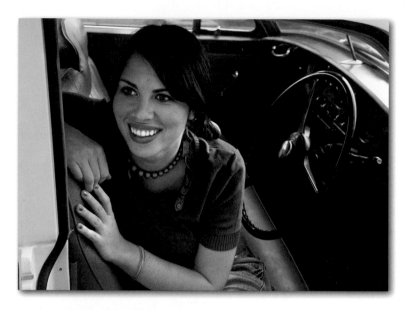

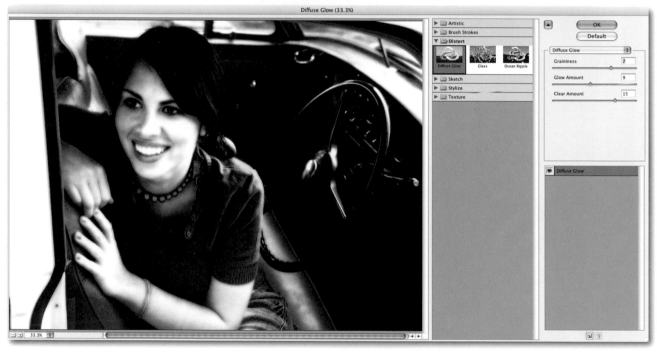

One of the fun and creative things we can do in Photoshop is to turn a snapshot into a more artistic image. That's what I did with this color photograph that I took of my friend, Andrea Laborde. She was relaxing in an old Bentley during a break in a workshop I was teaching in Salem, Massachusetts.

The first step in the snapshot-to-artistic-image process was to convert the color file to a black-and-white image. To do that, I used the Black and White adjustment I described in Lesson 39.

I like infrared photography. To simulate the IR effect, I went to Filter→Distort→Diffuse Glow and played around with the sliders until I was pleased with the pseudo-IR effect. When you use this filter, don't settle for your first choice of settings. Experiment. Take control of this fun filter. Also, make sure your Background Color is white.

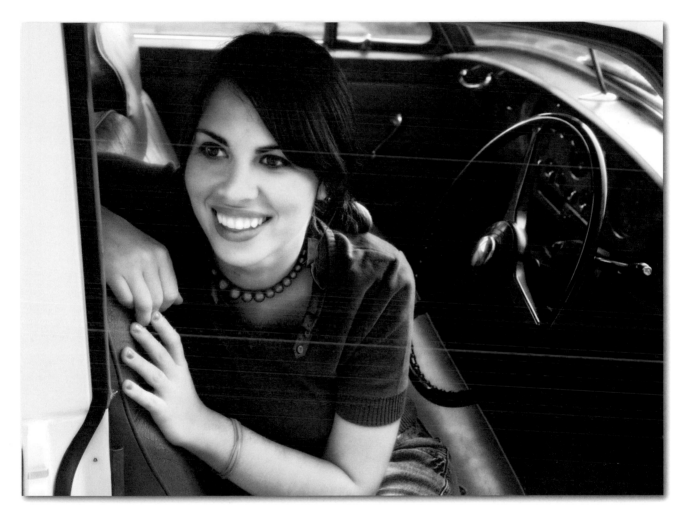

The above image is an example of how the Diffuse
Glow filter altered my image.

To dress up my newly created image, I applied one of the Camera frames in PhotoFrame Pro 3, a Photoshop plug-in from onOne Software (*http://www.ononesoftware.com*). This screen grab shows just a few of the options—Frames, Background, and Border—that are available in this creative plug-in.

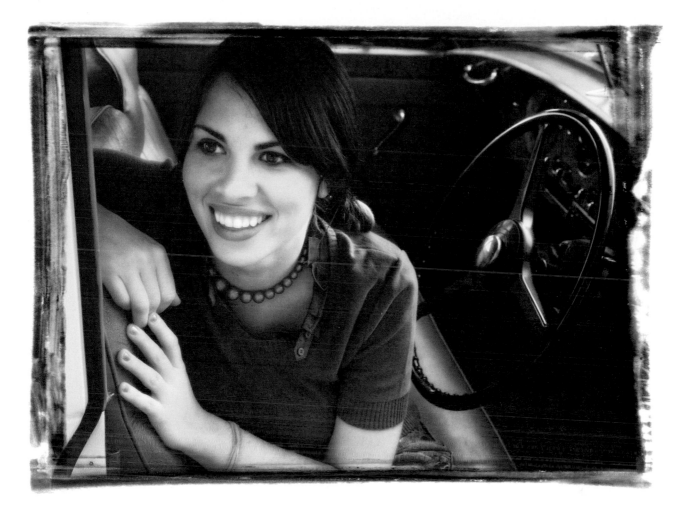

Once the digital frame was applied, my image took on a more creative look.

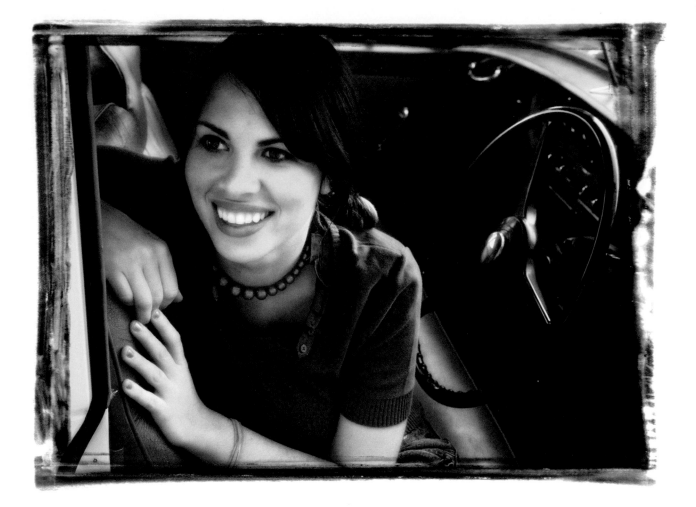

One of the basic guidelines that Photoshop users should follow is to adjust Levels (Image→Adjustment→Levels) so that the histogram has a full range of tones, from black to white. That's often accomplished by moving the histogram's highlight triangle on the right to just inside the mountain range, and moving the shadow triangle on the left to just inside the mountain range.

My framed image of Andrea already had a "good" histogram, as you can see here. However, I wanted a more dramatic image, one with deeper shadows. So, I moved the shadow slider beyond the "normal" adjustment.

Here's my final image, transformed from a fun snapshot into a more artistic image.

Now it's your turn. Think creatively—and artistically—the next time you open a snapshot in Photoshop.

Create the Disequilibrium Effect

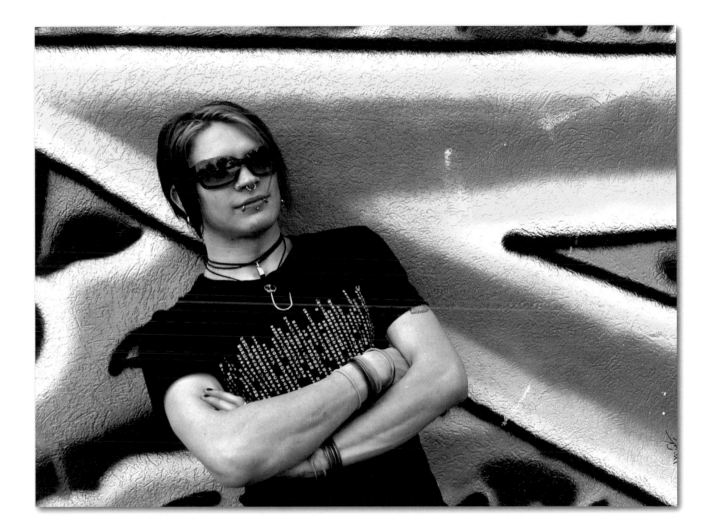

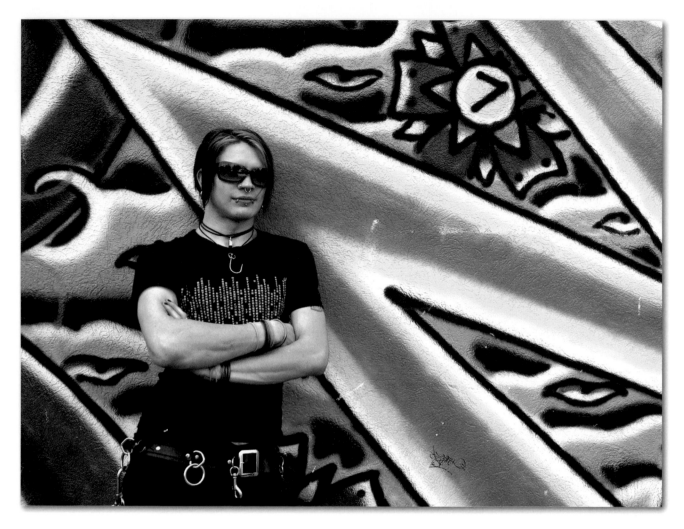

In Lesson 26, we learned how to use the disequilibrium technique (tilting the camera down to the left or right), to put the subject slightly off-balance, therefore creating a more dynamic image.

As I mentioned in that lesson, we can also create the disequilibrium effect in Photoshop. That's what I did with this photograph, which I took in Atlanta's Little Five Points.

Following is the quick and easy technique I used. But first, if you plan to create the disequilibrium effect, you'll need to select an image with extra area around your main subject. That's because, as you'll see, the technique causes you to lose some of the top, bottom, and sides of your original image.

Here you see my original, uncropped image, with plenty of space surrounding the subject.

After opening an image in Photoshop, select the Zoom tool on the toolbar and move the magnifying glass into the center of the frame. Hold down the Option key (Alt on a PC) and click inside the image once or twice until you have some gray space around your image.

Now, select the Crop tool from the toolbar and select the entire image. When you move the Crop tool outside the image area and into the gray area, the Crop icon turns into a curved, double-sided arrow. Now, when you move it up and down and left and right, you can tilt your image to create the disequilibrium effect. After you are pleased with the degree of tilting, you can click on the anchor points and tighten your crop.

You're done! That's all there is to it.

Change the Shutter Speed and F-Stop

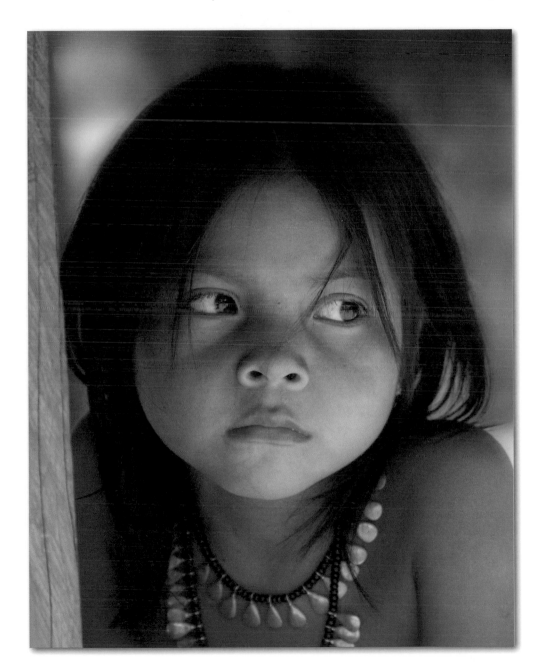

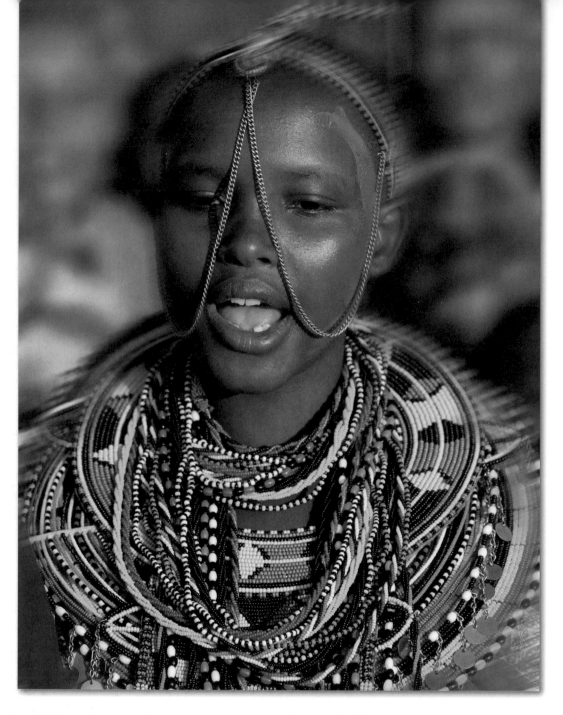

With a digital SLR, and even with some compact cameras, you can take charge of the shutter speed and f-stop for the ultimate in creative control.

Fast shutter speeds (1/500 of a second and higher) freeze most action, and slow shutter speeds (1/30 of a second and slower) blur action. Wide apertures (f/4.5 and wider) can be selected for shallow depth of field, and small apertures (f/8 and smaller) can be used for greater depth of field.

In Photoshop, we can simulate the result of whatever f-stop and shutter speed (to a degree) we used after a picture was taken.

Let's take a look at how we can create this magic, starting with changing the shutter speed.

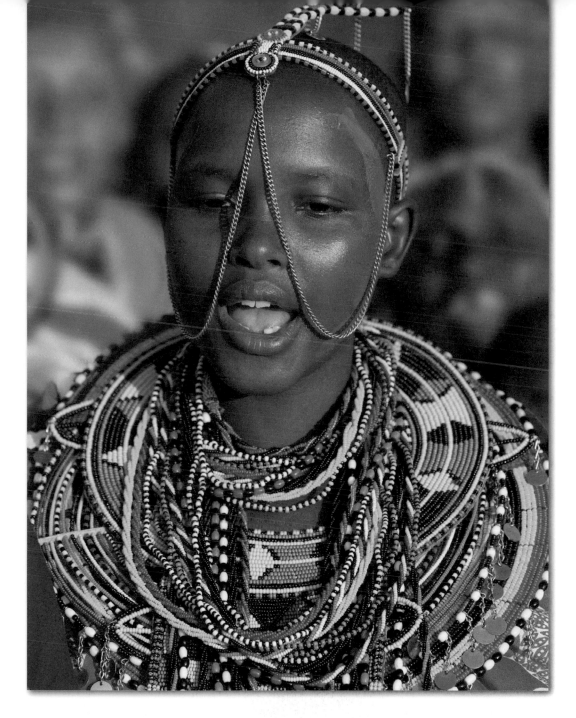

The picture on the preceding page, which appears to have momvement, started its Photoshop life as the image above. I used a shutter speed of 1/500 of a second to freeze the movement of the young Massai woman singing during a welcoming dance to her village in Kenya.

As you can see in my Photoshop-enhanced image above, the young woman is sharp (except around the outline of her body, which was intentional) but the background has some motion blur. I could

have created that way-cool effect in-camera by setting my camera to rear-curtain sync (an option on many digital SLRs), activating my flash, using a slow shutter speed, and praying that I got a picture in which the subject was sharp and the background was blurred. Praying would have been necessary because due to all the variables—subject movement, camera movement, and existing natural light conditions—rear curtain sync/flash photography is far from foolproof.

In Photoshop, creating that same effect is foolproof, easy, and, naturally, fun! Here's how to do it.

With an image and your Layers window open (Window→Layers), click on your background layer and drag it down to the Create New Layer icon next to the Trash Can icon. Now you have two identical layers, one on top of the other.

Activate the top layer by clicking on it in the Layers window, and then select Filter→Blur→Motion Blur. You can choose the amount of blur by moving the Distance slider (or by typing in a number in the Distance window). What's more, you control the direction of the blur by clicking on and rotating the Angle wheel (or by typing a number in the Angle window).

Because in real life the woman was moving from the top right of the frame to the bottom left of the frame, I swiveled the Angle wheel so that the blur would be in that direction.

After you click OK, the entire top layer will be blurred.

After your top layer is blurred, click on the Add Layer Mask icon at the bottom of the Layers window. That adds a layer mask to the right of the image. Click on that layer mask to activate it.

Now, with black selected as the foreground color, choose a soft airbrush from the toolbar and paint in the area over the subject, starting from the center and working outward.

As you move outward from the center of the subject, gradually reduce the brush's opacity (use the Option bar at the top of your monitor).

Reducing the opacity smoothes the transition from the sharp subject to the blurred background, as you can see in the screen grab.

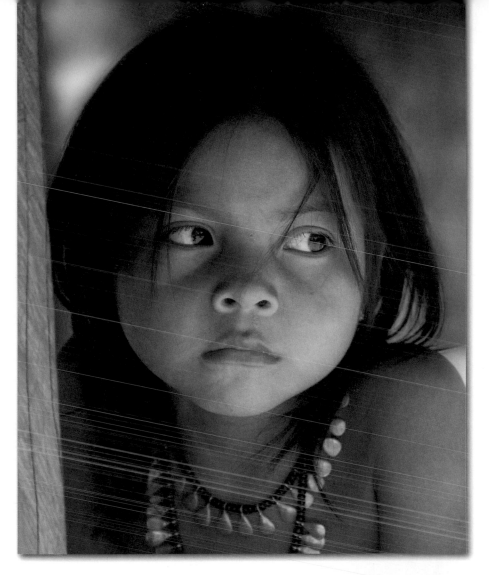

OK, let's move on to changing the f-stop.

Like the earlier picture of the Massai woman, I blurred the background of this picture as well.

Here, however, I used the Gaussian Blur filter (Filter→Blur→Gaussian Blur) because I wanted a softer, more out-of-focus background. It's a subtle enhancement, but the blurring hid some of the white highlights in the top right of the background. Blurring the background also drew more attention to the subject.

For this blurring technique, you can follow the same steps as I just described when using the Motion Blur filter: duplicate the layer, blur the top layer (only with the Gaussian Blur filter), add a Layer Mask, and paint out the blur over the subject—while reducing the Opacity as you paint from the center of the subject outward.

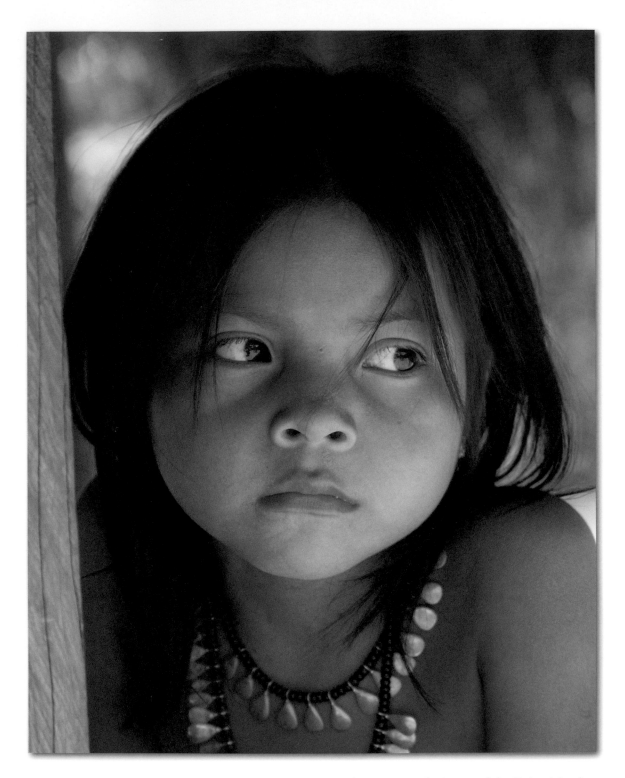

Here's my original picture of the little girl, whom I photographed in Panama. Again, my enhancement was quite subtle, but sometimes in photography, subtle changes are just what a picture needs to turn it into a perfect shot.

Remove Distracting Elements in a Scene

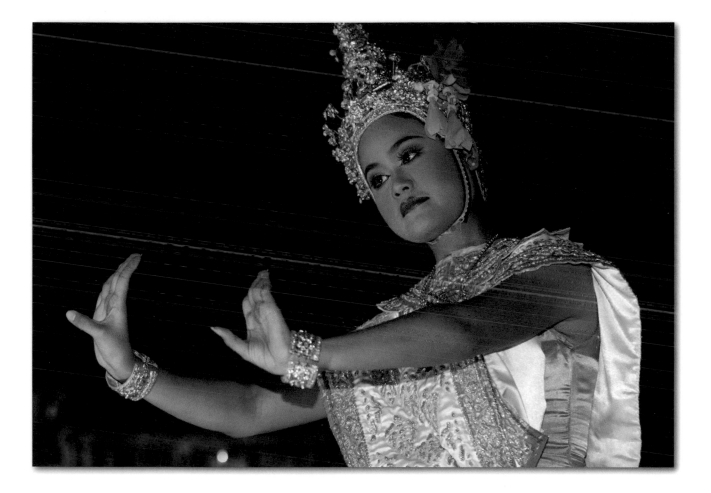

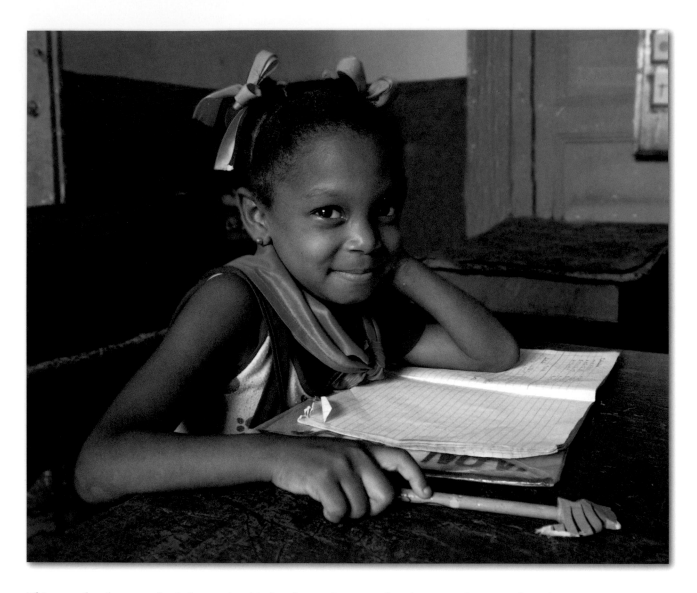

This may be the most basic lesson in this book. However, removing distracting elements from a picture is still an important technique for serious and creative people photographers—like you!

Compare the photos on this spread. In the picture on the opposite page, the girl in the white shirt in the background and the boy sitting next to her with his head down on the desk are distracting, reducing the impact of an otherwise nice portrait of a schoolgirl, whom I photographed in Cuba.

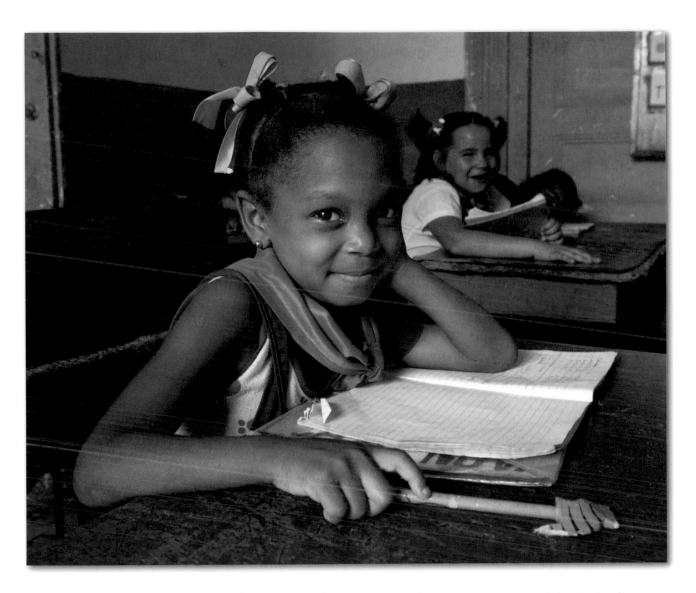

To remove the distracting background subjects, I used Photoshop's Clone Stamp tool, which you'll find on the toolbar. To use this tool, follow these steps:

1. Select the Clone Stamp tool.

2. While holding down the Option key (Alt on a PC), click on the part of the picture that you want to copy and paste over the area that you want to hide/remove/cover. In the schoolgirl picture, I copied parts of the desk, door, and wall—individually, one part at a time.

3. Release your mouse and the Option key.

4. Move your cursor over the part of the image you want to cover.

5. Click your mouse again, and you'll see crosshairs over the originally selected area at the same time that you see your cursor over the target area (the area to be covered). As you move your cursor, the crosshairs will follow the selected area while you copy and paste over the target area.

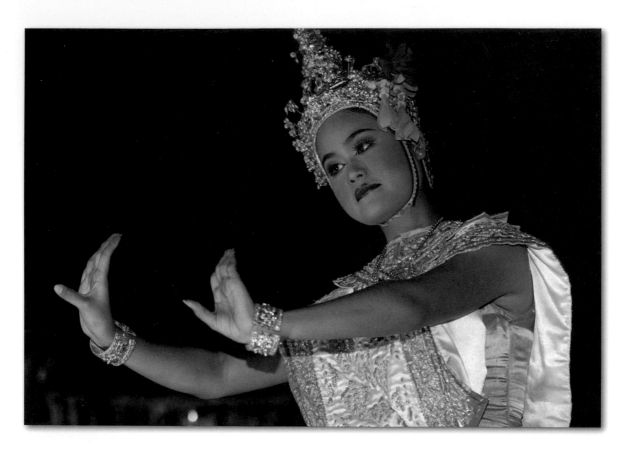

Whenever possible, compose your pictures without distracting background elements. That's what I did when I was photographing this dancer in Bangkok, Thailand. Remember to always strive for the very best in-camera photograph.

Compose carefully, think about how background elements can add or detract from the main subject, and you'll be able to spend more time taking pictures, rather than retouching them in Photoshop.

Brighten a Subject's Eyes and Smile

Check out this image of the bright-eyed young woman who was my guide on a photo shoot to Vietnam in 2004. Take a look at her beautiful, beaming smile! Her eyes and smile draw the viewer into the photograph.

The truth is that I used Photoshop to brighten her eyes and her smile—using the same techniques that professional digital retouching artists use to enhance the eyes and smiles in the photographs you see in fashion and glamour magazines.

Here is my original photograph. I slightly under-exposed the image so that I would not overexpose my guide's beautiful shirt, which may have result-ed in a loss of detail. That exposure, however, did not accurately record the brightness of her eyes and teeth.

I knew that would happen at the time of exposure. However, knowing that I could selectively adjust the exposure of those areas in Photoshop, under-exposing the image was a good choice.

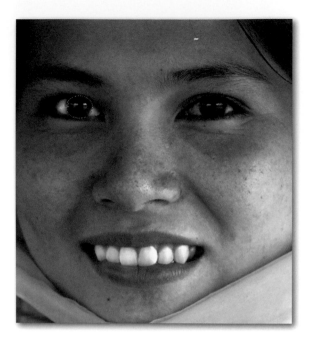

Here's my simple, but effective, retouching technique.

Select the Zoom tool on the toolbar and zoom in on the subject's face so that it almost fills your monitor. Then use the Dodge tool (on the toolbar) to paint the eyes and teeth, making them lighter and brighter.

When you use the Dodge tool for this technique, set the opacity (in the Options bar at the top of your monitor) very low, to 5% or 10%. Doing so will let you lighten the eyes and teeth very gradually. If you set the opacity to 100%, you'll lighten the eyes and teeth too rapidly, and they will look unnaturally white.

To brighten the center part of the subject's eyes, choose the Elliptical Marquee tool on the toolbar and select the dark part of the eyes (shown here by the white dotted circle on the girl's right eye). To select both eyes, you'll need to either press the Shift key on your keyboard after making your first selection, or click on the Add to Selection icon on

the Options bar at the top of your monitor. You need to select both eyes because you want to make the exact same adjustment to both eyes.

In this screen grab, I have only made adjustments to the eyes and teeth on the right side of the girl's face (the left side of the image) so that you can see the before-and-after difference.

Once you have selected both eyes, use Levels (Image→Adjustment→Levels) to brighten the selected areas. Pull the triangle slider to the left until you are pleased with the effect.

After making that adjustment, deselect the eyes (Select→Deselect), and your retouching is complete!

As you may have noticed, the young woman's shirt is darker in the retouched image than it is in the original image. I darkened her shirt (using the Burn tool on the toolbar) to draw more attention to the girl's face and to add impact to the picture.

Getting back to fashion and glamour magazines, the next time you are at the checkout counter at the supermarket, take a look at the cover photographs of those magazines. Notice the bright eyes and smiles of the models and celebrities. Now you know how the art directors enhance those pictures. You also know how easy it is to use those techniques on your own people pictures.

Basic Skin Softening

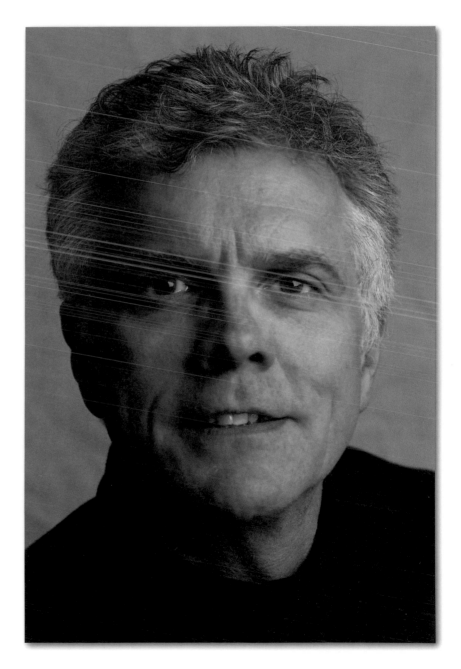

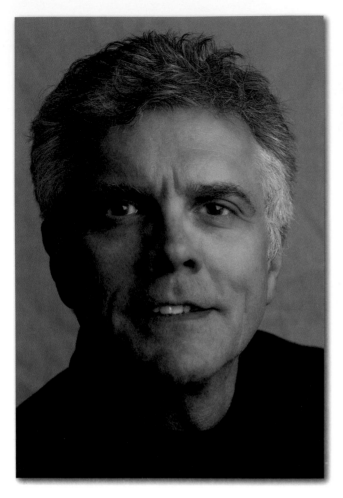

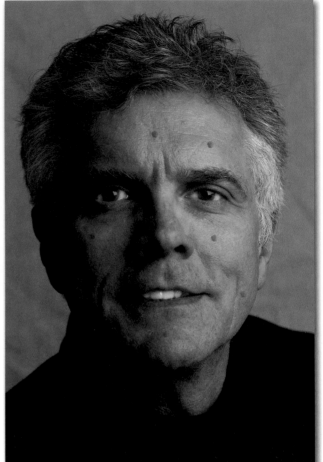

This lesson is titled "Basic Skin Softening" because it includes very basic skin softening techniques. If you want to learn more about skin softening techniques, I recommend Barry Huggins' book, *Photoshop Retouching Cookbook for Digital Photographers: 113 Easy-to-Follow Recipes to Improve Your Photos and Create Special Effects* (O'Reilly).

OK, let's begin.

Compare the image on the right with the picture on the left. The image on the left is more flattering because the skin has been softened, the wrinkles have been reduced, and the blemishes, which I added in Photoshop to the image on the right, are gone.

Here's the technique.

First, to remove blemishes, select the Spot Healing Brush from the toolbar. Once selected, place it over a blemish, click your mouse (you can instead tap your stylus), and the blemish is magically removed.

The fastest and easiest technique I've found to soften skin tones is to use the Dynamic Skin Softener filter in Nik Software's Color Efex Pro 2.0, a Photoshop plug-in (*http://www.niksoftware.com*). With this filter, you first select the skin color to be softened (using the eye dropper in the dialog box and clicking on the skin in the picture window). Then, using the sliders, you select the color reach (similar colors) and the soften strength. After you have set your color and percentages, click OK and the image is beautifully softened.

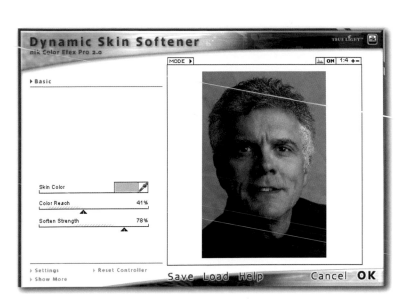

If you don't have the Nik Software plug-in, in Photoshop select the Blur tool from the toolbar and brush over the wrinkles. In this example, I softened the wrinkles under the eyes and on the cheeks.

Slightly reducing the saturation of an image can also help to make it look more pleasing, especially with older subjects who may have red areas of skin on their face.

You can also soften skin tones using Photoshop's built-in Gaussian Blur filter. If you blur the image too much, you'll lose important details. Therefore, keep the Radius low (I used 0.7).

Speaking of using the Gaussian Blur filter, in Photoshop CS3, you can use Smart Filters, which let you use filters as you would use an adjustment layer and a layer mask. (I could have done that in Lesson 44 when applying the Motion Blur and Gaussian Blur filters, but I wanted to show you both techniques—one there and one here. What's more, I figure that not all readers have Photoshop CS3.)

To use a Gaussian Blur Smart Filter (you'll see why it's smart in a minute) go to Filter→Convert to Smart Filter. Then, choose the Gaussian Blur (Filter→Blur→Gaussian Blur). When you do that, you'll see a Smart Filters layer mask appear under your original image in the Layers window.

Here comes the smart part. Click on the Smart Filters Layer Mask, and with black selected as your foreground color, select a soft brush and paint over the areas you don't want blurred—the eyes, mouth, hair, and background in this case. If you make a mistake and paint over the eyes, mouth, or background, simply press the X key on your keyboard (which sets the foreground color to white) and you can quickly and easily paint over and undo your mistake. To reset the foreground color to black, press the X key again. Now that's smart!

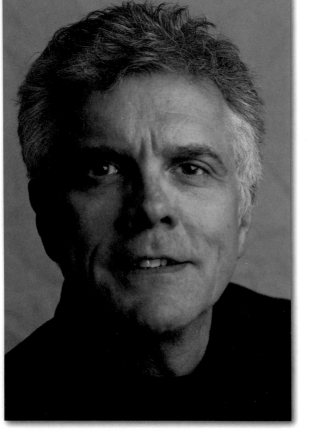

The photo on the left is the result of using the Gaussian Blur filter, the Blur tool around the eyes, and reducing the saturation.

To reduce your digital darkroom retouching time, photograph subjects in a soft, diffused light. Outdoors, use a diffuser or shoot in the shade. Indoors, use window light or, when using studio lights, use an umbrella or softbox to soften the light. When shooting with a flash, bounce the light off the ceiling or use a flash diffuser.

Using these recommended lighting techniques and the enhancements available in Photoshop should enable you to achieve more pleasing skin tones in your people pictures.

Hand-Color a Picture

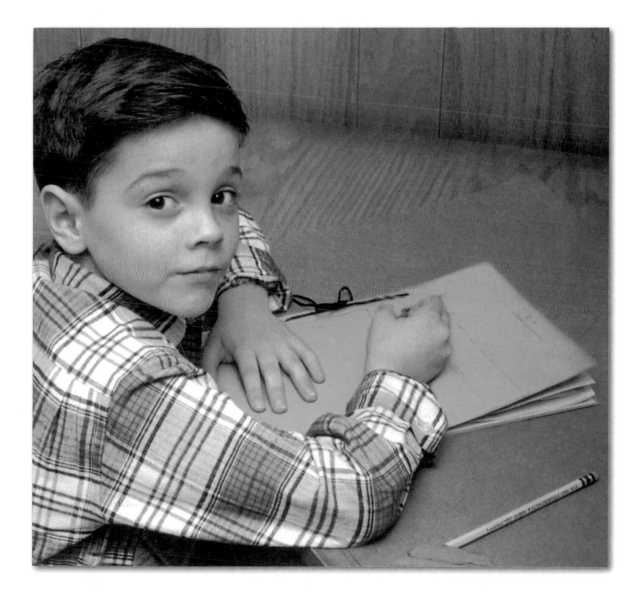

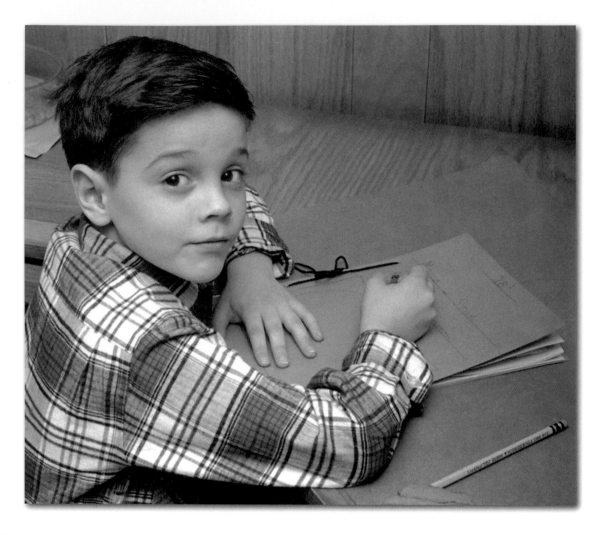

One of my earliest photographic memories is seeing a black-and-white print that my mother colored by hand with a brush and colored oil paints. It was magical to see the transformation from a black-and-white picture that my dad had taken to a color picture that my mother hand-painted.

In Photoshop, hand-coloring a picture is easy and full of creative possibilities. Let's take a look at a simple digital hand-coloring technique, the technique I used to hand-color a black-and-white picture that my dad took of me when I was a child.

Here is the scanned black-and-white image. To use this technique, you need to have an RGB image. So, if you want to work with a scanned, grayscale image, you'll need to convert it to RGB (Image→Mode→RGB).

The first step is to create a color layer, the layer upon which you will hand-color your image. On the menu bar on the top of your monitor click on Layer→New →Layer.

In the New Layer window, click on Mode and scroll down to Color to select a color layer.

At this point, when you look at your Layers window, you'll see your image as the bottom layer and a blank, color layer as the top layer. This top layer will be your hand-coloring layer.

Now comes the fun part. On the menu bar at the top of your monitor, click on Window and scroll down to Swatches to reveal the different colors in Swatches. (You could also use the Color Picker at the bottom of the toolbar to choose your color, but let's work with Swatches for now because it's an easy way to see the different colors that are available.)

Because I wanted to start by hand-coloring my shirt, I selected a shade of blue.

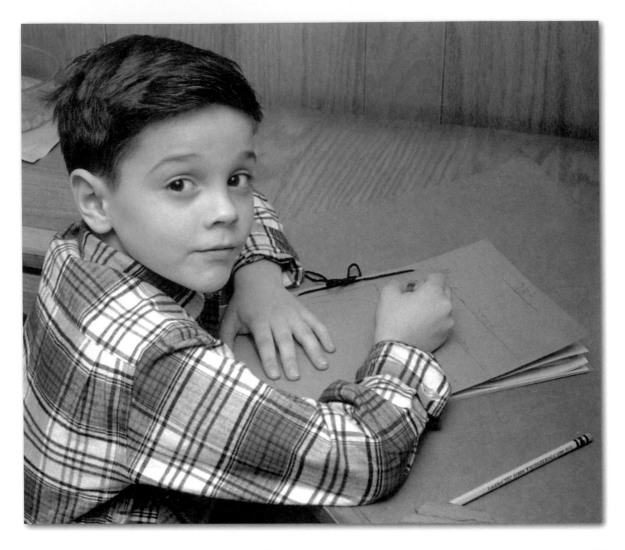

To begin the coloring process, click on the Brush tool in the toolbar and select a soft airbrush. You can change the size of the brush by using the bracket keys on your keyboard: the right bracket (]) makes the brush larger and the left bracket ([) makes the brush smaller.

Now, simply move the brush over the area of the image you want to color. Start with the Brush Opacity (on the menu bar) set to about 50%. That

setting lets you apply color at a slower rate than if your brush was set to 100%. When hand-coloring any picture, slowly applying a color gives you more control than if you were applying the color at a fast rate.

This screen grab shows the effect of hand-coloring my shirt and the pencil (with the wooden part painted yellow and the eraser part painted brown) on the desk.

During the hand-painting process, it's a good idea to occasionally turn off the bottom layer (click on the Eye icon next to the picture in the Layers window) to check whether you have missed any areas of a picture.

As illustrated by the screen grab, when the bottom layer is turned off, you'll see the areas that you have painted and the areas that you have missed.

After you have colored an area, move on to the next area. For the photo my dad took of me, I moved on to the blue blotter, then the green folder, and then the brown walls and desk.

"But how do I get good skin color?" you ask.

That's easy! Open a picture with good skin color in Photoshop. For my photograph, I used a picture of my son, Marco, playing his guitar. Click on the Eye Dropper tool in the toolbar and then click on the skin. That sets the foreground color to the skin color. Now go back to the picture you are hand-coloring and paint in the skin.

When painting the skin, which can be tricky, create a New Color Layer (now your third layer which rests on top of the other two layers). On that layer, paint the skin with the color you selected from your source image. Now, in the Layers window, click on Opacity and slowly reduce the opacity until you are pleased with the color of the skin.

The hand-coloring technique is not only fun, it's also quite creative, helping you to create one-of-a-kind images. Speaking of being creative, keep this in mind: you don't have to hand-color the entire image, as is illustrated by this picture that I took of my son, Marco, in a local music store. (I added the "spotlight" in the top left of the picture using the Lens Flare filter (Filter→Render→Lens Flare.)

Playin' with Plug-ins

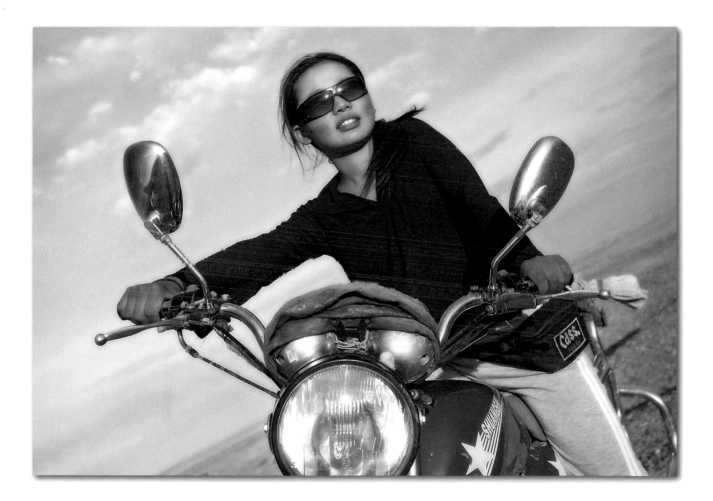

In the previous Photoshop lessons, you had to click your mouse (or tap your stylus) a few times to create a desired effect. In this lesson, you will see that with a single click or tap, you'll be able to create an artistic effect—if you have the appropriate Photoshop plug-in.

A Photoshop plug-in (available via download or CD) expands the creative potential of Photoshop by combining a series of effects and/or enhancements into a single effect. Therefore, the plug-in does all the work for you!

Photoshop's built-in Actions (Window→Actions) work like plug-ins, again doing all the work for you by combining several effects and/or enhancements.

To illustrate the effects of a plug-in and Photoshop's Actions, I'll use the picture below (a picture you saw earlier in this book of a young woman on a motorcycle), as my example.

		Image Effects
✓		▼ Aged Photo
✓		▶ Make snapshot
✓		Reset Swatches
✓		▶ Convert Mode
✓		Duplicate current l...
✓		▶ Dust & Scratches
✓		▶ Fade
✓		▶ Color Balance
✓		▶ Hue/Saturation
✓		▶ Unsharp Mask

This screen grab of Photoshop's Action Palette shows the various effects that, when combined, created Photoshop's Aged Photo Action. Even if you (or I) knew how to create the Aged Photo effect, it would take awhile to create it—step by step—in Photoshop.

Here you see how I transformed my photograph into a more creative image with the Aged Photo Action, which, by the way, is one of dozens of Photoshop Actions.

OK, let's take a look at two of my favorite plug-ins: PhotoTools from onOne Software (*http:// www.ononesoftware.com*) and Color Efex Pro 3 from Nik Software (*http://www.niksoftware.com*). Check out those web sites for demos and trial versions. You're in for some real photo fun!

Tech talk: some plug-ins are automatically placed in Photoshop's Plug-in folder, whereas others you need to drag and drop into the Photoshop Plug-in folder. Also, most plug-ins you can access at the bottom of Photoshop's Filter menu (including Color Efex Pro). Others show up in the Automate (File→Automate) menu (as is the case with PhotoTools).

Here's a look at the PhotoTools window after launch. Selecting an effect is fast and easy. What's more, you have creative options, including Fade, for customized effects.

Davis-WOW Portrait Glow

onOne–Tijuara

From the dozens of onOne effects and endless custom options, here are just three of my favorites.

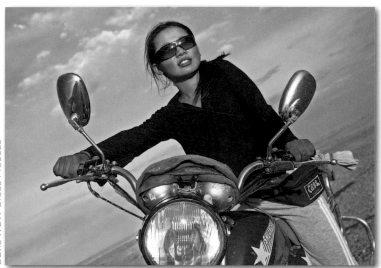

Davis-WOW Cross Process

Check out the Color Efex Pro 3 window. Again, selecting an effect is easy, after which you can customize the effect with color, tone, brightness, and contrast sliders (depending on the effect you choose).

And now, check out my favorite Nik effects.

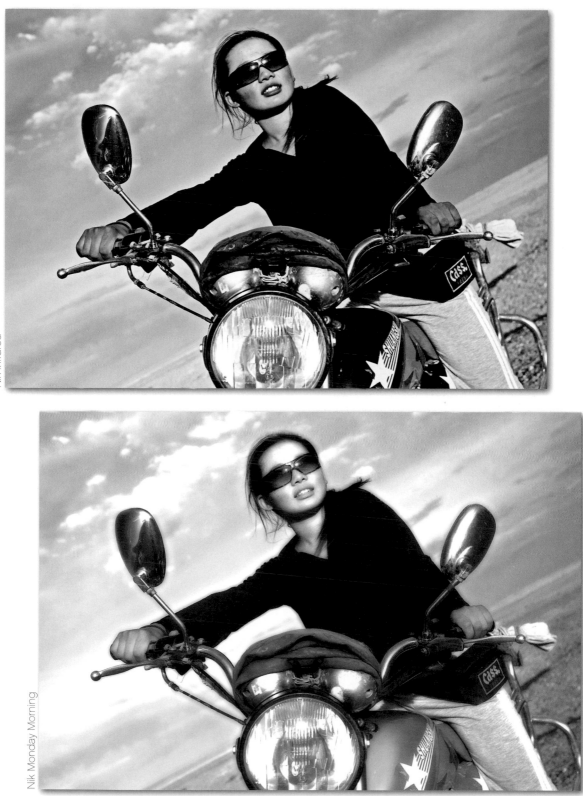

Nik Infrared

Nik Monday Morning

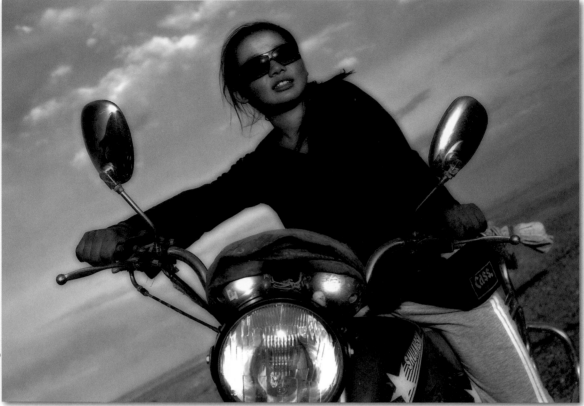

Nik Midnight

Want more plug-in fun? Check out *http://www.
thepluginsite.com/resources/freeps.htm* for some
free Photoshop-compatible plug-ins. Also do a
Google search for "Photoshop plug-ins".

Enjoy, as always.

Your Assignment:
On-Location Portraiture

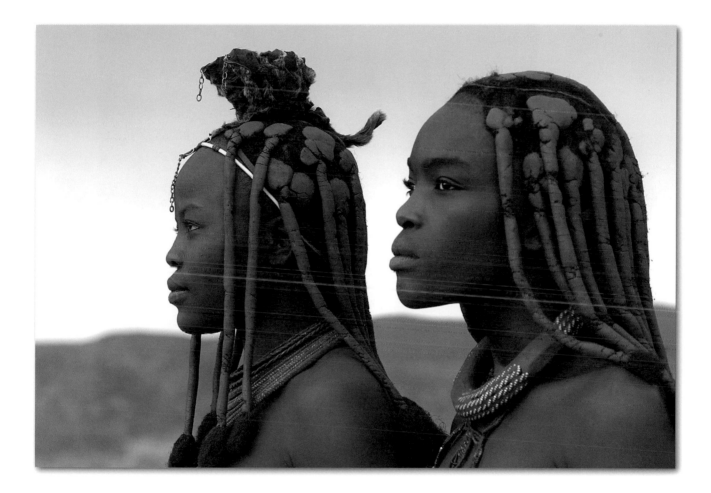

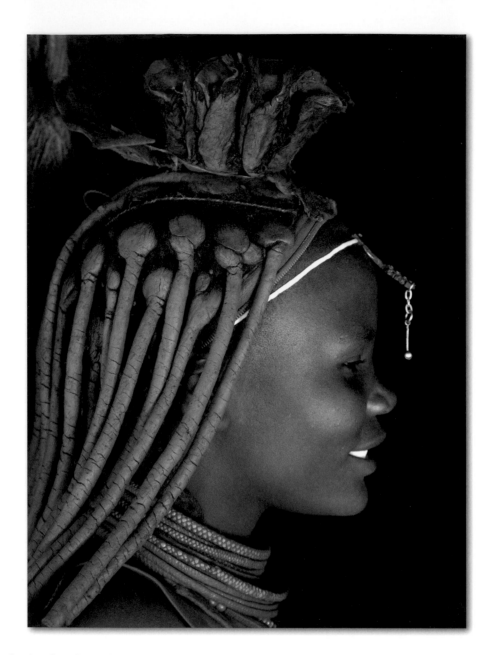

As a closing idea for this book, I thought it would be productive, instructive—and fun—to give you an assignment, one during which you could put together all the tips, techniques, and topics I discussed on the previous pages.

Your assignment: go on location with the goal of taking the best portraits you have ever taken. To help you along, I thought I'd share a few on-location portraits, each accompanied with a tip, that I took in two Himba villages during a photography workshop that I led in the fall of 2007.

Of course, you don't have to go to Namibia, or some other exotic location, for this assignment, but shooting in a new and exciting location is, indeed, very inspiring.

For starters, you could drop by your local firehouse, where you would find "hometown heroes" who would make interesting subjects. Believe me; the firefighters would love nice photographs of themselves in their firefighting gear, posing by the fire trucks. Of course, they'd like headshots, too.

Let's move on with the assignment.

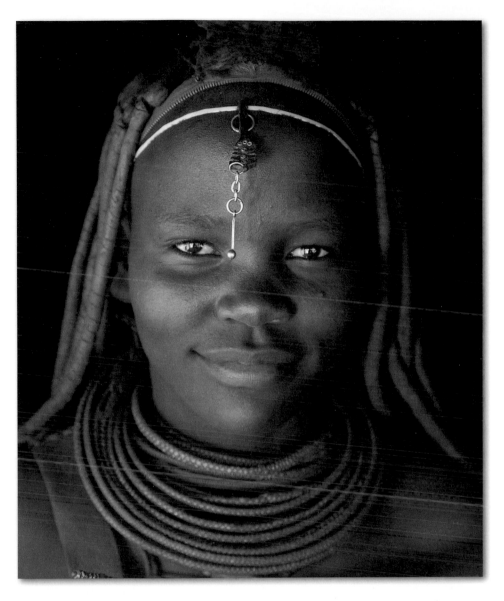

Remember That the Camera Looks Both Ways

I have found that, for me, the key to getting a good on-location portrait is to fall in love—photographically—with the subject. That is exactly what I did when I saw the young woman whose photograph opens this epilog. Out of the 50 or so people who lived in this particular village, this woman caught my eye immediately. It was photographic love at first site.

So, my first tip is to find a subject that you absolutely must photograph, someone who moves you

to say, "I'll do anything to get that person's picture, for myself and to share with others."

Earlier in this book, I shared with you my favorite photographic quote: "The camera looks both ways." In picturing the subject, you are also picturing a part of yourself. When you keep in mind that the energy, emotion, and feeling you project will be reflected in your subject's face, especially the eyes, you'll get a high percentage of pictures that you like.

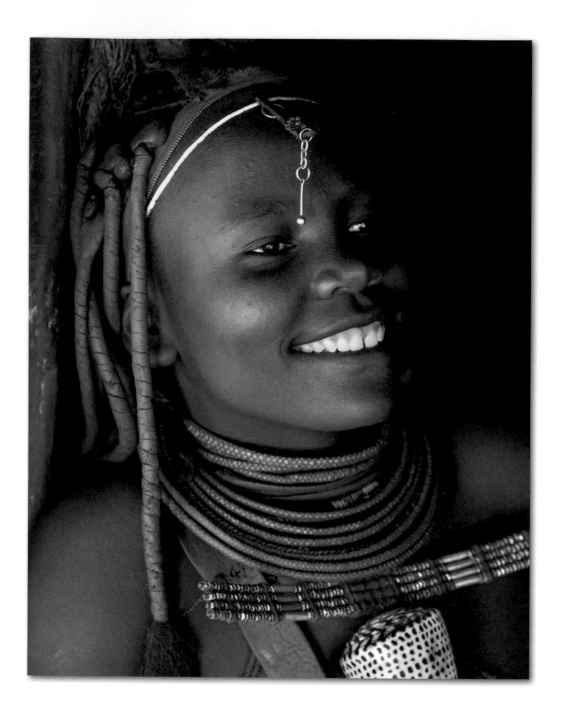

Take Three

When taking headshots, take a head-on shot, a profile, and a three-quarters view, as illustrated by this and the preceding two pictures in this epilog. Photographing a subject from different angles gives you different photographs from which to choose your favorite. In my trio of photographs of this young woman, the opening image is my favorite.

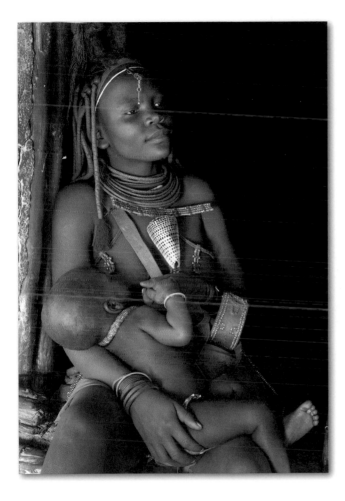

From Picture to Portrait

Compare these two pictures. One is obviously a snapshot, and the other is a portrait. The big—and simple—difference is that I moved in (zoomed in) closer for the portrait. Doing so brought more attention to the subjects by not only making them larger in the image, but also eliminating the bright (and distracting) wood trim of the hut's doorway.

So, when you think you are close, move in closer. You'll be surprised at the difference in your photographs when you "get up close and personal" with your subjects.

Both images capture an intimate and genuine moment in the woman's life, which is another goal you want to achieve when photographing people.

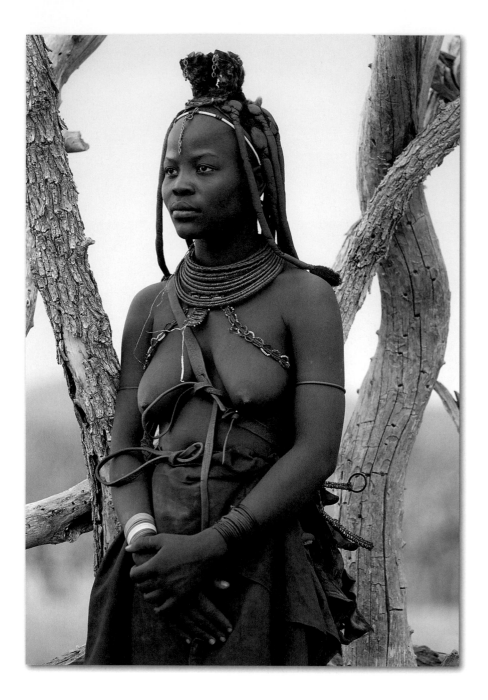

Frame It

When you put a print in a frame, you basically dress up and enhance the picture—when the frame complements the photograph. On-site, you can frame a subject with a doorway, a window frame, branches, or a fence.

The frame must complement the subject, which was not the case in the previous picture of the mother and child who were framed by the bright doorway, but which is the case in this picture of a young woman framed by some fence posts.

Framing a subject can also add some depth to the scene, helping to create a three-dimensional effect in a two-dimensional image.

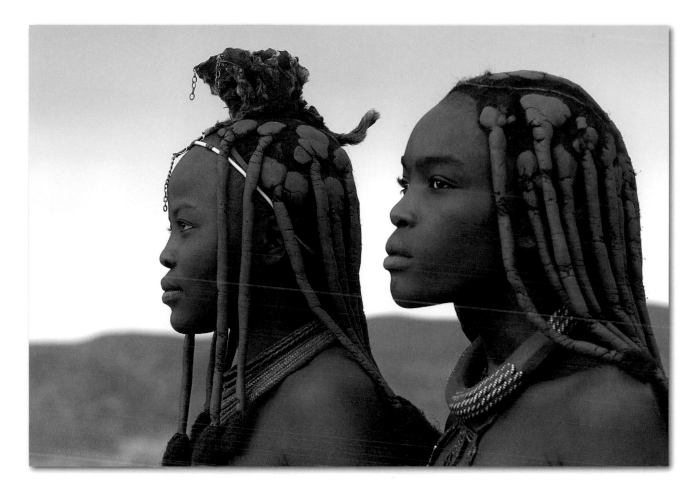

Make Pictures, Don't Just Take Pictures

Anyone can take pictures, but not everyone can make pictures.

You are holding this book, so I know you want to make pictures.

Making pictures is creative, fun, and easy. Rather than simply pointing your camera at a subject and pressing the shutter release button, take the time to carefully position your subject or subjects in a scene, as I did when I photographed these two Himba women against a clear sky.

Work with a subject on his or her pose and expression. Create a balanced photograph. Watch the background. Choose the best f-stop for the appropriate depth of field and the best shutter speed to either stop or blur the action.

Work—and play—at making pictures, and you'll feel a sense of accomplishment when you see the result of your effort.

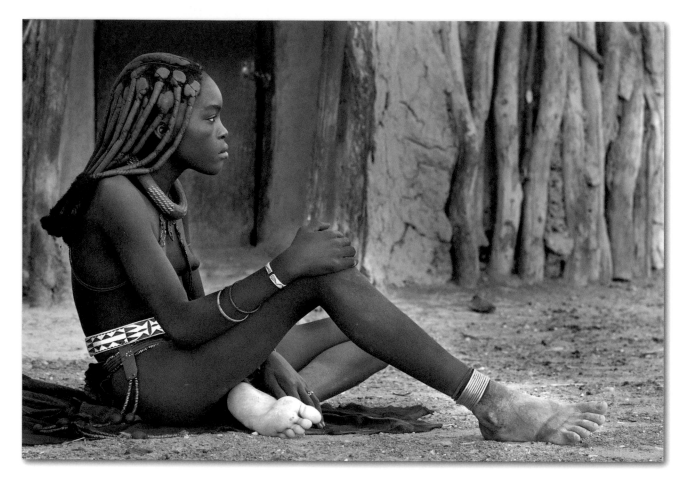

Be on the Lookout for Backgrounds

When you are on location, be on the lookout for interesting or complementary backgrounds. Once you find a good background, ask the subject to move into position.

While I was walking around a Himba village, I was looking for a nondistracting background against which to photograph the people there. The branches on the hut in the background of

this photograph are indeed quite distracting, but the plain wooden door was just perfect, allowing me to frame the subject's beautiful face so that it stood out prominently in the photograph.

So, be aware of the background—in all your photographs.

See and Control the Light

Seeing the light—the contrast, shadows, and high-lights—in a scene is the first step in getting the best possible in-camera picture. The second step is to know how to capture and control the light, either by using a flash, reflector, or diffuser, or by moving the subject into the shade, as I discussed in detail in the "Outdoor Photography" part of this book.

This Himba girl's face was partially shaded by her hair. To fill in the shadows, I used a flash for day-light fill-in flash photography. The picture does not look like a flash picture (my goal with all my flash pictures) because I dialed down the output of the flash, which balanced the light from the flash to the ambient light.

So, don't leave home without a reflector, diffuser, or flash. And keep an eye on the light.

Enough About You!

Of course, I am only kidding. Well, OK, I am only half-kidding. While on location, in addition to taking the kinds of pictures you want to take, ask your subjects what kinds of pictures they would like you to take. That will help you gain acceptance, which is important to getting good pictures.

While in a Himba village, I encountered this chief who wanted a picture of him smoking his pipe. It's not exactly the kind of picture I'd take, but taking it sure did make the chief happy, and it helped me gain a friend in the village.

Keeping the feeling of your subjects in mind is important—whenever you are taking photographs.

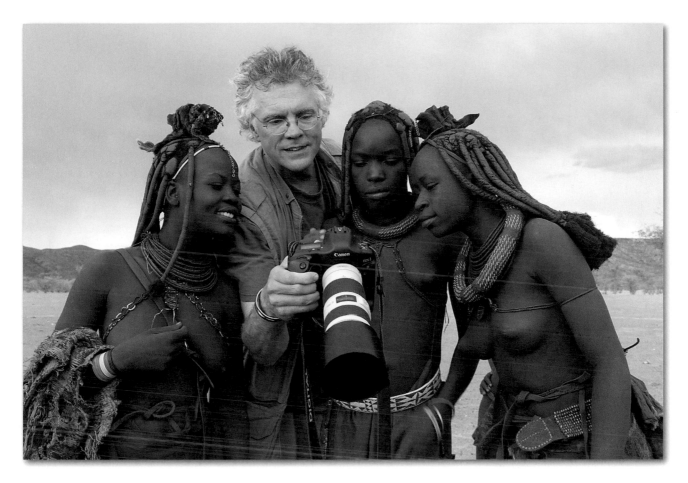

Go Interactive

When you share your pictures with your subjects, you make your photo sessions more fun and interactive. After all, who does not like seeing their pictures? That especially goes for the Himba, who live in a relatively remote part of Namibia.

Share your pictures, and you'll see how easy it is to make new friends.

This picture illustrates another important point: take fun shots! To capture this magical moment for me, I set up my camera and handed it over to one of the workshop participants, Deborah Sandidge. I asked her to shoot tight, following yet another one of my photo philosophies: "The name of the game is to fill the frame."

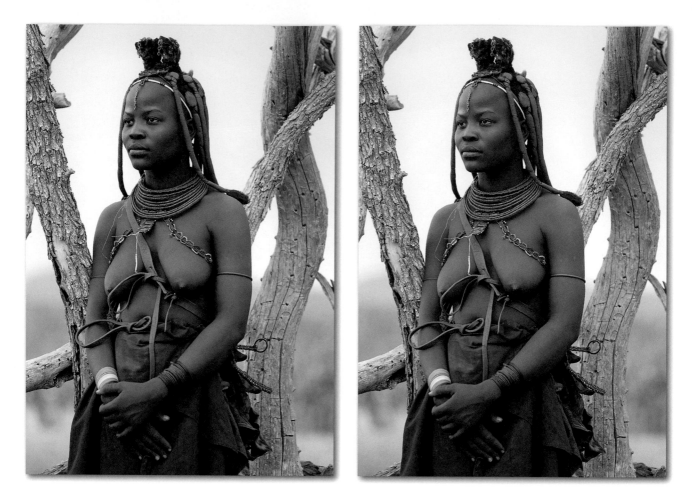

Envision the End Result

For me, digital photography is often a 50-50 deal: 50% image capture, 50% digital darkroom work.

I always try to envision the end result, trying to imagine how adjustments and enhancements in Photoshop can be used creatively and correctively.

The color picture of the woman standing in front of the fence that I used earlier in this epilog is one of my favorites. However, I like these Photoshop CS3 black-and-white (Adjustments→Black and White) and sepia (Actions→Sepia Toning) versions, too.

When you previsualize the end result, you'll see more creatively—and you may take a picture that you normally would not have taken.

OK, enough reading for now. Good luck on your assignment—and with all of your photography.

Learn about Your Subject

Learning about your subject makes it more interesting to photograph, and more interesting to share your photographs with others.

The women pictured on this page are not Himba, but Herero – from which the Himba are descendants. The Herero live in nearby towns and have a completely different look. Their traditional dress is derived from a Victorian's woman's dress, worn by missionaries. The horn shaped hat is said to represent the horns of a cow – which is a measure of wealth in Namibia.

The Himba pictured in this lesson cover their bodies with red ochre to protect themselves from the sun. It also gives them their rich red color appearance.

Now you know something about these two tribes in Namibia. When you go to a location, do a Google search and learn about your subject to enhance your travel experience.

Index

A

accessories, 24
 diffusers and reflectors, 25–26
 flash, 27
 Photoshop software, 28–29
Action Palette, 258
action shots, 109–112
Adjustment Layers
 black-and-white images, 210
 skin tones, 250
Aged Photo Action effect, 214, 258–259
AI Servo mode, 155
angles, 11
 blur, 236
 eyes, 76–79
 mirrors, 197
 on-location portraiture, 268
 reflectors, 114–115
apertures
 action shots, 110
 depth of field, 10
 festivals, 154, 156
 focus, 24
 garage glamour, 123
 low light photos, 139
 Rembrandt lighting, 172
 sense of depth, 162–164, 234
 settings, 5
 stage shows, 203
Automatic flash metering mode, 127
Av (aperture priority) mode
 night photography, 139
 profiles, 134
 stage shows, 203
available light
 night photography, 136
 stage shows, 200

B

Background Color setting, 224
backgrounds, 12, 59–61
 action shots, 111
 artistic images, 224
 distracting, 35–36
 festivals, 156
 group photography, 142
 night photography, 136–137, 139
 on-location portraiture, 272
 professional, 123, 193
 profiles, 134
 for sense of place, 42
backlight, 145–150
balance in group photography, 142
Black and White dialog box, 212–213
black-and-white images
 color in, 219–222
 creating, 209–214
blemishes, 248–249
Blending Mode setting, 221
blower devices, 155
blur
 action shots, 110–112
 camera shake, 189
 controlling, 10, 234–237
 festivals, 156
 garage glamour, 124
 sense of depth, 163
 skin softening, 249–250
 stage shows, 200
body language, 9, 71–74
brightening eyes and smiles, 243–246
Brightness/Contrast adjustment, 212
Brush tool, 254
Burn tool, 246

C

camera settings, 5
cameras, 22–24
Canon 580EX flash, 27
Canon EOS digital SLR cameras, 22

Canon lenses, 22–24
capturing action, 109–112
cell phones, 90, 159
children, paying, 65
cleaning filters, 155
Clone Stamp tool, 241
close-ups
 details, 158
 hands, 74
 stage shows, 200
color, 17
 in black-and-white images, 219–222
 clothes, 68
 hand coloring, 251–256
 of light, 204
Color Efex Pro plug-ins, 249, 259, 262
Color Picker, 253
communication with subjects, 7, 51–52, 102–103, 267, 274–275
composition, 8, 47–48
Continuous Focus setting, 155
Crop tool, 232

D

daylight fill-in flash, 125–127
dead center shots, 18, 45–48
depth, 10, 161–165
Dfine plug-in, 200
Diffuse Glow filter, 224–225
diffusers, 25–26, 117–120, 179
digital noise
 exposure, 146, 150
 ISO settings, 154, 189, 200
 tripods for, 124
disequilibrium technique, 129–132, 229–232
Distance slider, 236
distractions
 backgrounds, 35–36
 removing, 239–242
Dodge tool, 246
dust, 155
Dynamic Skin Softener filter, 249

E

Elliptical Marquee tool, 246
environmental portraits, 55–58
exposure, 16
 festivals, 155
 fill-in flash, 126–127
 garage glamour, 124
 highlights, 6
 lighting, 190
 night photography, 136, 139
 profiles, 134
Eye Dropper tool, 255
eyes
 brightening, 243–246
 photographing, 75–80

F

F.J. Westcott products
 backgrounds, 123
 lighting kits, 188
f-stops, 24
 festivals, 154, 156
 fill-in flash, 127
 and lighting, 189
 night photography, 137
 portraits, 271
 settings, 233–234, 237–238
 silhouettes, 174
fast lenses
 low light, 190
 stage shows, 200
festivals, 151–152
 background, 156
 camera settings, 154–155
 fun and courtesy, 158
 goals, 157
 plans and locations, 153
 whole stories, 158
 zoom lenses, 155
fill-in flash, 125–127, 158
fill setting, 217
flash
 as accessory, 27
 daylight fill-in, 125–127
 group photography, 142
 indoor photography, 177–186
 vs. natural light, 13, 16
 night photography, 136–139
 practicing, 184–186

flash bounce, 179
flash brackets, 179
focus
 aperture size, 24
 blurring, 237
 festivals, 154–155
 garage glamour, 124
 settings, 5
 tripods, 200
framing
 methods, 37–40
 on-location portraiture, 270
freezing action shots, 10, 112
full-frame shots, 40
full-length shots, 15, 38–39

G

garage glamour, 121–124
Gaussian Blur filter
 background softening, 237
 skin softening, 249–250
Gaussian Blur Smart Filter, 250
gear, 21–22
 cameras and lenses, 22–24
 diffusers and reflectors, 25–26
 flash, 27
 Photoshop software, 28–29
Genuine Fractals plug-in, 94
group photography, 141–144

H

Halloween lighting, 122
hand coloring, 251–256
hands, 71–74
head and shoulders shots, 15, 38
head-on shots, 268
headshots, 14, 37–38, 268
highlights, 5
 exposure for, 6, 127, 155
 hot lights for, 189
 noise, 200
 Renaissance painter effect, 216
 seeing, 273
histograms
 highlights, 6
 Levels, 228
horizontal pictures, 49–50
hot lights, 189
Hue and Saturation settings
 black-and-white images, 211
 skin softening, 249

I

Image Effects, 214
image stabilization lenses, 23
 action shots, 110
 hot lights, 189
 low light, 136
 stage shows, 200
indoor photography
 flash techniques, 177–186
 lighting kits, 187–194
 mirrors, 195–198
 Rembrandt lighting, 169–172
 silhouettes, 173–176
 stage shows, 199–205
IR effect, 224
ISO settings, 5
 festivals, 154
 flash, 179
 garage glamour, 124
 and lighting, 189
 night photography, 137
 Rembrandt lighting, 169
 stage shows, 200

J

JPEG files, 155

L

Lens Correction setting, 218
lens flare, 147–150, 256
Lens Flare filter, 256
lenses, 22–24
 festivals, 155
 garage glamour, 123
 low lighting, 190
 sense of depth, 162–165
 stage shows, 200
Levels
 artistic images, 228
 brightness, 246
lighting
 diffusers and reflectors for, 25–26
 garage glamour, 122
 with mirrors, 196
 on-location portraiture, 273
 Rembrandt, 169–172
 stage shows, 200, 202–203
lighting kits, 187–194

location
 festivals, 153
 guidelines, 81–84
 stage shows, 202
low light photography, 135–139
 lenses, 190
 mirrors, 197
 Rembrandt lighting, 172
 shutter speed, 154
 stage shows, 200
 tripods, 124
LumiQuest 80-20 flash bounce, 179
LumiQuest UltraBounce, 178

M

making pictures vs. taking pictures, 4
 on-location portraiture, 271
 techniques, 33–36
man hands, 73
mannequins, 184–186
Manual exposure setting
 fill-in flash, 127
 night photography, 136
manual flash technique, 138
mirrors, 195–198, 201
Motion Blur filter, 236–237

N

natural light vs. flash, 13, 16
night photography, 135–139
Night Portrait mode, 136, 138
noise
 exposure, 146, 150
 ISO settings, 154, 189, 200
 tripods for, 124

O

off-center shots, 18, 45–48
on-location portraiture, 265–276
one-light technique, 192–193
one-shot AF mode, 155
onOne effects, 259–261
opacity settings, 246, 254, 256
outdoor photography
 backlight, 145–150
 capturing action, 109–112
 daylight fill-in flash, 125–127
 diffusers, 117–120
 disequilibrium technique, 129–132
 festivals, 151–159

garage glamour, 121–124
group photography, 141–144
low light and night, 135–139
profiles, 133–134
reflectors, 113–116
sense of depth, 161–165
overexposure, 6
 festivals, 155
 fill-in flash, 127
 lighting, 190
 profiles, 134

P

panning, 110
paying people, 63–66
philosophies
 background, 59–61
 being there and being aware, 53–54
 body language and hands, 71–74
 creative thinking, 99–100
 dead center shots, 45–48
 dress, 67–69
 eyes, 75–80
 framing, 37–40
 horizontal and vertical shots, 49–50
 location, 81–84
 making pictures vs. taking
 pictures, 33–36
 paying people, 63–66
 people for scale, 95–98
 pictures within pictures, 91–94
 portraits vs. environmental
 portraits, 55–58
 props, 85–90
 relationship with subjects, 51–52
 sense of place, 41–44
Photo Basic Kit, 188
photoflood light bulbs, 189
PhotoFrame Pro 3 plug-in, 226
Photoshop software, 28–29
 artistic images, 223–228
 black-and-white images, 209–214
 color in black-and-white
 images, 219–222
 disequilibrium effect, 229–232
 distractions, 239–242
 eyes and smiles, 243–246
 hand coloring, 251–256
 plug-ins, 257–264
 Renaissance painter effect, 215–218
 shutter speed and f-stops, 233–238

skin softening, 247–250
PhotoTools plug-in, 259–260
pictures within pictures, 91–94
place, sense of, 41–44
plans, 153
plug-ins, 257–264
portable lighting kits, 188–189
portraits
 vs. environmental portraits, 55–58
 on-location, 265–276
 vs. sense-of-place photographs, 44
profiles
 guidelines, 133–134
 on-location portraiture, 268–269
 silhouettes, 173–176
props, 85–90

R

rapid frame advance, 110
RAW images, 6
 festivals, 155
 pictures in pictures, 94
 stage shows, 200
red color, 68
redeye, 179
reflections in mirrors, 196–198
reflectors, 25–26, 113–116, 192–193
relationship with subjects, 7, 51–52,
 102–103, 267, 274–275
Rembrandt lighting, 169–172
Renaissance painter effect, 215–218
rule of thirds, 47–48

S

Saturation slider, 211, 213
"seeing the camera" in group
 photography, 142
sense of depth, 19, 161–165, 234
sense of place, 41–44
sensor cleaning devices, 155
separation of subjects, 205
shadows, 5, 25–26
shutter speed, 10
 action shots, 110
 festivals, 154
 garage glamour, 124
 night photography, 136–137
 settings, 5, 233–237
 stage shows, 200
side lighting, 170–171

silhouettes
 backlight, 146
 guidelines, 173–176
 natural light, 139
 profiles, 134
skin softening, 247–250
Smart Filters, 250
Smart Filters Layer Mask, 250
smiles, brightening, 243–246
softboxes, 179
Spot Healing Brush, 248
spot meters
 exposure, 126
 profiles, 134
 stage shows, 203
stage shows, 199–205
stop action shots, 110, 112
strobe lights, 184, 189
Stroboframe flash bracket, 179
strong colors, 68
swatches, 253
swivel head flash units, 178–179

T
teeth, brightening, 246
telephoto lenses
 festivals, 155
 sense of depth, 165
 stage shows, 200
three-light technique, 190–191
three-quarter shots, 38–39, 268–269
tilting cameras, 130–132
Tint setting, 213
tripods
 action shots, 110
 garage glamour, 124
 hot lights, 189
 night photography, 136
 stage shows, 200
Tv (shutter priority) mode, 154

U
UltraBounce, 178
upsizing images, 94

V
vertical pictures, 49–50
Vignette setting, 218

W
white balance settings, 5
wide-angle zooms
 festivals, 155
 mirrors, 197
 sense of depth, 162, 164–165
 stage shows, 200
wide apertures
 background blurring, 163
 depth of field, 234
 festivals, 156
wrinkles, 248–249

Z
zoom lenses, 22–23
 depth of field, 100
 festivals, 155
 mirrors, 197
 stage shows, 200
Zoom tool, 231, 246

TheSmileTrain
Changing The World One Smile At A Time.

I could not end this book without acknowledging how very lucky I have been to travel around the world and to meet the photogenic subjects on the preceding pages.

Unfortunately, some of our fellow human beings are not born as photogenic.

That's where The Smile Train, the world's leading cleft charity, comes in. Through a simple operation, a child's appearance can be magically transformed, bringing a smile to her face and to all of those around her.

To see how you can help to bring a smile to a child's face, please check out The Smile Train at *http://www.smiletrain.org*. Thanks!

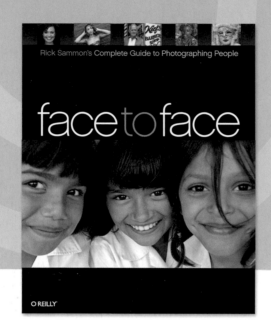